WILD FOCUS

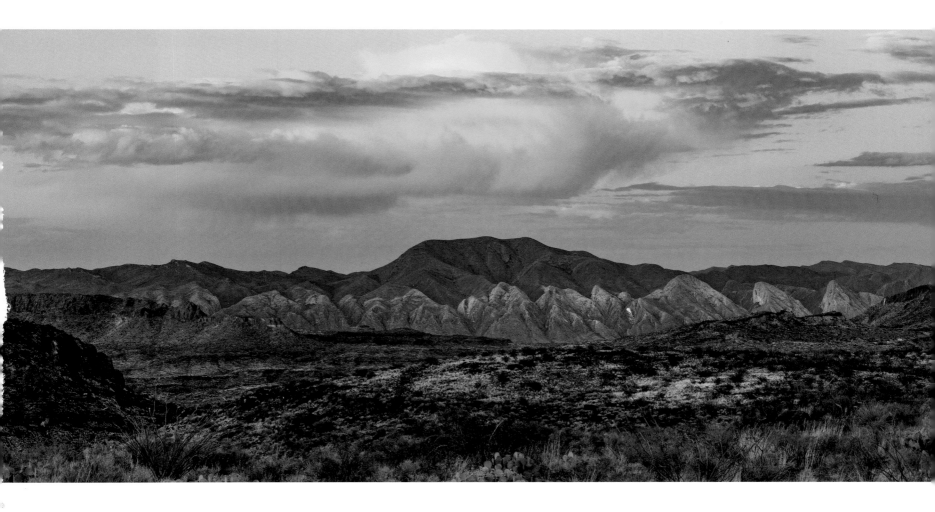

Kathie and Ed Cox Jr. Books on Conservation Leadership
Sponsored by

THE MEADOWS CENTER
FOR WATER AND THE ENVIRONMENT
TEXAS STATE UNIVERSITY

Andrew Sansom, General Editor

*Generously supported by the Texas Natural Resource Conservation Publication Endowment,
Meadows Center for Water and the Environment, Texas State University*

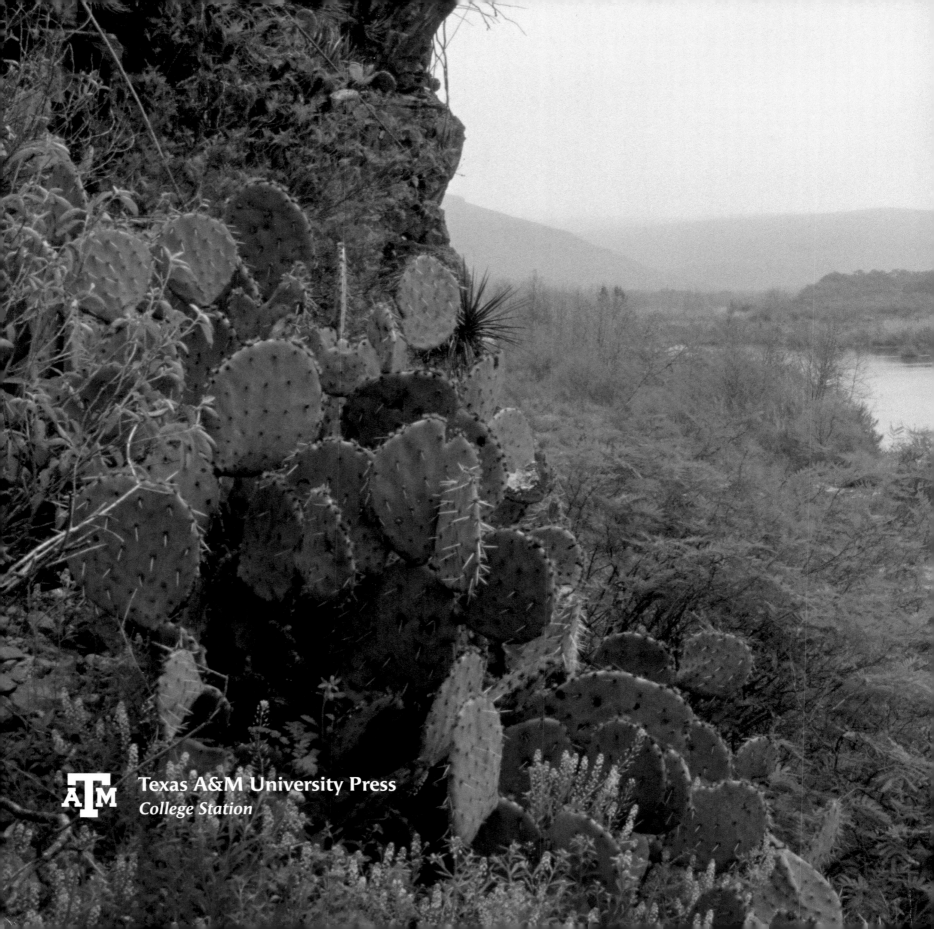

Texas A&M University Press
College Station

WILD FOCUS

Twenty-five Years of Texas Parks and Wildlife Photography

Earl Nottingham

With essays by Carter P. Smith and Lydia Saldaña
Foreword by Andrew Sansom

This paper meets the requirements of ANSI/NISO Z39.48–1992
(Permanence of Paper).
Binding materials have been chosen for durability.
Manufactured in Canada by Friesens

Library of Congress Control Number: 2021945516
ISBN (cloth): 978-1-64843-001-5
ISBN (ebook): 978-1-64843-002-2

A list of titles in this series is available at the end of the book.

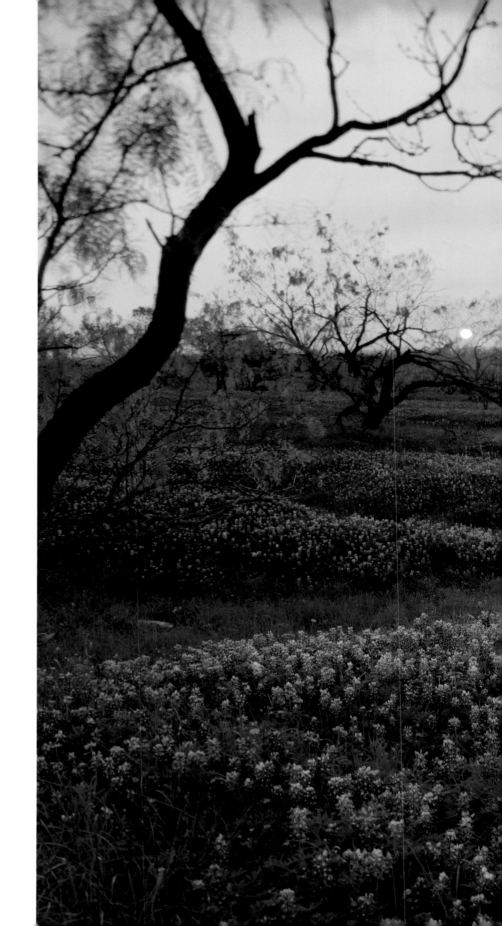

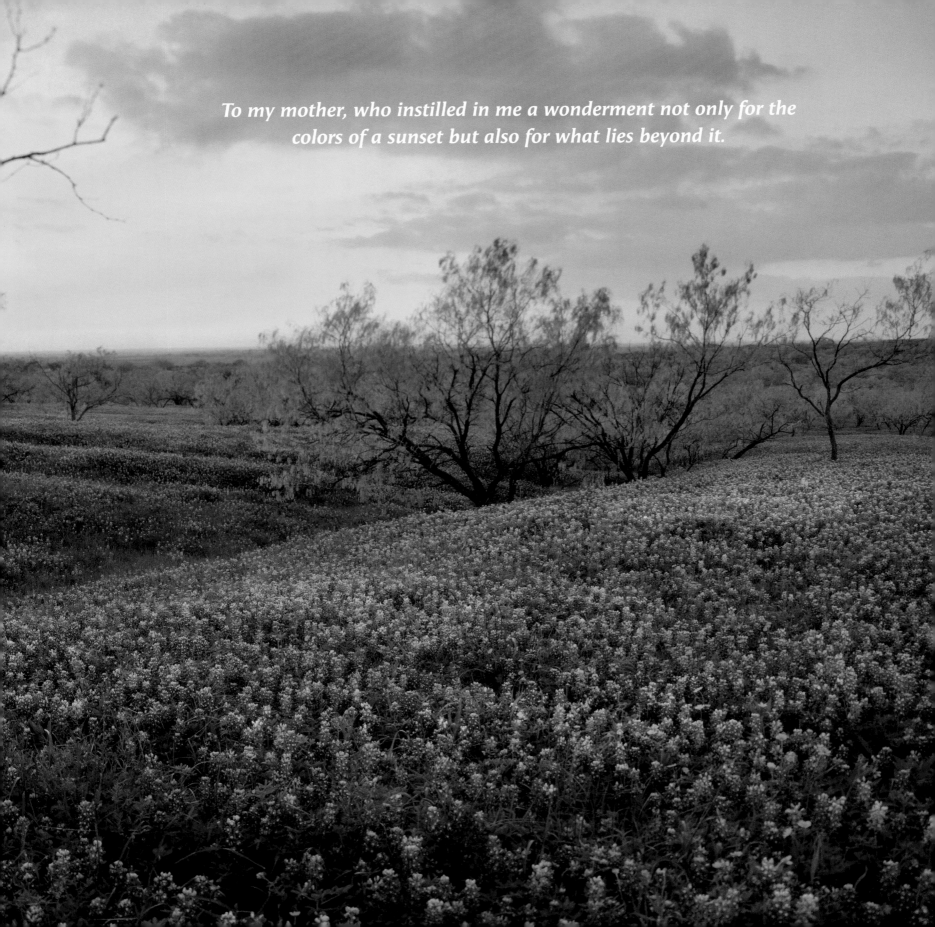

To my mother, who instilled in me a wonderment not only for the colors of a sunset but also for what lies beyond it.

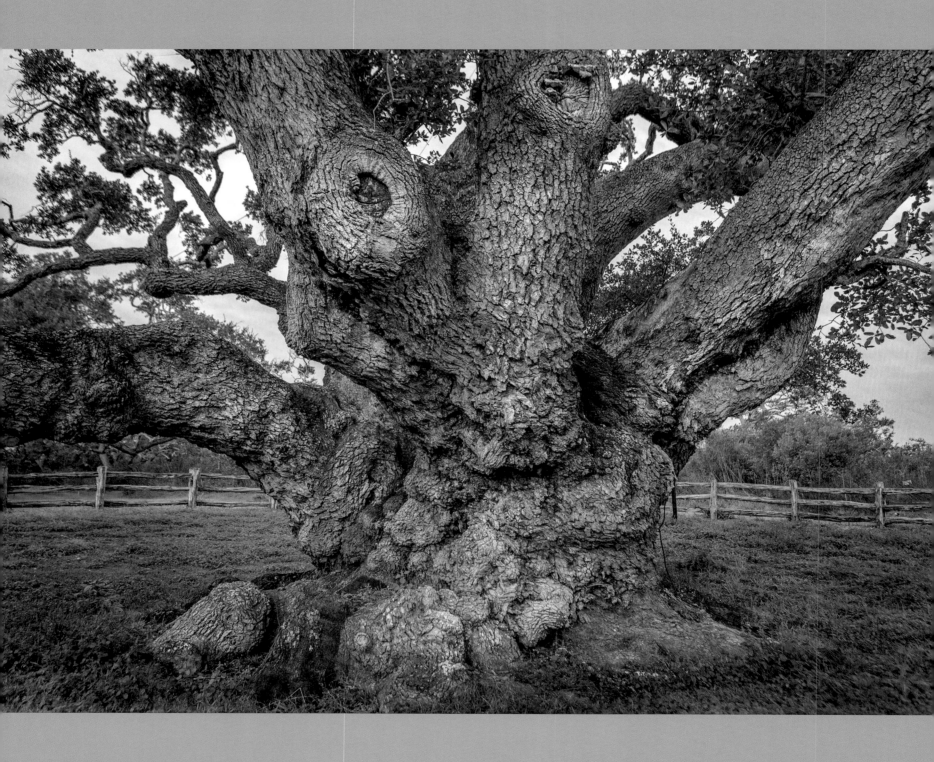

Contents

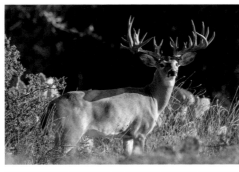

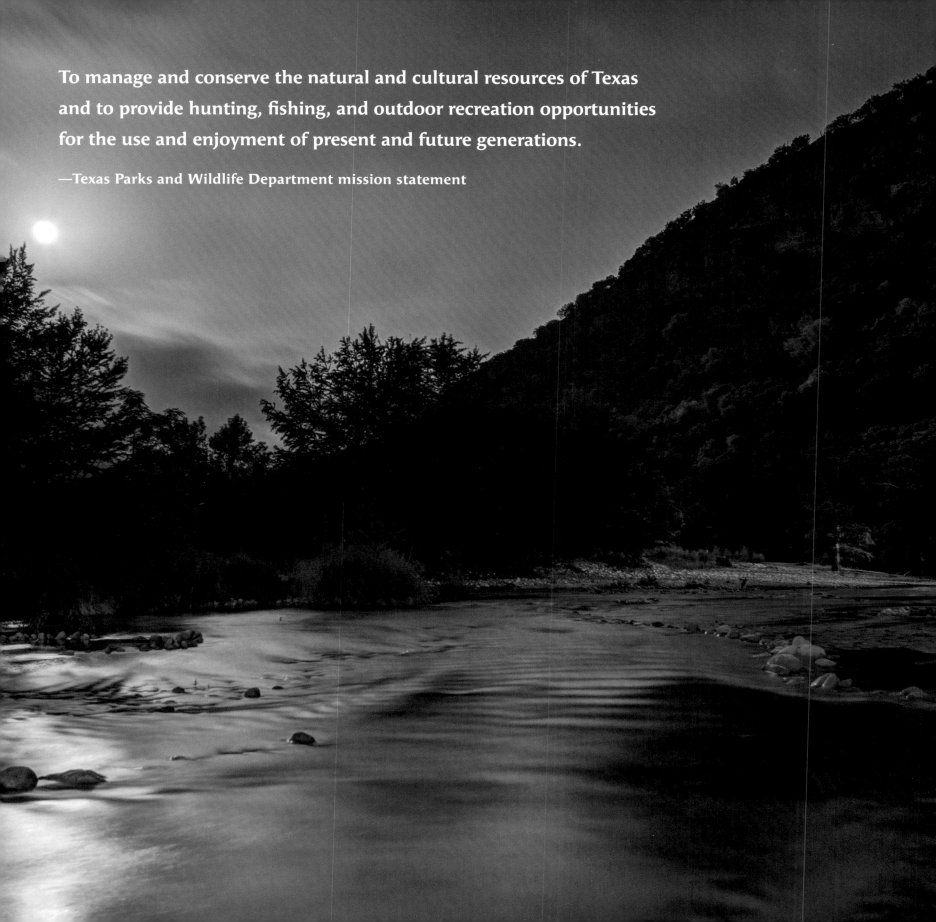

To manage and conserve the natural and cultural resources of Texas and to provide hunting, fishing, and outdoor recreation opportunities for the use and enjoyment of present and future generations.

—Texas Parks and Wildlife Department mission statement

Foreword

———

Over the years, people have often asked me what I loved most about working at Texas Parks and Wildlife Department or what was my favorite state park or wildlife management area. Though I have thought about these questions many times, I always remind myself that what I loved the most was and still are the incredible diversity of natural and cultural resources in the care of the department and the wonderful family of professionals who are their stewards.

On these pages, my colleague Earl Nottingham absolutely illuminates both passions. Here the reader is in for an amazing cornucopia of images depicting some of the most beautiful places in America by one of its most skilled photographers. At the same time, Earl himself is exemplary of the extraordinary company of people who are as dedicated to each other as to the resources in their care. It is no mystery that there is very little turnover at Texas Parks and Wildlife because we all love and loved working there so much. Earl's photographs show that love as well, through a focused lens.

Throughout the department's history, illustration of wildlife, historic sites, and wild lands has been fundamental to its mission through painting, photography, words, and video by some of the most talented people I have had the honor of working alongside. Earl Nottingham is surely one of those. His photographic skills are only matched by his kindness and good humor.

Along with me, another person who understands and appreciates Earl and his colleagues and the resources they manage is former Texas Parks and Wildlife Commission chairman Edwin L. Cox Jr. He and his wife, Kathy, have made this series of books on conservation leadership possible.

I know Ed agrees with me that we are proud to include Earl's work in this distinguished array as it is reflective of the incredible beauty of our state and a prime example of the finest group of conservation professionals in America.

—ANDREW SANSOM
General Editor, Kathie and Ed Cox Jr. Books
on Conservation Leadership

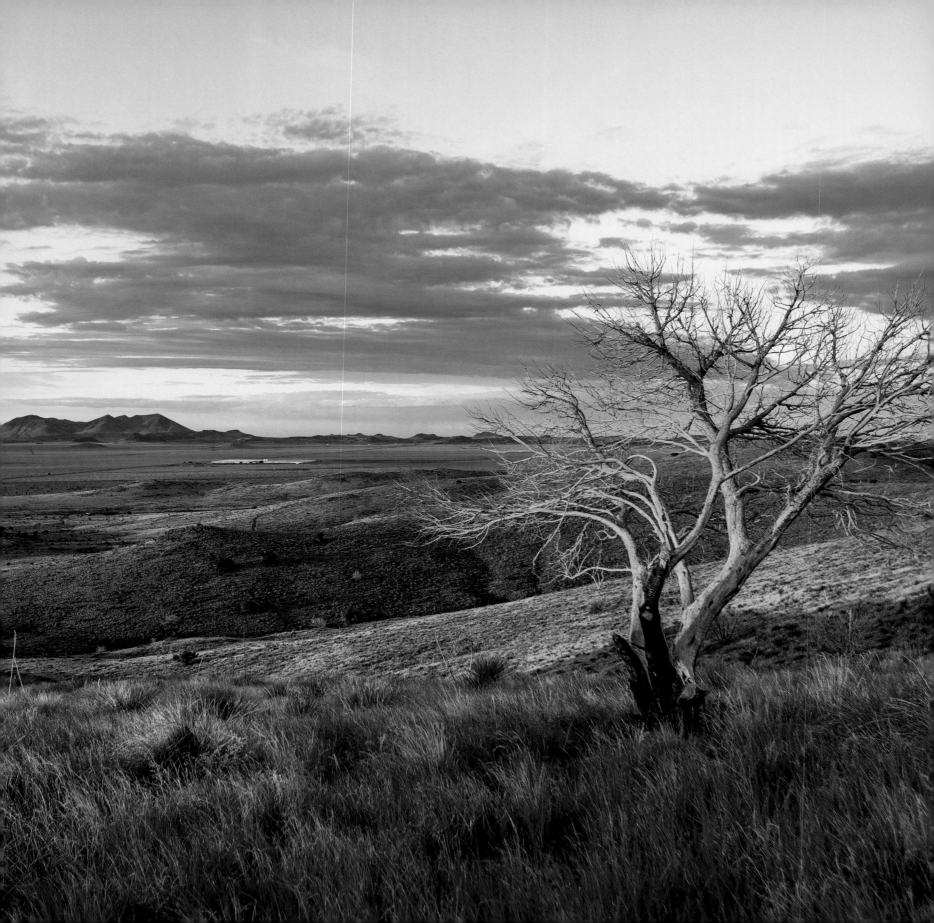

Acknowledgments

It's not an easy task, poring through thousands of photographic images taken over a twenty-five-year span to select roughly two hundred images that best illustrate the breadth of subject matter that comes with putting a face to the multifaceted mission of the Texas Parks and Wildlife Department (TPWD). It's especially not easy on aging eyes when straining to view pre-digital-era 35mm slides with a vintage magnifying loupe. Whether analog or digital, each image is like revisiting an old friend, and the exact moment of its creation is recalled with crystal clarity. I am instantly transported back to desert sunrises, moonlit rivers, fragrances of wildflowers, and aromas of campfire breakfasts. Each image takes me on a ride back down the lonely highways, dusty roads, and trails followed in pursuit of the perfect photograph and which, like life in general, consists of occasional detours, U-turns, and burnt bridges. Regardless of the path, I recall with gratitude the faces of the individuals encountered along the way who played a vital part in my journey.

First among them is my family, especially my wife, Paula, who let it be known early on, after sitting in the Terlingua ghost town cemetery for several hours waiting for magic light, that photographic patience wasn't her cup of tea but she would gladly support me in any other way she could—and she has. My gratitude also goes to my children, James, Karrie, Robert, and Adam, who were frequently conscripted as unpaid models.

Without the support of the Meadows Center for Water and the Environment, this book would not have been possible, and I am honored that it will be among the center's other publications that champion the stewardship of the state's resources. Special thanks go to its executive director, Andrew Sansom, not only for his eloquent foreword in this book but also for his personal inspiration over the years that fostered in me a deeper understanding and appreciation for wild Texas that translated to many of the images you see in this book.

Next I thank my editorial colleagues at *Texas Parks & Wildlife* magazine, who have given me the opportunities, freedom, and support to use my own vision to create the images that accompany their words when telling the stories of Texas. I am forever grateful to the current staff, Randy Brudnicki, Louie Bond, Russell Roe, Sonja Sommerfeld, Traci Anderson, and Chase Fountain, as well as to former editors Charles Lohrmann, Susan Ebert, David Baxter, and Bill Reaves.

TPWD executive director Carter Smith and former communications director Lydia Saldaña have graciously

lent their voices to this book through their essays. Each contributes a unique perspective of the value and contribution that the photographic image has in sharing conservation issues with the public.

All the proceeds of this book have been dedicated to the Texas Parks and Wildlife Foundation, which is the official nonprofit partner of Texas Parks and Wildlife Department. Its goal is to advance Texas' proud outdoor traditions and conserve our state's wildlife, habitat, and natural resources. Their efforts to create more outdoor opportunities for everyone are worthy of support.

A major debt of gratitude goes to Texas A&M University Press and its professional staff for taking a chance on this photographer's first book. In particular, I thank Thom Lemmons, who supported my proposal from the get-go, as well as Christine Brown, Patricia Clabaugh, Cynthia Lindlof, and Emily Seyl, who gently herded a literary neophyte through the gauntlet of the publishing process.

And finally, but certainly not least, is my Texas Parks and Wildlife Department family—over three thousand of them. Made up of twelve divisions and spread throughout the state, these conservation professionals share a common pride in their work and the TPWD mission. I have had the privilege to cross trails with most of them over twenty-five years, and I can say without reservation that they are Texas' finest.

WILD FOCUS

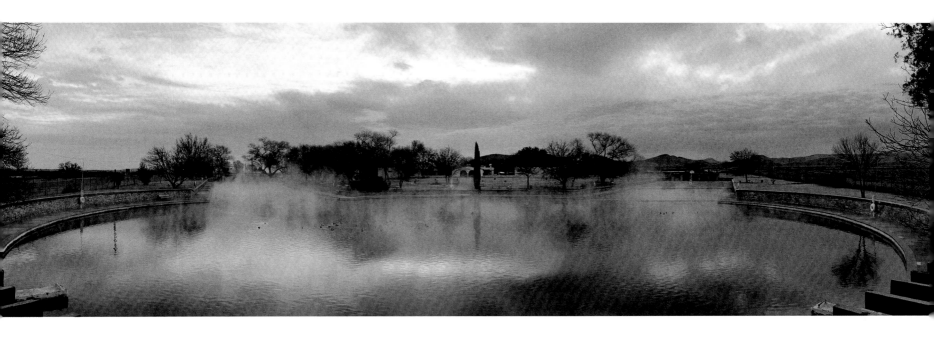

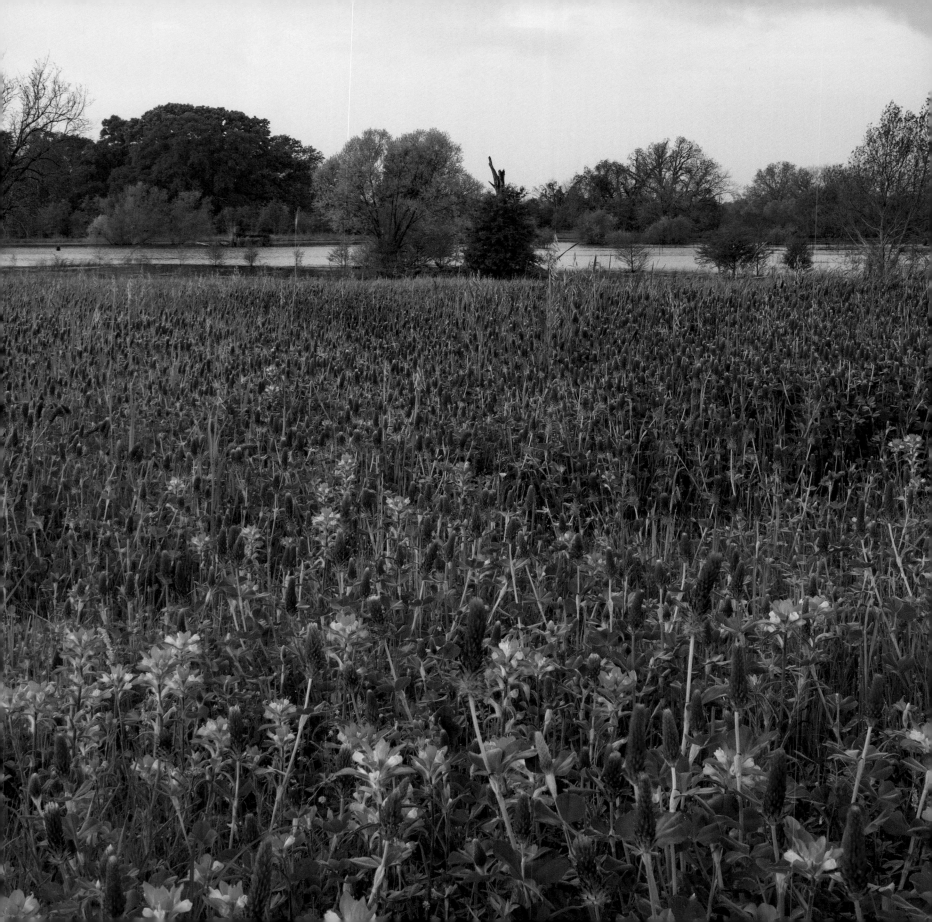

Introduction

Earl Nottingham

I wanted to be a cardiologist; it was an aspiration fueled in my younger years by many of my elementary and middle school classmates whose parents were physicians at our local hospitals in Temple. I assumed that most of those friends, with the aid of their parental mentors, would pursue a medical career when they grew up. Some did; most did not. My only exposure to the medical world was through my mother, a registered nurse at the Veterans Administration hospital who would frequently take me along with her on visits to the wards where she worked, mostly through the inhalation therapy sections to see, and hopefully heed, the detrimental effects of smoking via the many patients with chronic coughs and removed larynxes. Her efforts were heeded.

While in high school and still determined to be a doctor, I began to have doubts about my planned occupational path in my junior and senior years. In particular, math and science classes increasingly became a struggle, and it was difficult to grasp the upper-level concepts of these subjects. It was a fog. Accordingly, my grades reflected that struggle, and I came to the realization that the dream of any med-

ical career was fading away. However, one of the things I did excel at was music. Playing the trumpet in band was a breeze, and I quickly became first chair in the concert band as well as the stage band. Music felt second nature. I was equally comfortable with writing in journalism class, and when asked to join the high school newspaper and class annual staff as a photographer, I jumped at the chance and quickly discovered that visualizing, taking, and developing photographs came as easily as did music. To my mind, the photographic image was, and is, interconnected with music by its own visual equivalency of tonality, textures, tempos, and crescendos. Only in later years, when the concept of left- and right-brained dominance came into the vernacular, did I have some understanding, as well as some personal closure, about why some people are good at some things but not others—and why it was okay that I wasn't destined be a cardiologist.

After graduation from high school in 1972 I decided that photography was indeed my calling, and I enrolled in the photography program at the Art Institute of Atlanta, Georgia. It was a very basic curriculum but provided me

with enough training to be hired back home as a photographer for the local newspaper. After only two years as a staffer, it became apparent that I didn't really want to be a newspaper photojournalist for the rest of my life and, with the encouragement of colleagues and family, decided to pursue a more advanced photographic education.

Among institutions in the United States offering a bachelor of science degree in photography at that time, East Texas State University (now Texas A&M at Commerce) was considered one of the country's best and on a par with the bigger East and West Coast photo schools. Upon graduation, its students departed well versed in a wide range of photographic fields, including portrait, commercial, and photojournalistic photography as well as traditional film and print processing and even cinematography. Unlike the bustling campuses of larger universities, the small and usually quiet town of Commerce provided the perfect environment to concentrate on studies. Extracurricular activities were sparse, limited to a few watering holes on Main Street or taking a break from study by walking through the nearby woods or fishing on small lakes just outside town, which freed up the time needed for the long, late-night hours of film and print processing in the photo department's darkroom. Little did I know at that time that the well-rounded photographic curriculum of that small school in the woods of Northeast Texas would be fully utilized in the following years.

With diploma in hand I began my journey in 1978 as a freelance photographer and for the greater part of the next eighteen years shot anything and everything that came my way. Commercial, portrait, and wedding photography was the mainstay of my repertoire, but as many freelancers can attest, while enjoyable, the job can be a tough and hardscrabble way to earn a living, often resulting in a lack of finances, creativity, and, even worse, relationships—which is exactly what happened. I lost all three. It was time for a new direction for my work and my life.

One evening I stood in front of the magazine rack at the local bookstore, perusing the various publications and pondering which ones I might enjoy shooting photos for and where I might find my "dream job." Of course, the venerable *National Geographic* was front and center, as well as many of the other top photography-themed magazines, but I quickly dismissed them as a pipe dream. My eye then struck an issue of *Texas Highways* magazine, and as I opened and fanned through the pages, its stories and photos brought back happy memories of the days traveling as a child with my parents and our times spent in the outdoors, especially the parks, rivers, and lakes around Texas. Now *that* was the type of photography I could enjoy and possibly even make a living with. The next morning, and taking a bold chance, I cold-called the photography editor of *Texas Highways*, introduced myself, and asked if the magazine would accept any photo submissions on speculation from unknown photographers for any current publishing needs they may have. Surprisingly, the editor said, "Sure, you can try if you want. We have a story on the Frio River coming up." I thanked him, immediately packed up my 4×5 view camera, loaded some film holders with color transparency film, and headed to the Frio River, where I spent the next four days shooting on a gamble. My images made not only the magazine but also its cover! My foot was in the door.

Providing freelance photography for *Texas Highways* opened up other doors to publications such as *Texas Monthly*, *Southern Living*, and eventually *Texas Parks & Wildlife*, whose photo editor at the time, Bill Reaves, began to give me frequent freelance assignments covering the things I was passionate about: the woods and waters of Texas. In time, I applied for a full-time staff photographer position that had opened up with the agency. Thanks to the track record I had built as a freelancer, and against the odds because of the massive number of people who had applied for the position, I got the job.

On March 18, 1996, I walked in the front door at the headquarters of Texas Parks and Wildlife Department, replacing the legendary photographer Leroy Williamson, who had recently retired. Immediately after filling out my entry paperwork and receiving credentials, I was informed that I had to hit the ground running on an assignment to photograph an oil spill near Galveston. On such short notice, the only motor-pool vehicle that could be found for me was an ancient, rusting gray van with peeling paint and bald, out-of-balance tires that was normally used to shuttle kayakers on river excursions. It made no difference to me as I wobbled and squeaked toward Galveston. I was proud to be driving a vehicle with the TPWD seal on the door.

Fast-forward twenty-five years to the publication of this book. It is with good reason that one of its first pages contains the Texas Parks and Wildlife Department's mission statement: "To manage and conserve the natural and cultural resources of Texas and to provide hunting, fishing, and outdoor recreation opportunities for the use and enjoyment of present and future generations." It is this one concise sentence that defines and drives the goals of one of the state's largest agencies, which is made up of more than thirty-five hundred permanent employees in twelve divisions devoting their work to conservation efforts. The mission statement is also the roadmap that has dictated the subject matter I put in front of my camera, enabling the public to experience the Texas outdoors vicariously through engaging photography. It is my job to use camera, lens, and light as tools to manifest the many facets of the mission statement that could be illustrated with a photograph of a West Texas vista, a hunter in East Texas, a tropical bird in South Texas, or a historic site in the Panhandle, just to scratch the surface. Sadly, it also involves often documenting nature's devastation brought about by droughts, flooding, hurricanes, or fires.

Twenty-five years can seem like either a lifetime or a blink of the eye, depending on your perspective. For me,

it's a time span measured by the number of miles driven, sets of truck tires replaced, sunrises and sunsets witnessed, and faces captured for posterity. The result is reflected in the number of images added to the vast TPWD photo archive, which is a valuable compendium and historical documentation of the Texas outdoors. The archive also represents what is perhaps one of the most important seminal moments in the evolution of photography that was born during the past twenty-five-year period—the transition from traditional film to the digital image.

Prior to the year 1999, most magazine photographs were created with transparency film such as 35mm slides, medium- and large-format film stocks for finely detailed images. These films had very little tolerance for under- or overexposure (latitude), and you never knew for sure if you got the image right until the film was processed, which meant mailing or hand-delivering the rolls or sheets to a photo lab and then awaiting the results. I can attest to instances of using several choice words and cries of anguish upon looking at newly processed transparencies that could have been prize-winning images but were either overexposed, underexposed, or slightly out of focus. Additionally, the downside to having any type of film processed was the negative environmental aspect of the chemicals that were needed to develop them, eventually going down the drain.

Although prototypes of digital cameras had been experimented with for several years, the introduction of the Nikon D1 digital camera body in June 1999 gave us a somewhat viable tool for magazine photography. For five thousand dollars we could get a whopping 2.7-megapixel image, just enough resolution needed for only a quarter-page photograph. I was convinced that this lower resolution, combined with the less-than-stellar color rendition, would be a passing fad, and in short order we would be back to using "real" film. However, it seemed that every few months another camera maker would come up with

a newer/better sensor that increased both resolution and color quality. We were soon at the 8-megapixel point needed for a full-page reproduction and finally the gold standard: 16 megapixels for a double-page spread. Another benefit was the ability to instantly review an image on the camera's LCD screen and confirm that you had the photo, or not. The value of this instant feedback was enormous. The day had finally arrived when the digital image had met, and exceeded, the quality of most films. Additionally, there were no more trips to the photo lab and waiting for the film to be processed.

Rapid innovations in digital technology quickly brought along new ways of disseminating photography to the public. Whereas a photograph might have previously been used only for a printed publication, it could now be used in a multitude of ways to get the agency's message out via portals such as websites, social media, and other internet-based platforms. An added function of many digital cameras that makes them valuable communication tools is the ability to shoot video. This has opened up creative opportunities for traditional still-image photographers such as myself, and I use it often to produce videos for our other TPWD media branches. Even today's simplest camera phones have become capable of shooting quality photos and video, many worthy of publication, broadcast TV, or even feature-film use.

I'm often asked what is my favorite subject to photograph. Considering the size of Texas and its diverse natural regions and all that inhabit it, picking one subject is like picking a favorite child—it is impossible to do. How do I choose between a fog-shrouded Caddo Lake, the Lighthouse formation at Palo Duro Canyon, sunrise at Padre Island, or a magnificent sunset in the Chihuahuan Desert of the Big Bend? It is, and will always be, the memories of those scenes, along with thousands of images of other places, people, and things of Texas that will be preserved indelibly in my mind, each one instantly recalling the emotions and senses felt the moment the shutter clicked for that fraction of a second. They allow me to recall and reflect that for one magnificent moment, somewhere in the grand state of Texas, I was really there.

Telling the Story of Texas Conservation

Carter P. Smith

I don't suppose many, if any, Texans feel much compelled to look to the words of a long-gone Irish poet to describe the deep attachment to place from whence and which we call home. That being said, I think my high school English teacher was on to something. W. B. Yeats did have something of a knack for the written word. That wonderfully evocative line from his classic "The Trembling of the Veil," about all people having their first unity from a mythology that marries them to rock and hill, seems to sum it up as well as, or better than, just about anything else I have read or heard.

Oh, to be fair, we come to much of that sentiment pretty naturally. If nothing else, we Texans are by our very nature pretty proud of our home ground, united by a shared love of our wide-open spaces and vast places, our wild things and wild places. It's part of our mythology, our identity, our culture—who we are and what we love and treasure about our home ground. And for good reason.

Pick your geography, pick your place, pick your season, pick your setting: I don't care. Our rocks and hills, real and metaphorical, are pretty special. For one, we have a lot of them. We are big, vast, and diverse. Within our borders are more than 150 million acres of terrestrial habitats; nearly 200,000 miles of rivers, creeks, and streams; over 6 million acres of surface water; 367 miles of coastline; and eleven different ecoregions that span the horizon from the vast deserts and sky-island mountain ranges of the Chihuahuan Desert to the blue water and barrier islands of the Gulf Coast, from the southern terminus of the Great Plains to the northern extralimital bounds of the subtropics in the Rio Grande Valley.

And what's in between those borders matters a lot to most Texans, those here by birth and those here by choice. I dare say, who among us doesn't savor the sense of contentment when perched atop the massive dome at Enchanted Rock; the sense of wonder from trekking

up the peak of El Capitan and gazing out across the vast expanse of West Texas desert, sky, and mountains; the sense of awe from sitting in the bowels of Palo Duro Canyon and staring straight up at the sheer rock face of Fortress Cliffs; the sense of repose at sunrise or sunset when walking along a lonely stretch of remote barrier-island expanse at Padre or Matagorda Islands; and the sense of pride welling up when standing on the state's most sacred soils of San Jacinto and gazing upward at the San Jacinto Monument?

Oh, there are plenty of others besides the iconic ones, places that you know, and some that only you know. Maybe it's a favorite bend or bluff along some creek or river; a scenic overlook along a hiking trail in your country place, greenbelt, or park of choice; a beloved fishing spot, duck marsh, brush-country *sendero*, patch of woods, or swath of prairie. Or maybe it's something as simple as a favorite old tree, under whose sprawling canopy you seek, against whose trunk you sit, and within whose shade you rest.

So with a posthumous, and appreciative, nod to the late poet Yeats, I will respectfully posit that absent being immersed in one of those special places, few things evoke that same sense and pride of place more than a rousing photograph of such. And if you are looking for a photographer who knows the entire state; one who shares that love of our rocks and hills; one who has captured the life, history, and stories of the people and places of our great state, look no further than the pages of the *Texas Parks & Wildlife* magazine, where you will see the work of Earl Nottingham.

For more than twenty-five years Earl's photos have graced the cover and pages of the state's flagship outdoor magazine. By passion and profession, Earl is an artist, a creative genius, and outdoor enthusiast who marries light and frame, aspect and exposure, mood and subject. His photos draw you in and make you feel like you are standing in the middle of a scene, a place, a setting, or an adventure you surely wish you were in or on.

Maybe it's a picturesque shot of the canyons at Caprock, dusted from a light, midwinter snow and dotted with wild bison, descendants from Charlie Goodnight's historic herd. Or perhaps it's a lovesick, Hill Country tom, parading for a group of indifferent hens, pictured in an impossibly beautiful mélange of brightly hued and multicolored wildflowers. Or maybe it's a lone fisherman, wetted line and all, standing atop a bass boat, ostensibly fishing but really reflecting on just how damn lucky he is to have the whole day ahead of him on such a beautiful lake.

Don't think for a second, however, that Earl shoots just the proverbial blue skies and bluebonnets you wish were surrounding you. Among other things, he has been there to chronicle the wreckage from the hurricanes, the floods, and the fires. He has been there when the lakes were empty and the fish, belly-up. His lens has captured the sadness of the last call of game wardens who gave up theirs trying to answer one in the solemn call of duty.

You see, Earl the photographer is really Earl the storyteller. In his own way, he is on a kind of par with a Dobie, a Bedichek, or a Graves. He is not only part artist but part raconteur, part messenger, and part historian.

For those of us in the trenches of conservation, Earl's pictures have given life to some of our greatest triumphs but also to some of our greatest tragedies. And in the last twenty-five years, there have certainly been plenty of both. Change of all kinds is inevitable for our home ground, some of it good, some of it not. I have long since learned to accept that our lands, waters, fish, wildlife, and parks are not immune from change.

On the positive side, we have done well for a host of fish and wildlife, game and nongame, finned, feathered, and furred. Thanks to the labors of a gaggle of biologists, landowners, conservationists, and others, we can herald the restoration of bighorn sheep back to the mountains

and the eastern wild turkeys back into the woods; we may celebrate the recovery of the black-capped vireos in Hill Country pastures and brown pelicans along our coast; and take pride in the return of the paddlefish in Big Cypress Bayou and Guadalupe bass in Hill Country streams.

As a proudly private lands state, we have come a long way from the acrimony of the golden-cheeked warbler wars and the Take Back Texas movement of the late 1980s and early 1990s. The ethic of venerable land stewards such as Robert McFarlane of the BigWoods and J. David Bamberger from Selah now leads the way and helps set the tone for conservation on private lands. Over thirty million acres of farms, ranches, and other private lands, encompassing nearly 20 percent of the whole state, are under a voluntary wildlife management plan with TPWD. And according to the Texas A&M Real Estate Center, one of the primary reasons people purchase rural land today is that they have an interest in nature, wildlife, hunting, and being outdoors.

But it doesn't stop there. Well over 1.6 million acres of valuable open space and wildlife habitat have been permanently preserved through the work of the burgeoning land trust community and the generosity of landowners. Fights over the future of water and imperiled species residing in places such as the Edwards Aquifer have been reduced because of collaboration and farsighted investments through initiatives such as the state's Recovery Implementation Plan and the city of San Antonio's Aquifer Recharge Protection Program.

Along the way, important new public lands have been added to the system of state and national parks, wildlife management areas, and national wildlife refuges: for example, the new sprawling Powderhorn State Park and Wildlife Management Area at Port O'Connor and the Kronkosky State Natural area near Bandera; the Dan A. Hughes Unit of the Devils River State Natural Area and the Palo Pinto Mountains State Park outside Strawn; the

Roger Fawcett Wildlife Management Area in the Cross Timbers and the Yoakum Dunes in the High Plains.

But, alas, along with all that good has been news of the less salutary kind. We have also had to learn how to fight the incursion of unwelcome interlopers such as giant salvinia, water hyacinth, lionfish, and zebra mussels in the water and K-R bluestem, Chinese tallow, and giant arundo on the land. We have had to battle pernicious pests such as feral hogs and red imported fire ants from taking over our rangelands and tried to stave off chronic wasting disease and white-nosed syndrome in our deer and in our bats.

Trying to keep sufficient water in the rivers and for the bays can be a real challenge, and the loss and fragmentation of our habitats on Texas farms, ranches, and timber holdings have transpired with too much rapidity and too much expanse. We have witnessed one of the single largest divestitures of private lands in Texas with the sale and splitting up of the big timber holdings in East Texas. And as a state, we hold the dubious distinction of leading the country in the loss of farm and ranchland open space.

Meanwhile, the wreckage and recovery from ever-mercurial Mother Nature and the massive storms named Rita, Ike, Harvey, and Imelda remain fresh on our minds, as do the droughts and floods of record and the Armageddon-like fires in places such as the Lost Pines of Bastrop and the hills of Possum Kingdom.

Conservation is not, and never has been, for the faint of heart. Ultimately, though, as a father of a young son, the eighth generation of our family to be born here, I take great comfort in the fact that so many still do care, that we are indeed making progress, and that there always will be much to love and to cherish about the Texas outdoors. As director of Texas Parks and Wildlife Department, I feel richly blessed to live and work in and for a state where there are still plenty of wild things and wild places to conserve; where stewardship of our lands

and waters, our farms and ranches, our parks and our refuges is still seen as a virtue, not a vice; where engaging and immersing our young people in nature and the outdoors and introducing them to our proud outdoor heritage are believed to be an imperative of the highest order and calling; and where the people of our fine state still care passionately about the place we, and only we, know as our home ground.

J. Frank Dobie famously reminded us, "Great literature transcends its native land, but none that I know of ignores its soil." Thank you, Earl Nottingham, for not ignoring ours.

A Legacy of Visual Storytelling

—

Lydia Saldaña

Humans have incorporated visuals into their storytelling for as long as there have been stories to tell. From prehistoric cave drawings and ancient petroglyphs, to medieval tapestries and Renaissance paintings, to the advent of photography in the nineteenth century, humans have documented their experiences through the images of their lives.

Photojournalism hit its stride in the early twentieth century as camera technology evolved, and the photographic image soon became the cornerstone of visual communication. In 1936, *Life* magazine was born, bringing glorious images to the masses each week. Magazines proliferated to meet the needs of every imaginable audience, and even government agencies became publishers, including the Texas Parks and Wildlife Department (TPWD).

The first issue of *Texas Game and Fish* magazine was published by TPWD in 1942 and has been published continuously ever since, making it one of the longest-running magazines in the state. After the 1963 merger of the State Parks Board with the Texas Game and Fish Commission, the title of the publication was changed to *Texas Parks & Wildlife* magazine. Stunning photography has always been a staple of the magazine, and its roster includes some of the most talented photographers in Texas.

In 1996, TPWD had an opening for a chief photographer position for the first time in many years. The position would provide imagery not only for the magazine but also for the many other communication needs of the agency. Hundreds of people applied, including a gentleman named Earl Nottingham. His extensive portfolio impressed a critical job interview panel, and he was ultimately selected for a position he would soon describe as the best job in Texas.

Shooting for the magazine remains one of his key duties, and through that work, Nottingham has brought to life magazine manuscripts about the parks and wildlife

of Texas and the people who have devoted their lives to their conservation. His photo credits no doubt number in the thousands, and his images have probably graced the pages of more issues of *Texas Parks & Wildlife* magazine than any other photographer in its history.

But shooting for the magazine is just one of his duties. Nottingham is also called on to chronicle the news of the agency and to help put a face to a government bureaucracy. His evolution in the position parallels the evolution of technology and his personal evolution as a visual storyteller. When he began working for TPWD, shooting film and developing it in a darkroom were the norm. When digital cameras first became widely available, Nottingham was not the only photographer who was skeptical about the concept of a digital image. He will be the first to tell you that he thought the whole thing was "a fad" and that traditional film and its processes would survive as the primary methods of photographic capture.

However, as the quality of the digital image began to meet—and then exceed—that of film, he saw the handwriting on the wall and began the transition of TPWD photography services from film to digital, eventually shuttering the TPWD darkroom as well as the need for outside processing services. He also developed and organized the first digital archive of TPWD imagery, now a treasure trove of images that chronicle the department's history along with the flora, fauna, and beautiful landscapes of our state.

Along the way Nottingham honed his digital photography skills, becoming an advocate for the new technology but realizing that although technology evolves, the artistic fundamentals of photography will never change. Capturing a compelling image to tell a story remains job number one. As the images throughout this book attest, Earl has chronicled the beauty of every corner of Texas. He has captured all manner of wildlife with his lens, letting us get an up-close view of the creatures that call

Texas home. His work has also helped us understand the critical role we play in the conservation of the lands and waters that wildlife, and humans, need to thrive.

One notable example is the decade-long effort the TPWD Communications Division undertook to educate Texans about the critical water issues facing our state. Kicked off by *Texas Parks & Wildlife* magazine with a historic 116-page issue in 2002, the magazine led the way for an unprecedented deep dive into the most important environmental issue facing Texas: the availability of clean water to sustain fish, wildlife, and human populations. Nottingham's images can be seen throughout all ten issues, helping readers appreciate the visceral side of often-mind-numbing complexities of water policy.

Taking the lead from the magazine, the rest of the Communications Division climbed aboard, producing five hour-long video documentaries over the course of the decade, three of which were narrated by Walter Cronkite. The documentaries aired in prime time on PBS channels across Texas. Along the way, TPWD Marketing, Creative Services, and Education staff rolled it all together into a web resource that is chock-full of information and educational resources. Those resources are still being used today by Texas teachers, parents who are home-schooling their children, and many others. Nottingham's work, along with the work of many other photographers, videographers, writers, and educators, is helping the next generation of Texans understand the nuances of water policy and the importance of the ongoing water issues facing our state.

Policy is made by people. TPWD's on-the-ground conservation efforts happen through the work of wildlife and fisheries biologists, park professionals, game wardens, and a legion of others who support their efforts. Putting a face before the public of these conservation professionals who help determine the way Texans hunt, fish, and enjoy the outdoors is another element of Nottingham's portfolio. His portraits of these conservation professionals have

enhanced the pages of *Texas Parks & Wildlife* magazine over the years.

Some of those portraits also deck the hallways of TPWD headquarters in Austin. In the mid-1990s, TPWD executive director Andrew Sansom encouraged the creation of an annual employee awards program to highlight the work of TPWD employees across the state. Tasked with capturing the essence of each award winner through his camera lens, Nottingham and his colleagues have created a series of portraits, sometimes serious, occasionally whimsical, that are treasured by employees as much as the award itself. The TPWD Employee Recognition Award Program is still going strong after more than twenty years, and the award boards containing employee portraits are a welcome adornment at TPWD headquarters.

Likewise, a series of portraits of legendary Texas landowners is another feather in Nottingham's cap. The Lone Star Land Steward Program, launched in 1996, honors the conservation ethic of Texas landowners across the state. From the very first year of the program, Nottingham has captured the character of the men and women who love their land and share its bounty with others. These portraits, shared in the pages of the magazine and in the foyer at TPWD headquarters, are cherished keepsakes for the award winners.

Earl Nottingham's work not only captures the people and places that are keeping Texas wild and beautiful, but he has also chronicled the fury of nature at its worst. Some of the most dramatic shots in Nottingham's portfolio came in the wake of Hurricane Katrina in 2005. The deadly storm marked the first time Texas game wardens crossed state lines to assist in a natural disaster. Nottingham accompanied game wardens into the flooded neighborhoods of the devastated Lower Ninth Ward of New Orleans to document the harrowing search-and-rescue efforts. It's an experience he will never forget.

A few years later when Hurricane Ike tore through Texas and Louisiana, he was embedded with Texas game wardens at ground zero when the hurricane made landfall on the upper Texas coast. He chronicled the search-and-rescue work, putting a human face on both the first responders and the storm's victims. Nottingham and his TPWD photo and video colleagues continue to cover these natural disasters, sometimes at their own peril, from floods and fire to a seemingly never-ending string of hurricanes that make their way into the history books. The images he and his colleagues have produced are a powerful testament of how the work of Texas game wardens touches the lives of all Texans, especially in their hour of need.

The advent and pervasiveness of social media have amplified the reach of TPWD's traditional methods of communicating its message to the public. Photo and video images are the bedrock of TPWD's social-media feeds, and Nottingham's work, along with that of his colleagues, has never been more important in effectively telling TPWD's story. Social media plays a critical role in TPWD's communication toolbox, and Nottingham understands that an engaging image that pops up in a social-media feed is just as important as an award-winning photograph that appears in the pages of the magazine.

Technology continues to emerge, advance, and converge. As Nottingham has demonstrated, even a simple smartphone is more than capable of taking magazine-quality photos as well as broadcast-quality video, and the wireless technology within allows for those images to be quickly shared with others. As digital still cameras gained the ability to capture video, he began experimenting with the moving image in 2009, and under the tutelage of the Emmy award–winning videographers in TPWD's Media Production team, his skills quickly improved. He now routinely shoots video while he is out in the field, and his work has appeared not only in

TPWD's weekly PBS television series but has also been featured on *CBS Sunday Morning*.

Nottingham has a way with words, too. As readers of *Texas Parks & Wildlife* magazine will confirm, his "Picture This" column is one of the most popular. Nottingham shares his extensive knowledge with readers on topics ranging from scouting before a shoot, to picking a specialty lens, to developing your own signature photographic style. His ability to effectively share what he has learned is yet another example of an expert storyteller in his prime.

Nottingham can be self-deprecating about his incredible skill in capturing an image and telling a story. As his longtime boss and always friend, I have always told him how much I admired his ability to evolve and grow as a storyteller, always willing to learn something new. His response is telling: "You may call it evolution, but I call it a continuing case of teaching an old dog new tricks. It's a matter of not only keeping up with technology but also keeping up with the ever-changing story of how TPWD's mission translates into conservation in Texas. There are only so many nuts and bolts to a camera. What I've found over the last quarter century is that the stories are infinite and worthy of being told in the most effective way possible with a variety of tools. After years behind a lens, using a camera is reflexive, and it truly becomes an extension of the eye, which allows the photographer to more effectively translate nature's nuances in an image."

Texas is fortunate to have a storyteller of Earl Nottingham's caliber as a public servant who has made his mark as TPWD's chief photographer for so many years. May there be many more.

Part 1
Wild Places

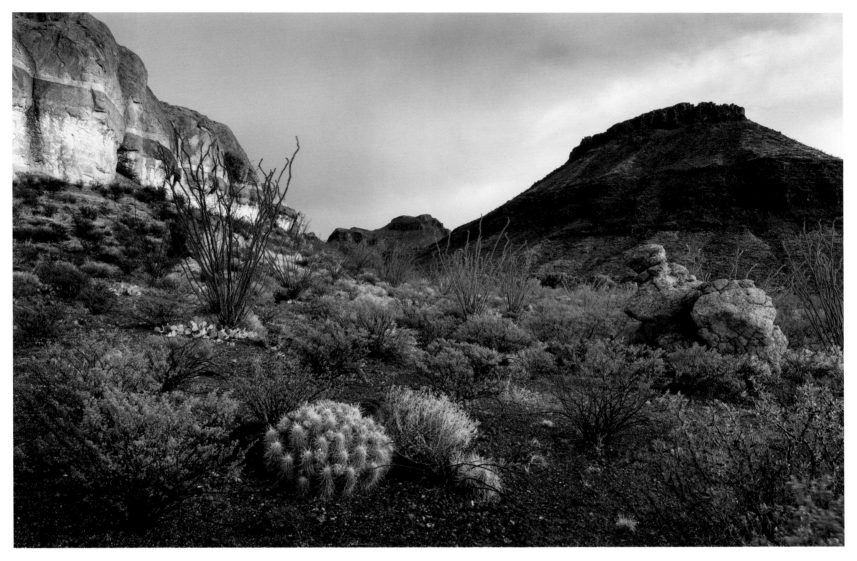

After a spring rain near Cuevas Amarillas, Big Bend Ranch State Park.

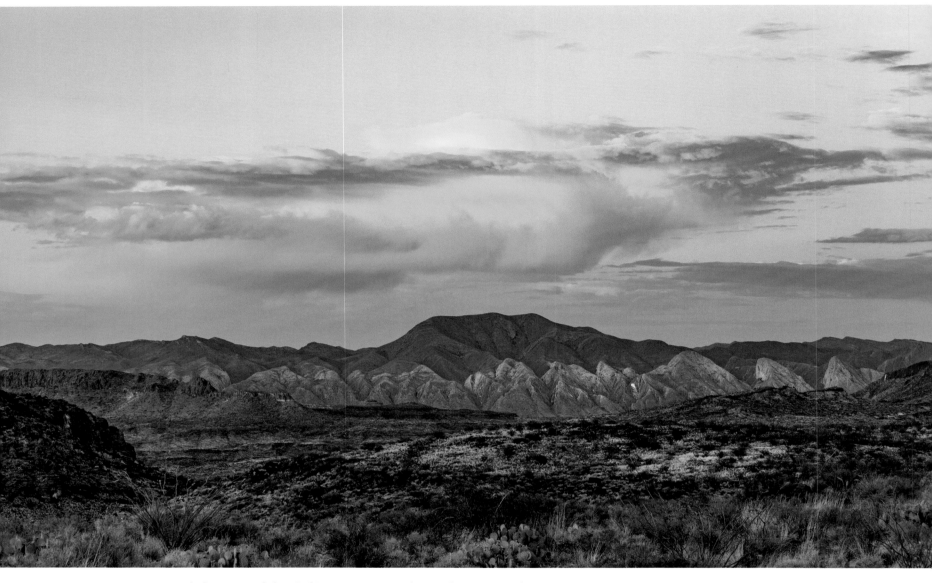

View toward the rim of the Solitario, Big Bend Ranch State Park.

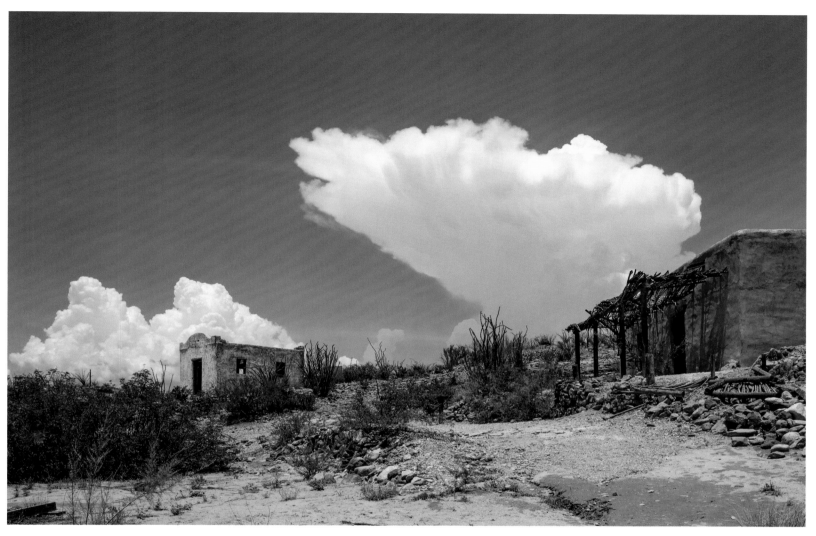

Distant thunderhead at abandoned Contrabando movie set near Lajitas.

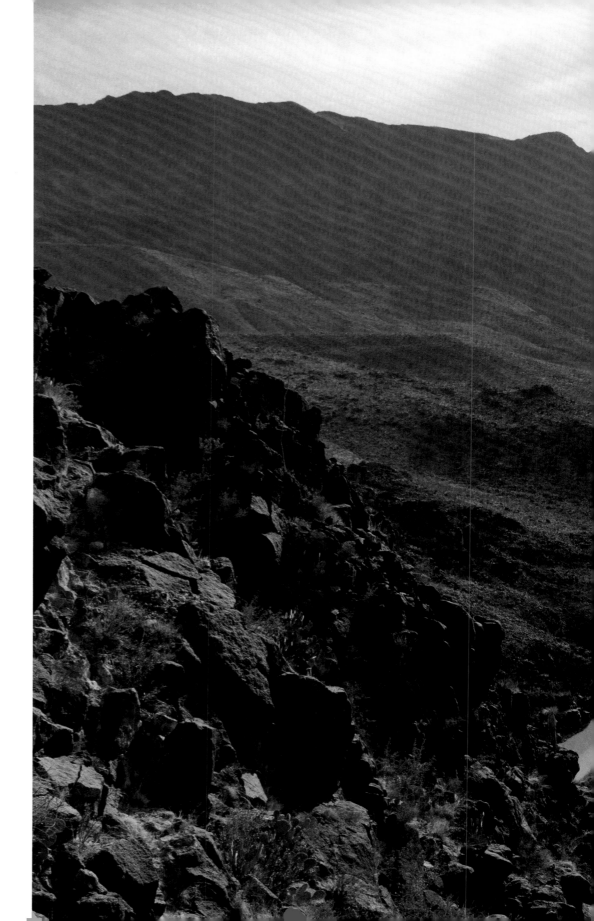

Rio Grande from the Big Hill,
Big Bend Ranch State Park.

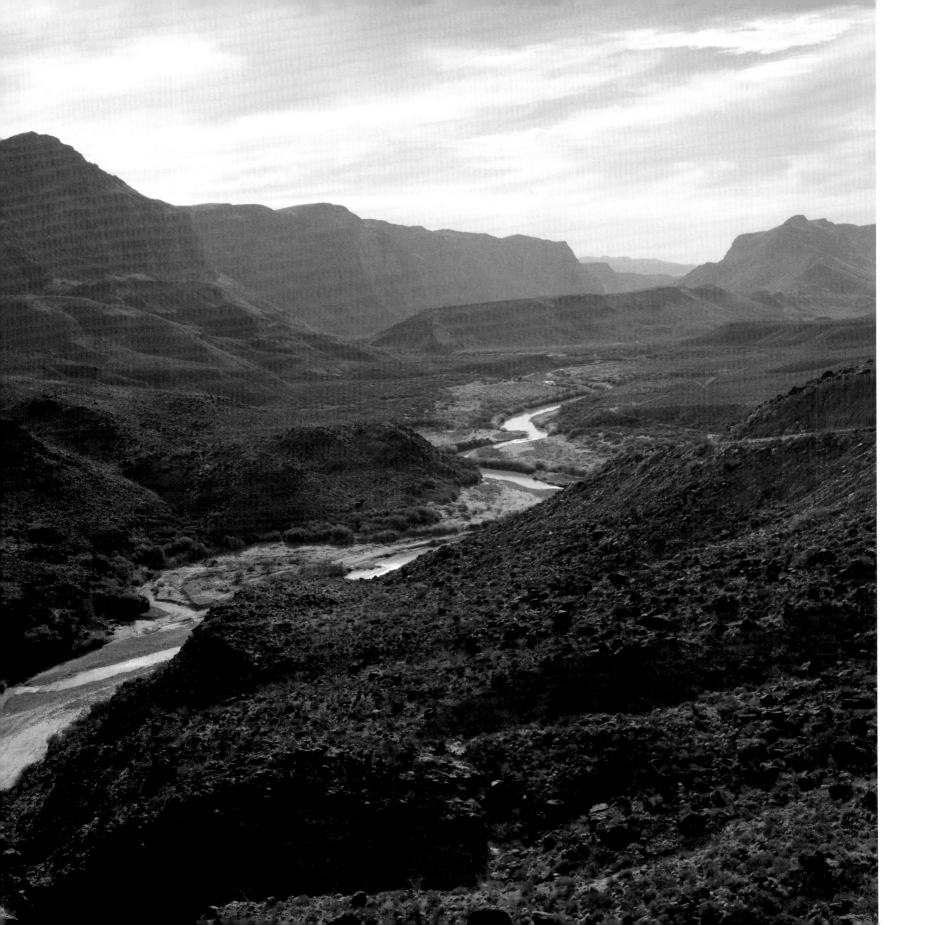

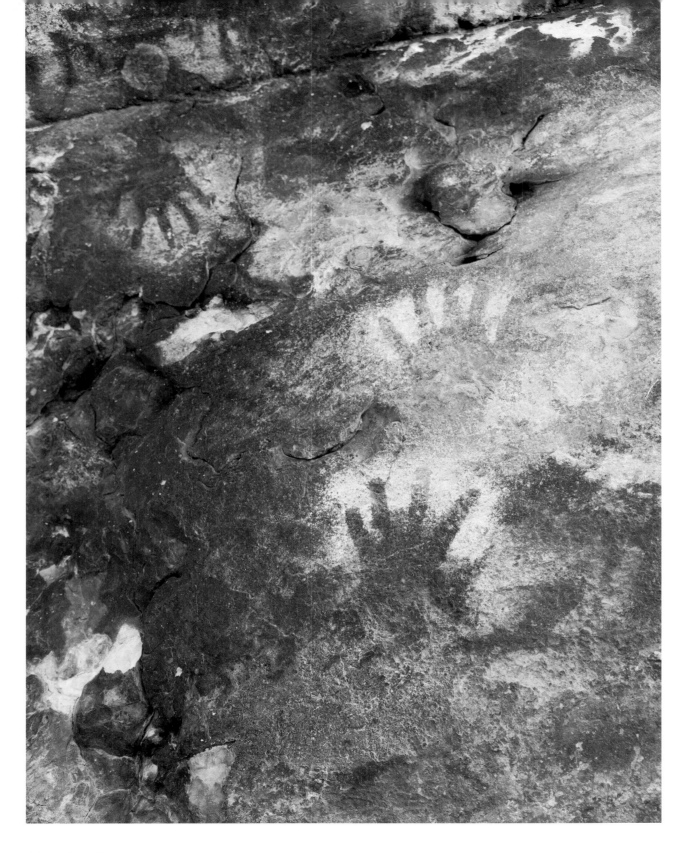

Rock art, Big Bend
Ranch State Park.

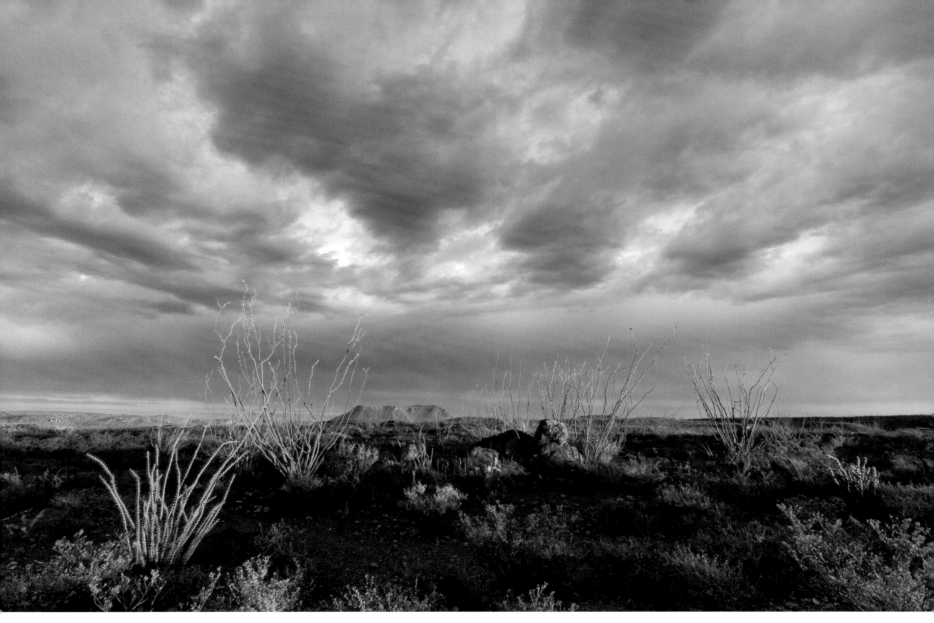

Ocotillo at sunrise, Big Bend Ranch State Park.

Ocotillo, Lajitas.

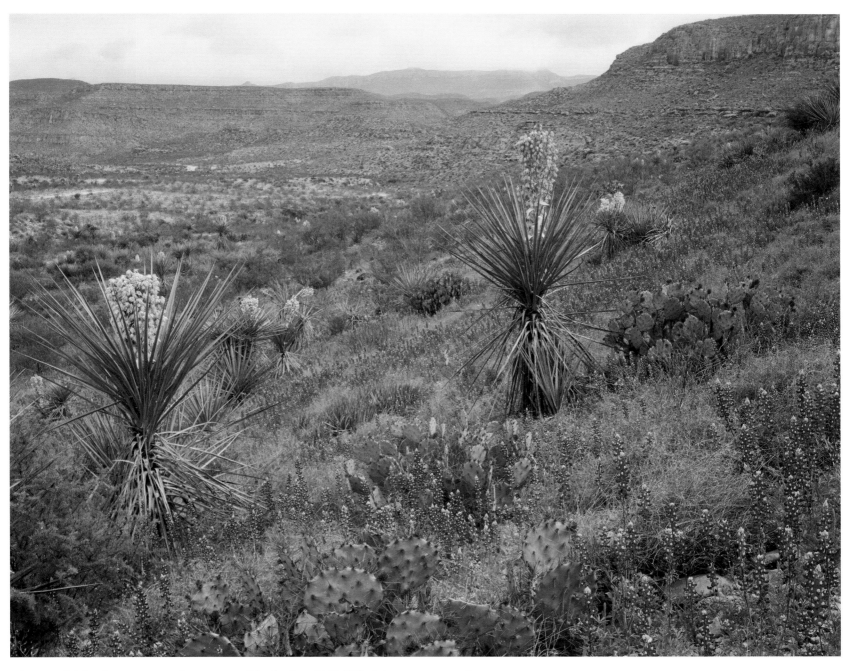

Big Bend bluebonnets and yucca at Black Gap Wildlife Management Area.

Close-up of feather dalea, Brewster County.

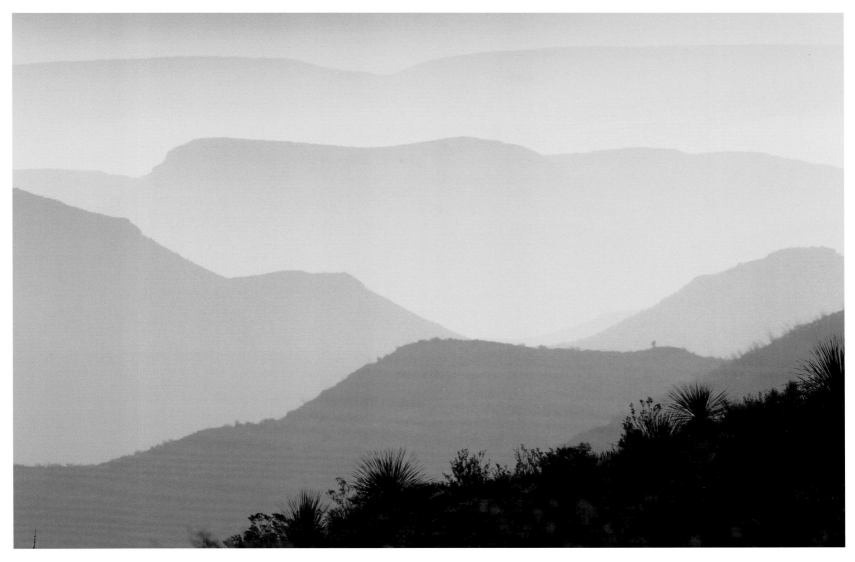

Distant mountains viewed from Black Gap Wildlife Management Area.

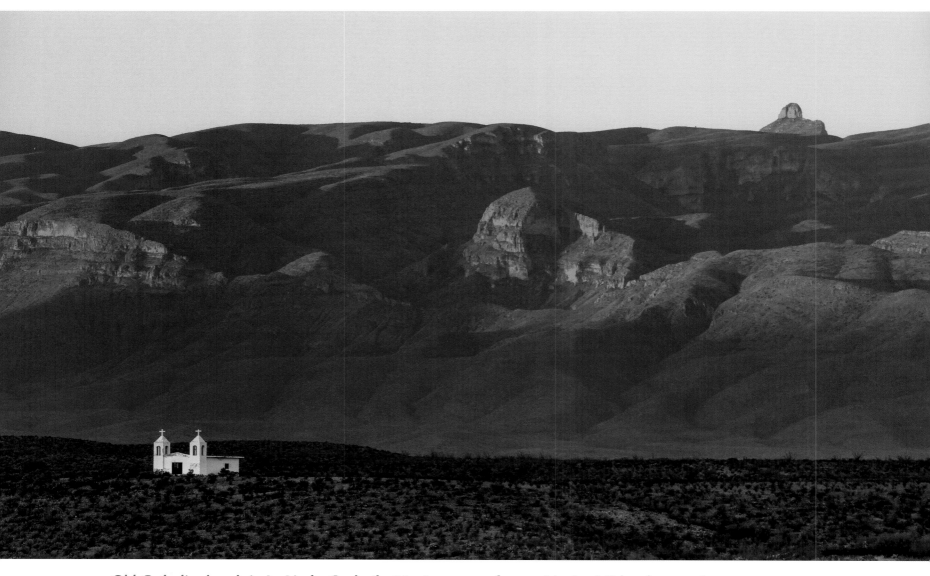

Old Catholic church in La Linda, Coahuila, Mexico, near a former Mexico–US border crossing.

Distant thunderstorm in
the Davis Mountains.

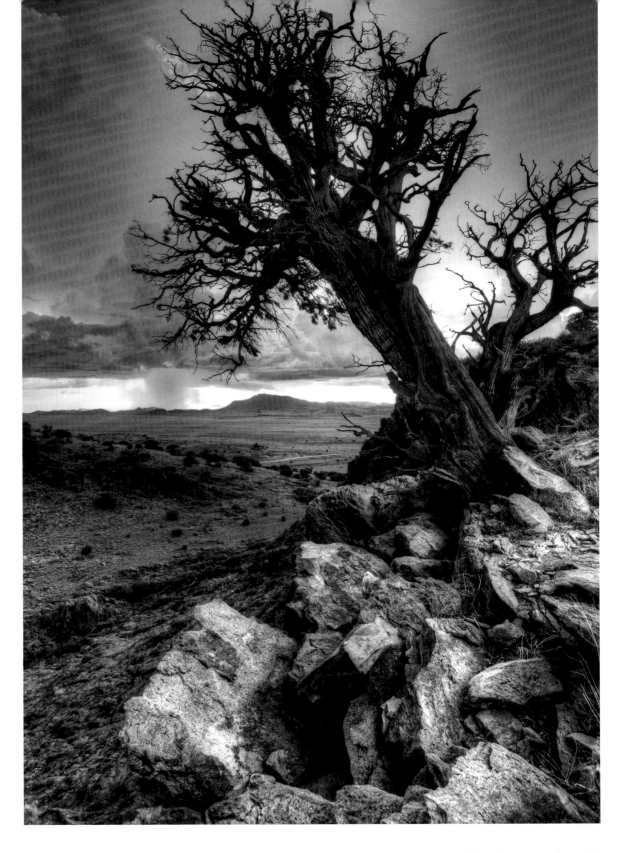

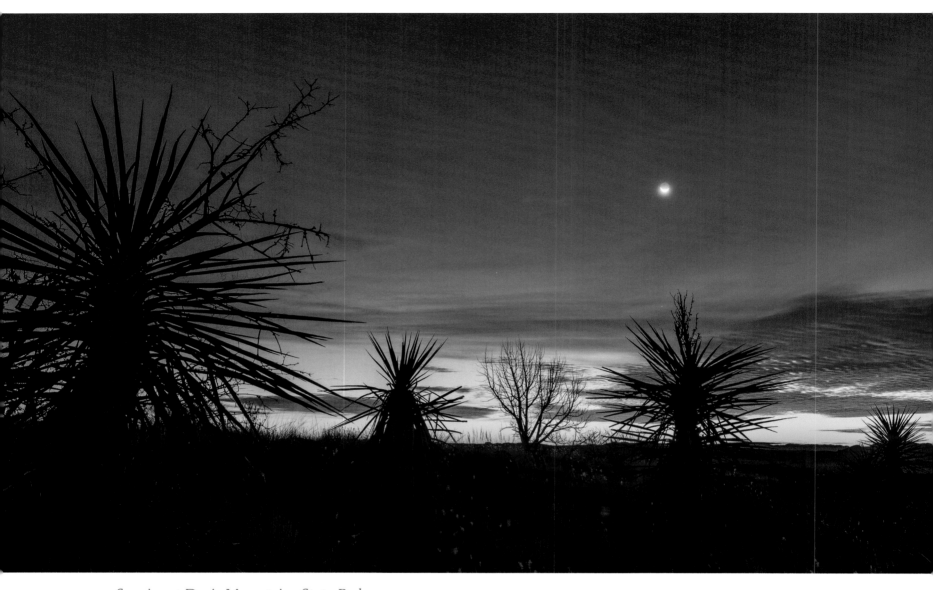

Sunrise at Davis Mountains State Park.

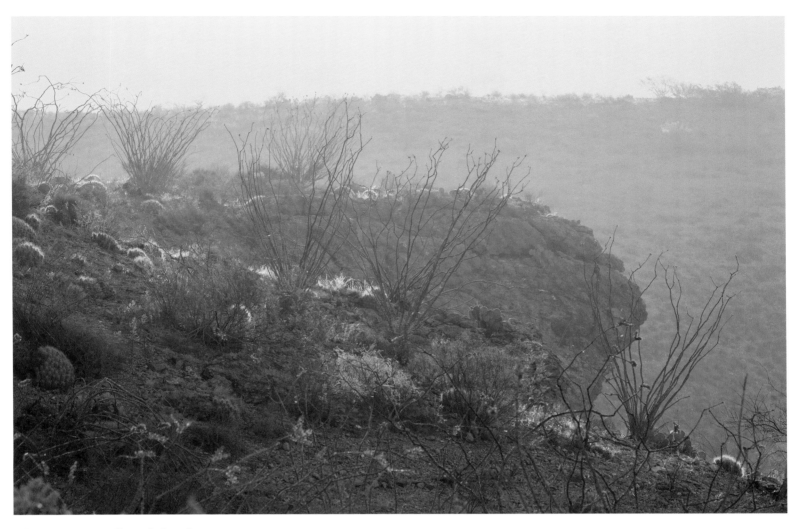

Blooming ocotillo, Chihuahuan Desert.

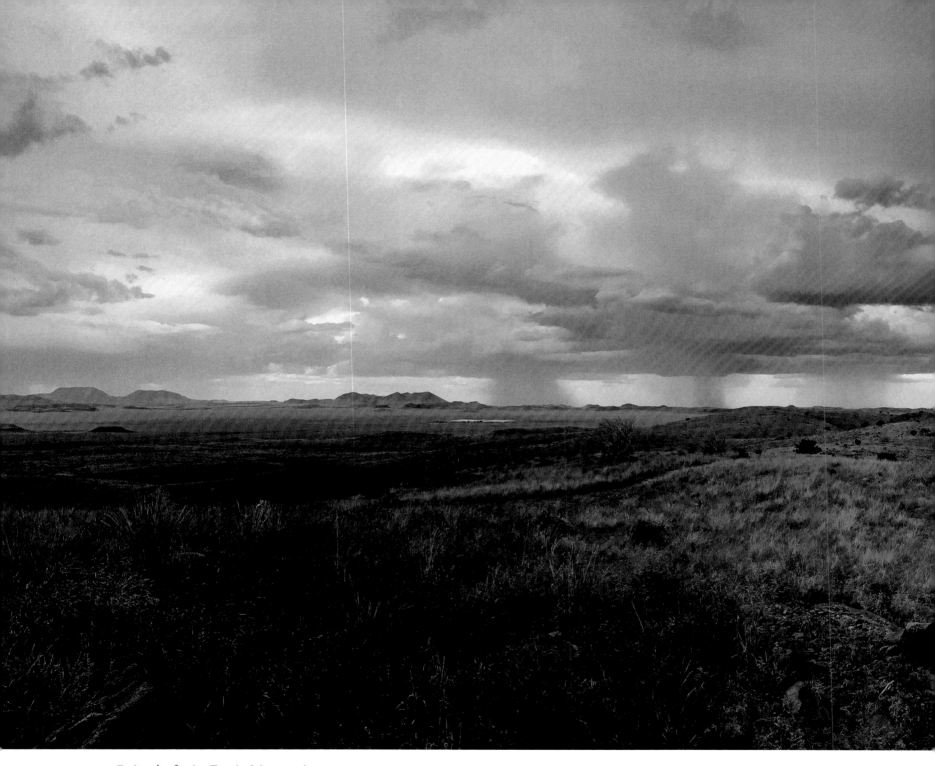

Rain shafts in Davis Mountains.

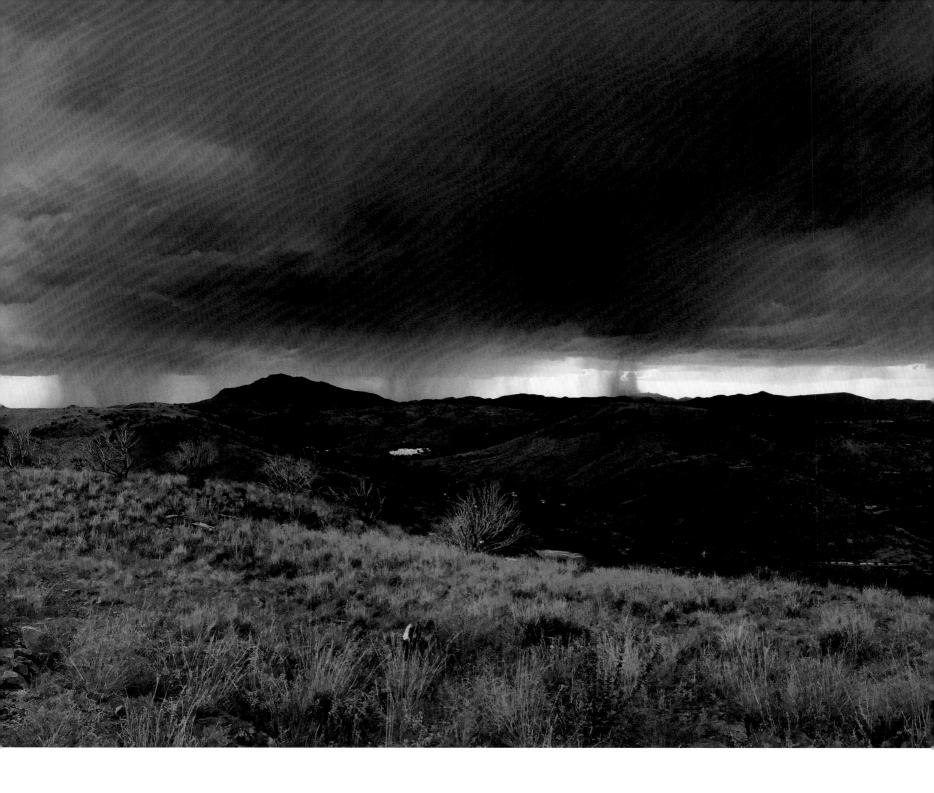

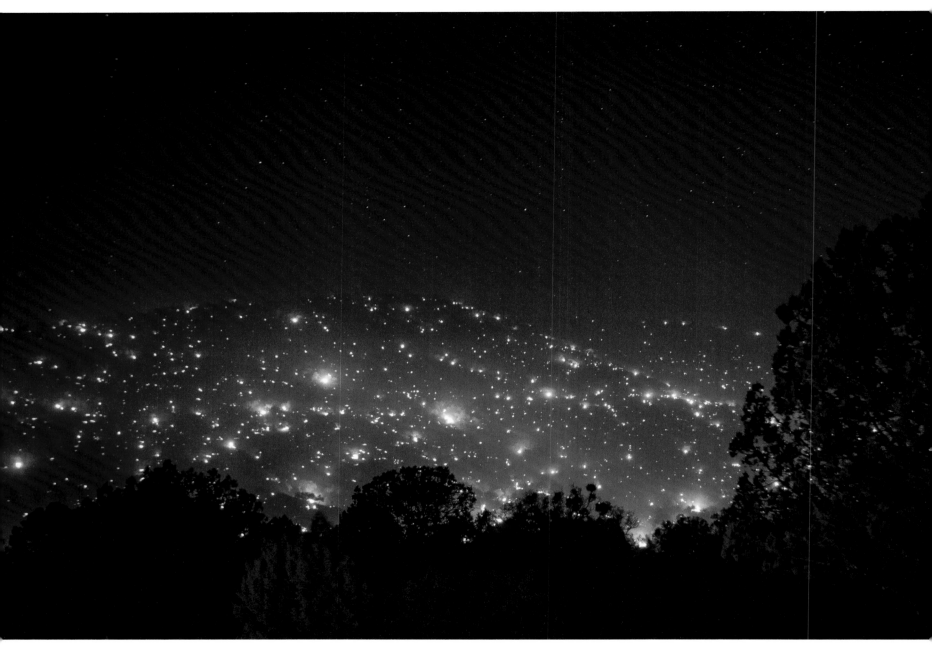

Embers against a starry sky in Davis Mountains during the "Rock House" fire.

Volcanic rock and cottonwood trees near Fort Davis.

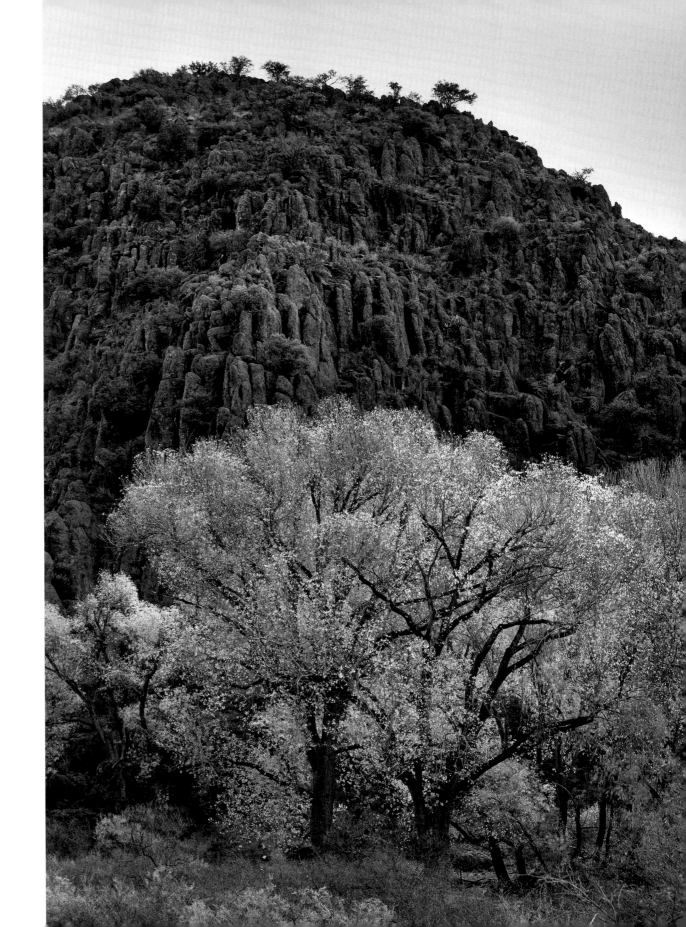

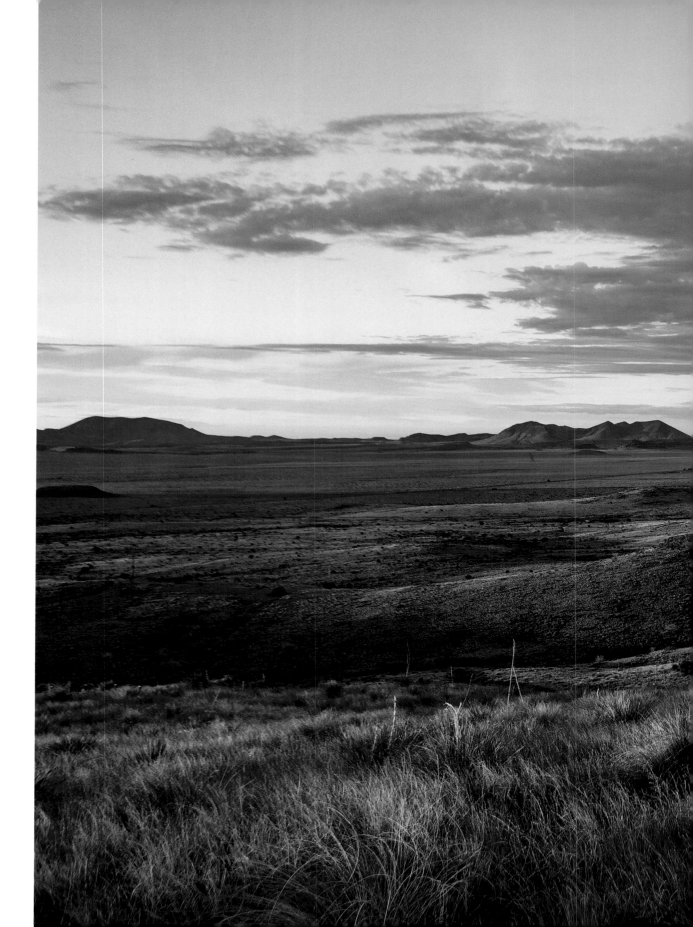

Morning light at Davis Mountains State Park.

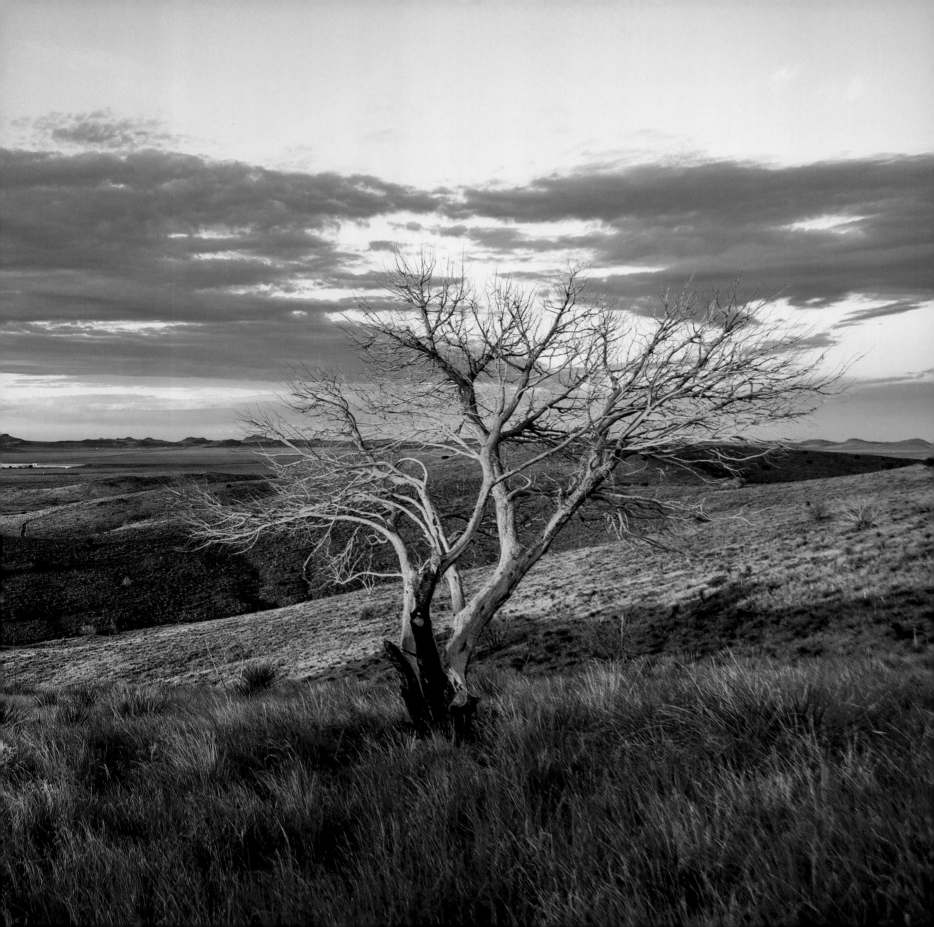

River Road follows the Rio Grande near Lajitas.

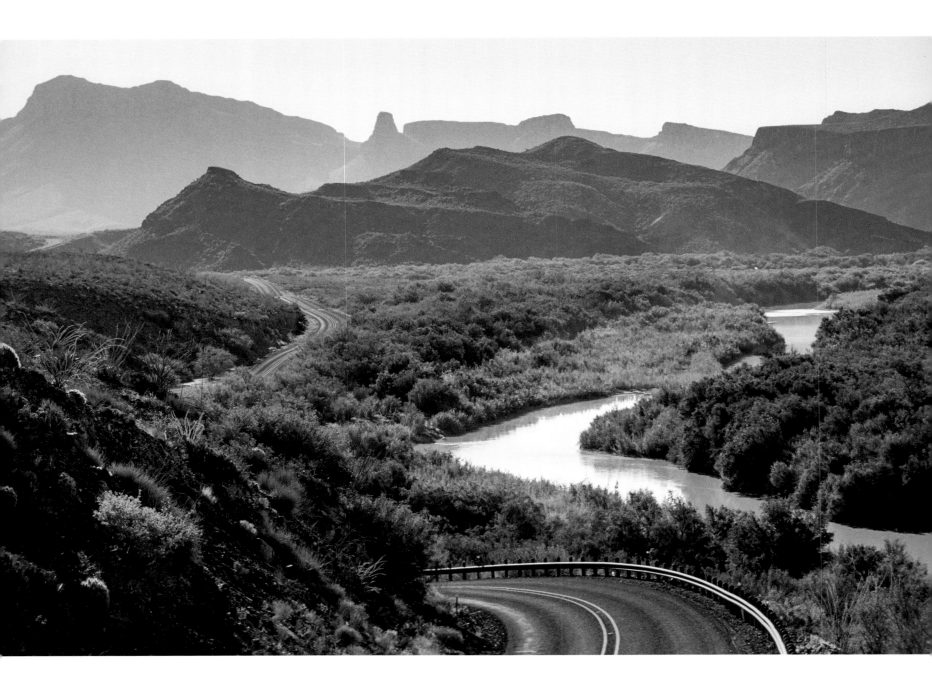

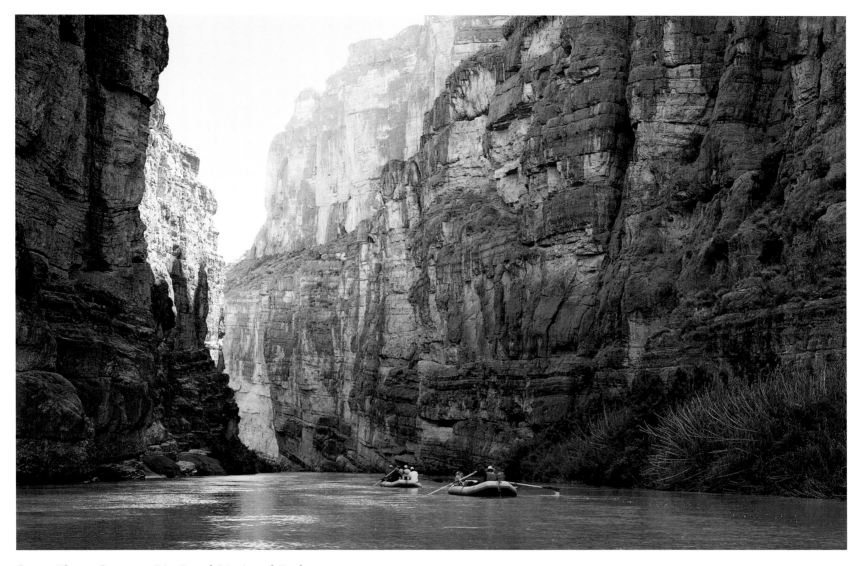

Santa Elena Canyon, Big Bend National Park.

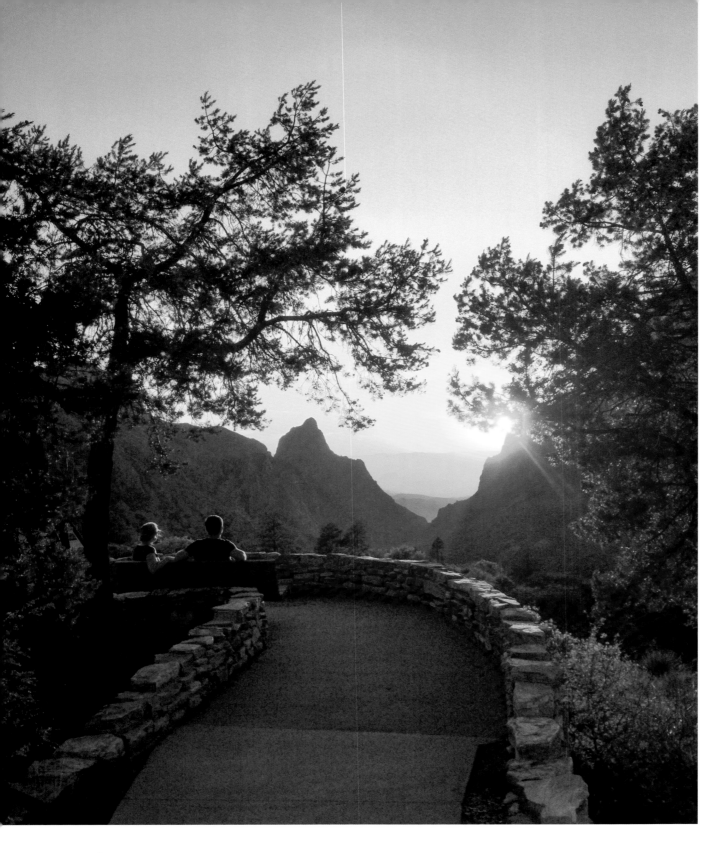

Sunset at the Window, Chisos Basin, Big Bend National Park.

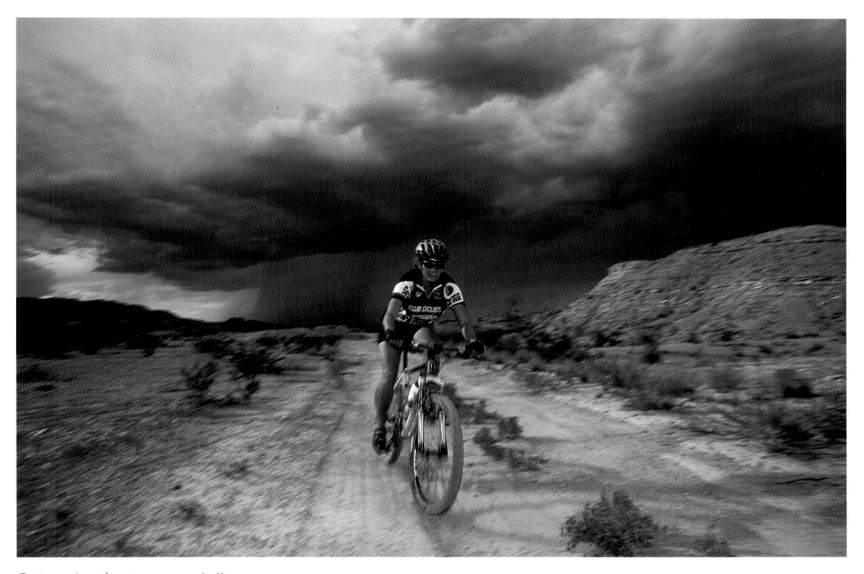

Outrunning the storm near Lajitas.

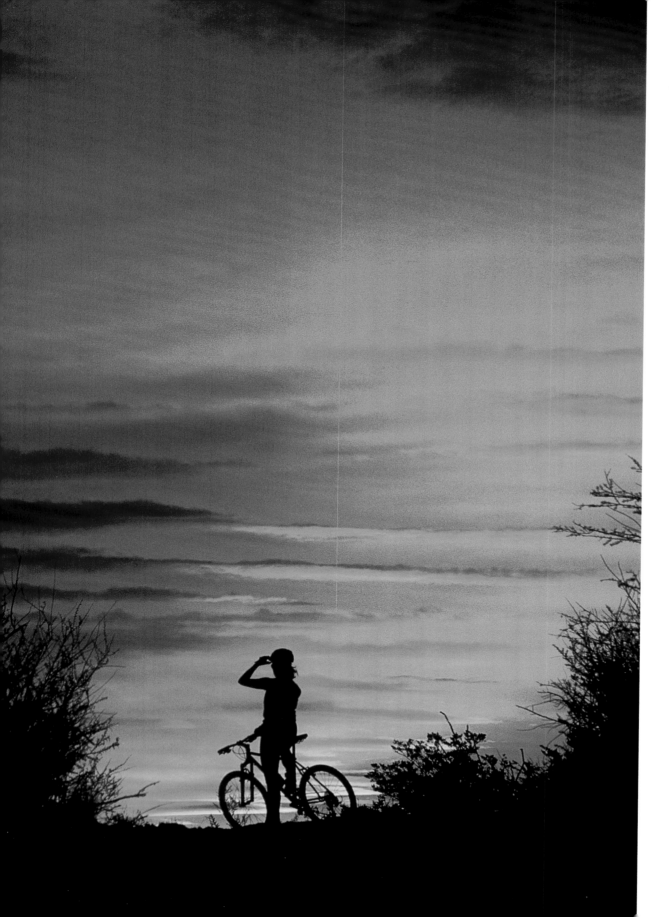

Desert cyclist, Big Bend
Ranch State Park.

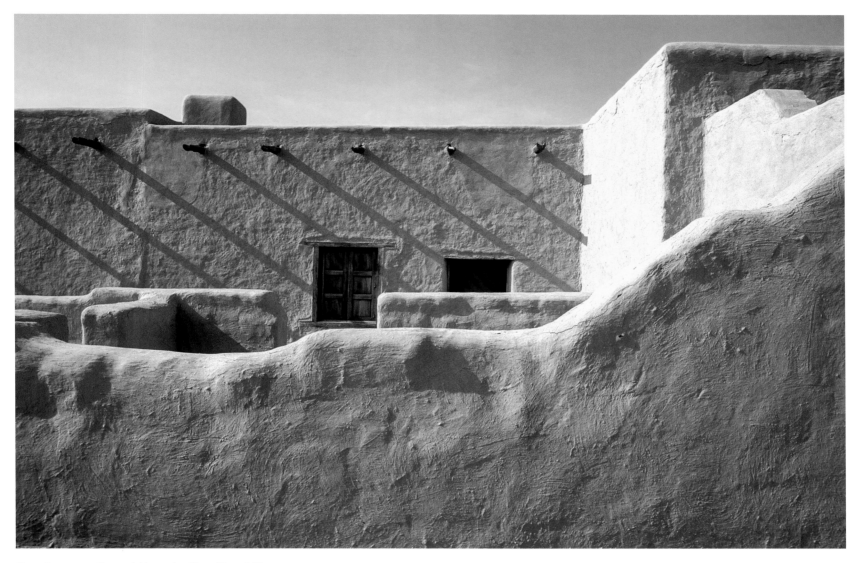

Fort Leaton State Historic Site, Presidio.

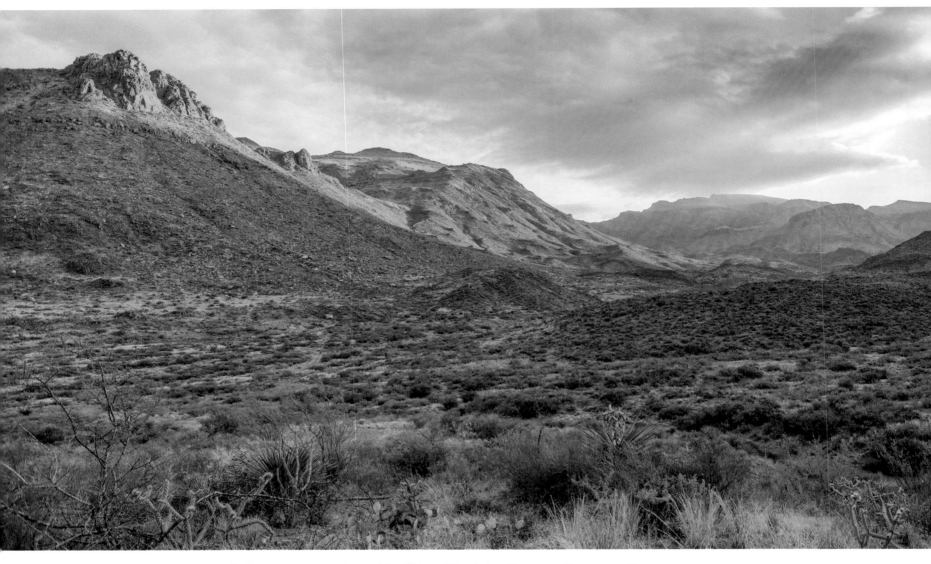

Panoramic view of Chinati Mountains with Chinati Peak in distance, Brewster County.

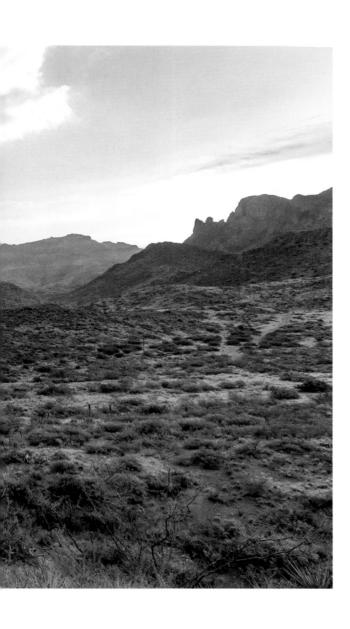

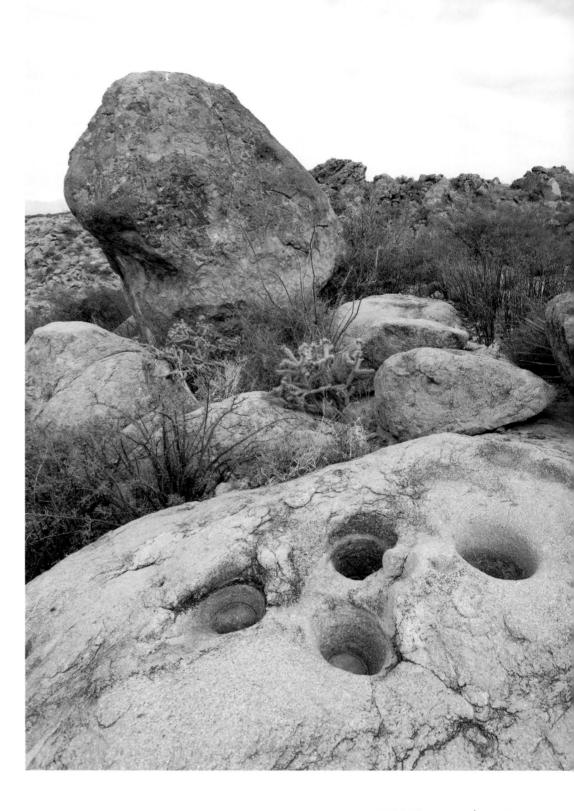

Rock mortars, Chinati Mountains State Natural Area, Brewster County.

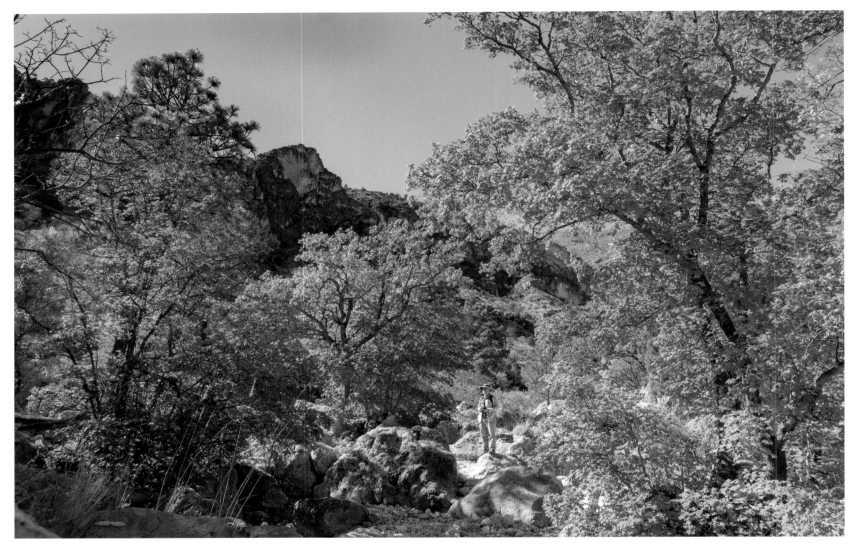

Fall color at McKittrick Canyon, Guadalupe Mountains National Park.

Guadalupe Mountains National Park.

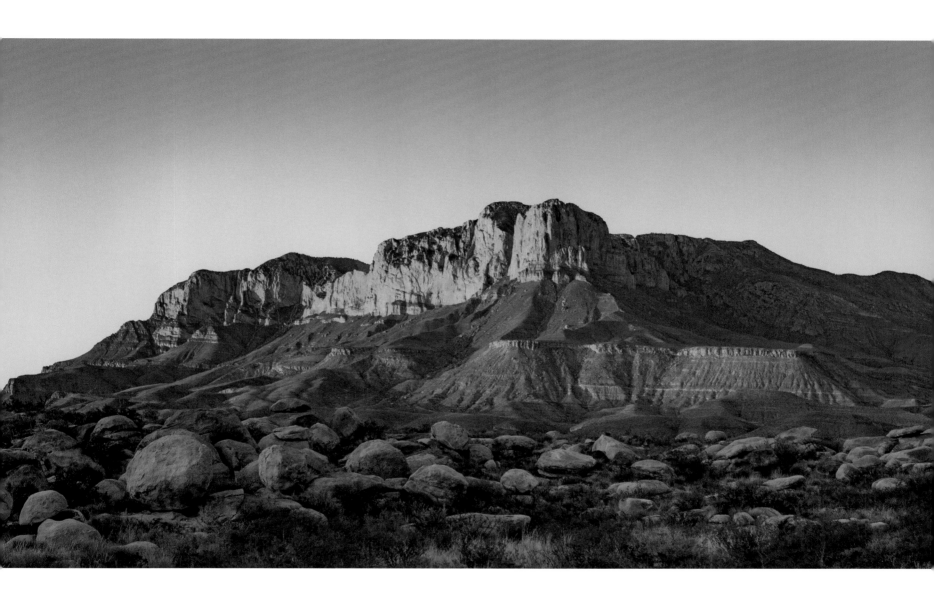

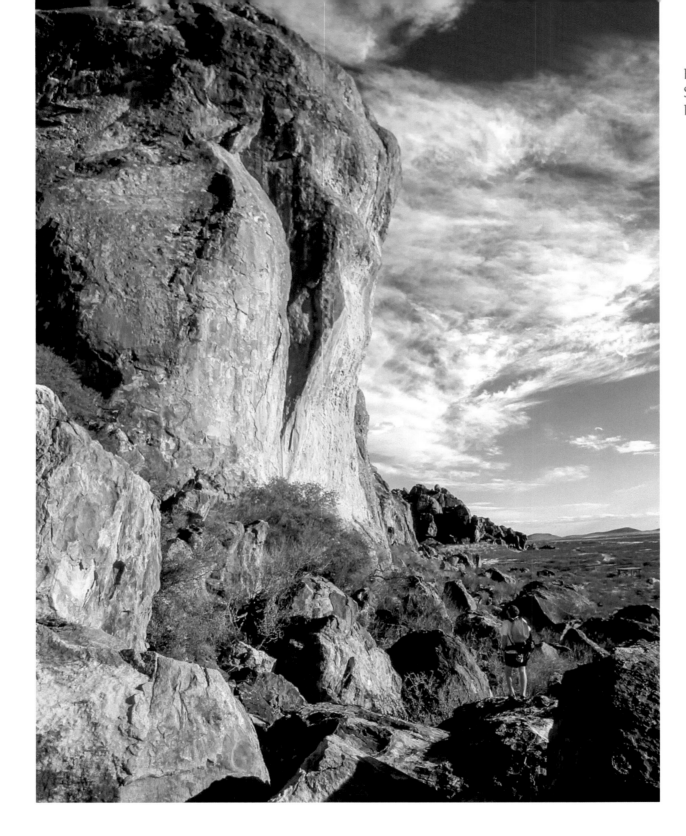

Hueco Tanks
State Park and
Historic Site.

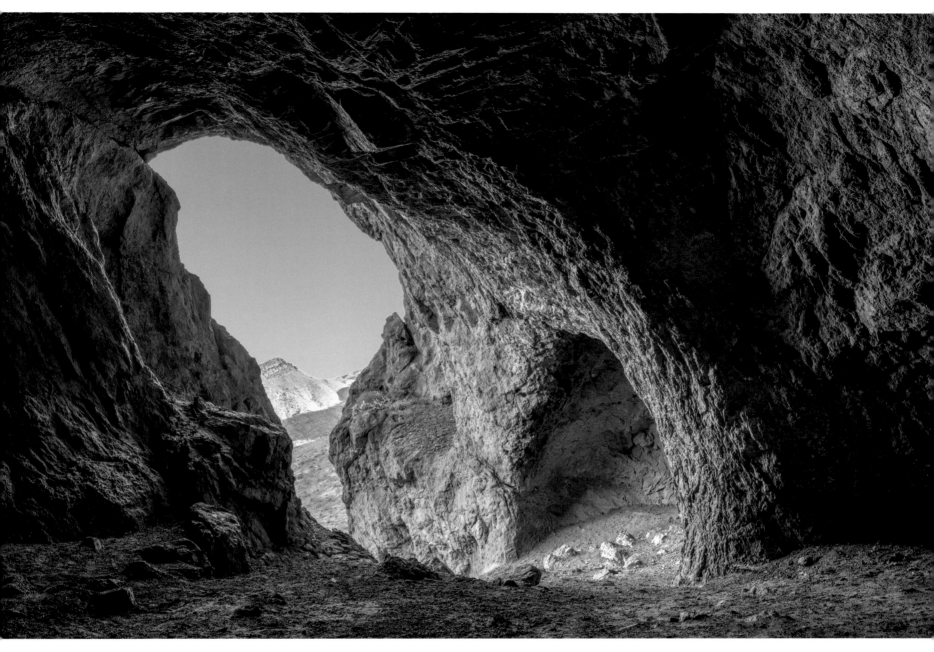

Aztec Caves, Franklin Mountains State Park.

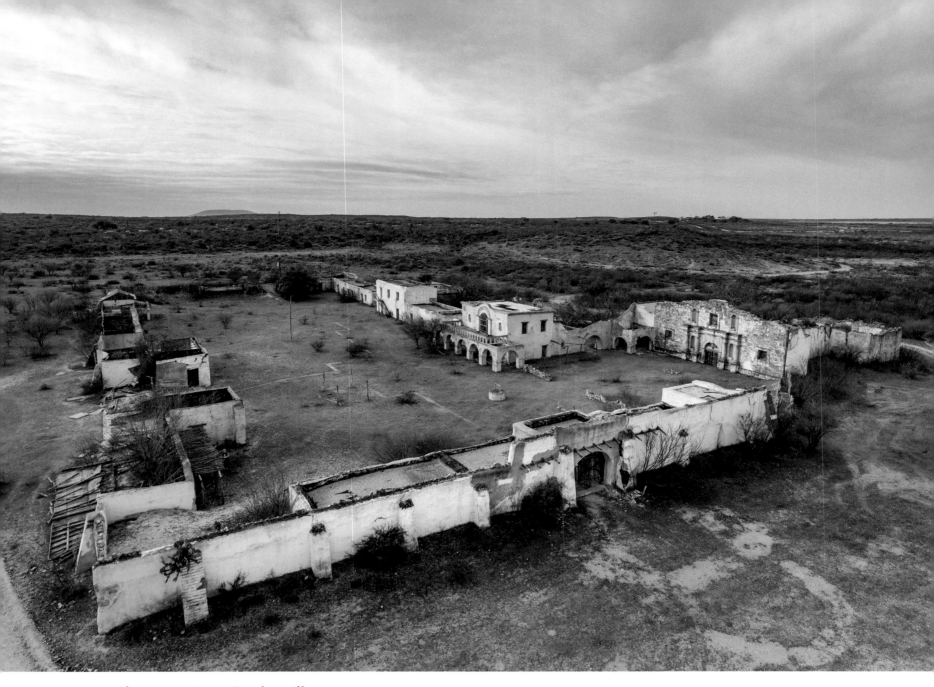

Alamo movie set, Brackettville.

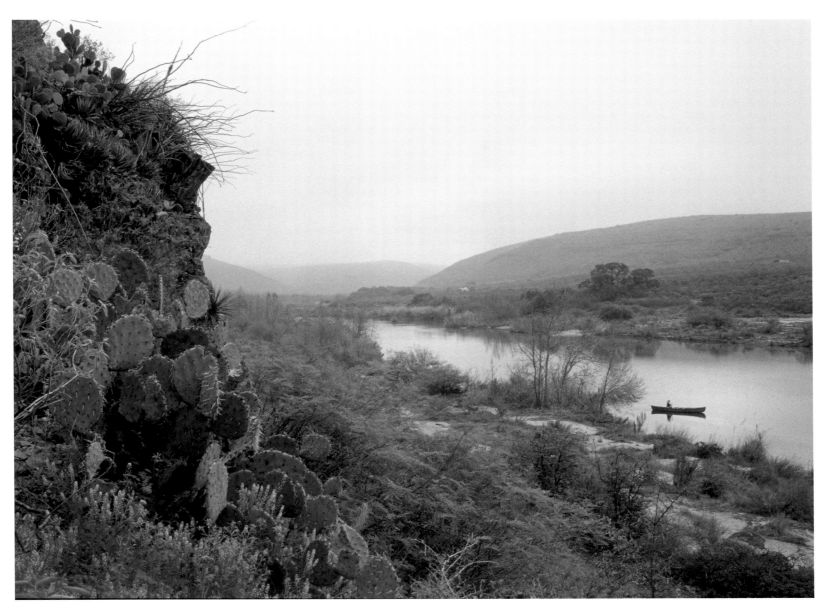

Foggy morning on Devils River.

Oyster boat and shells,
Port Lavaca.

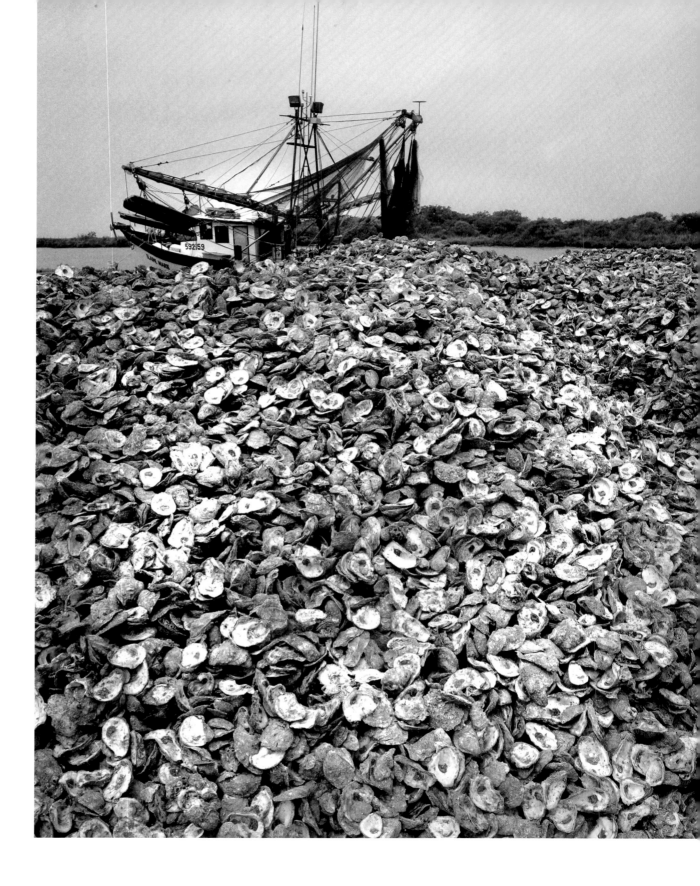

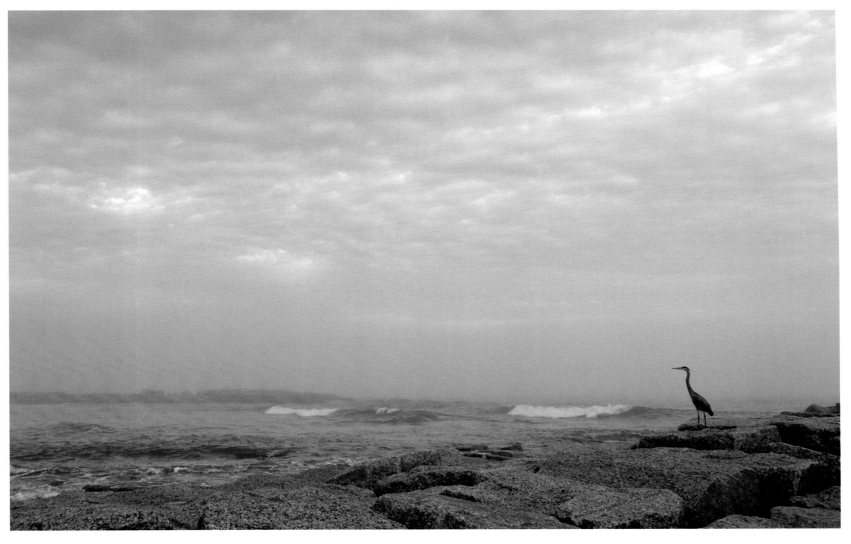

Great blue heron on jetty at Mustang Island State Park.

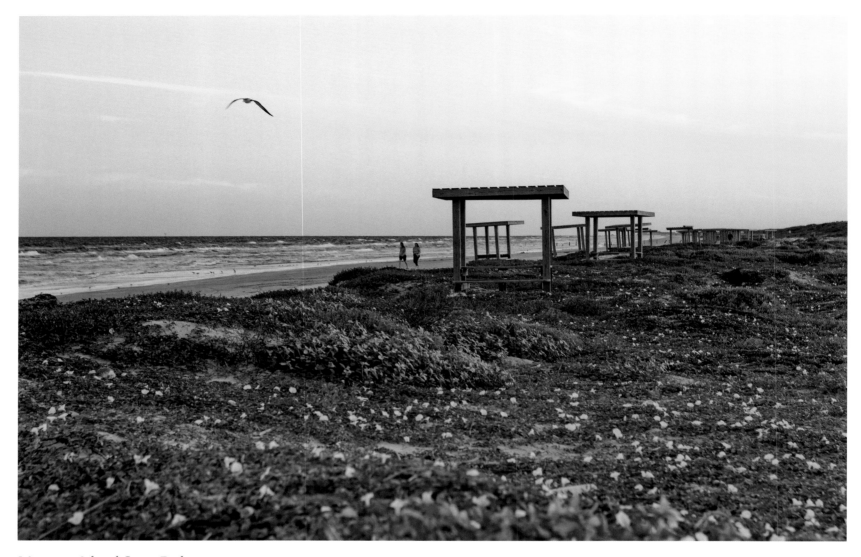

Mustang Island State Park.

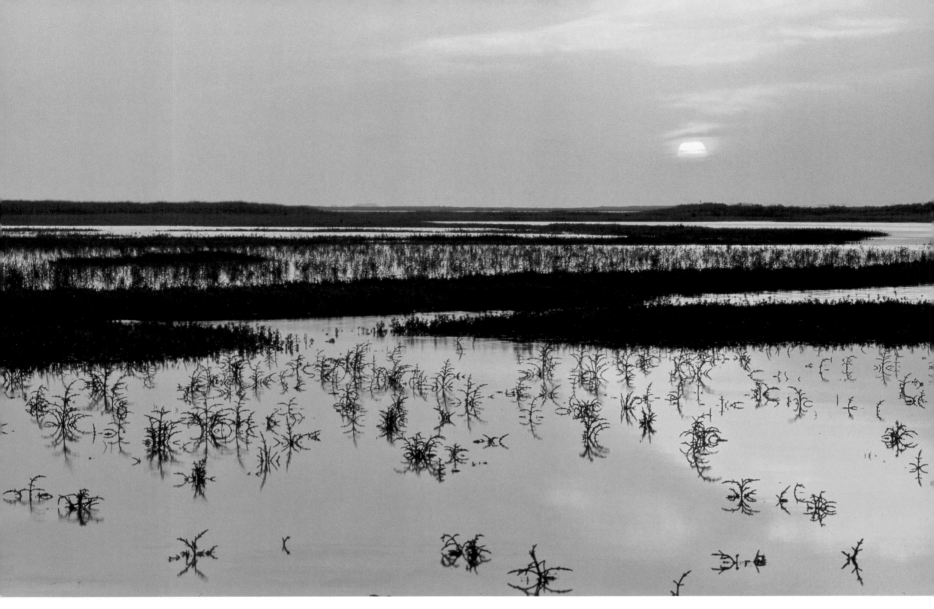

Nueces Bay flats near Corpus Christi.

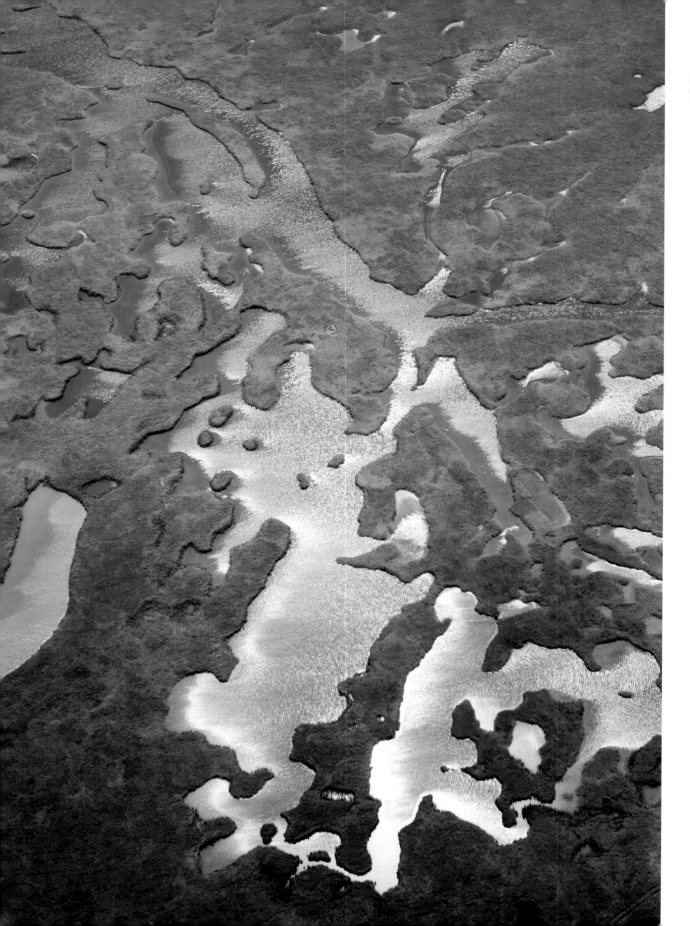

Marsh areas of Colorado River Delta near Matagorda.

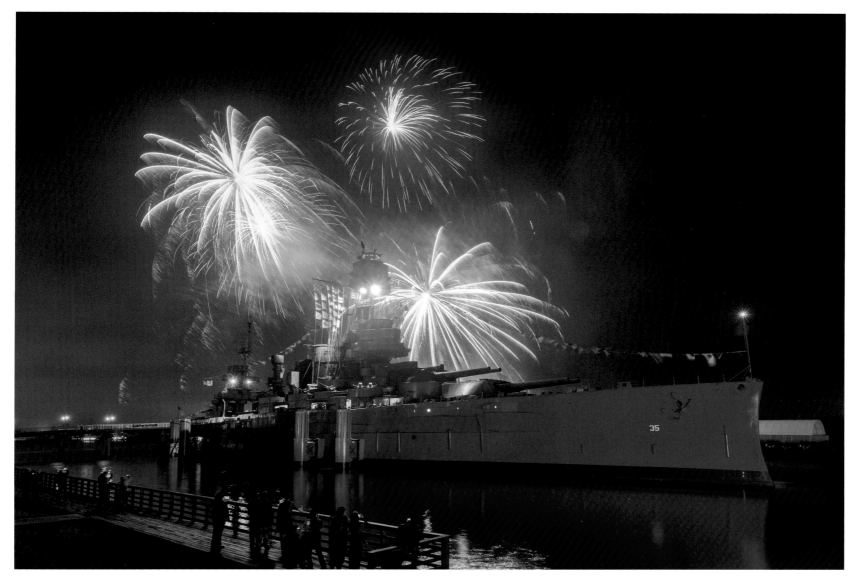

One hundredth anniversary celebration of the *Battleship Texas*, La Porte.

Shells on beach at South Padre
Island National Seashore.

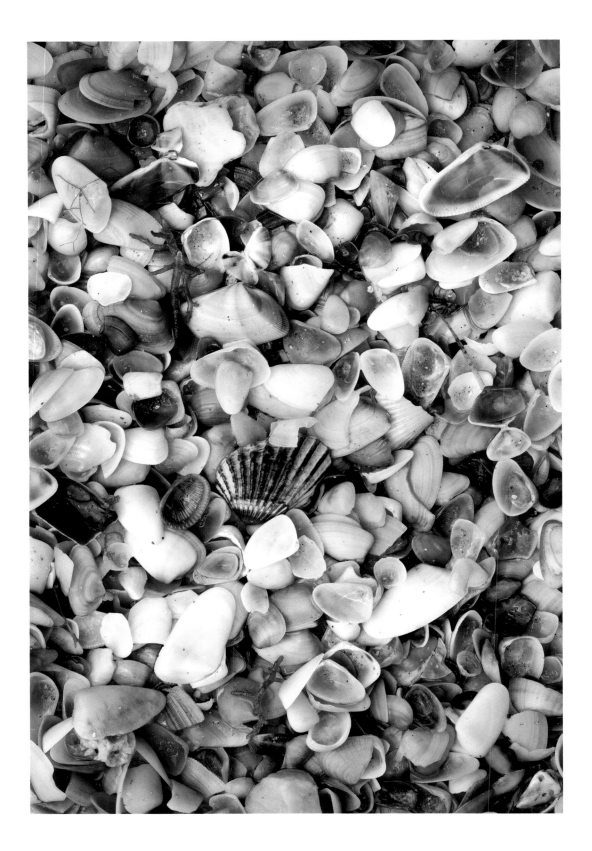

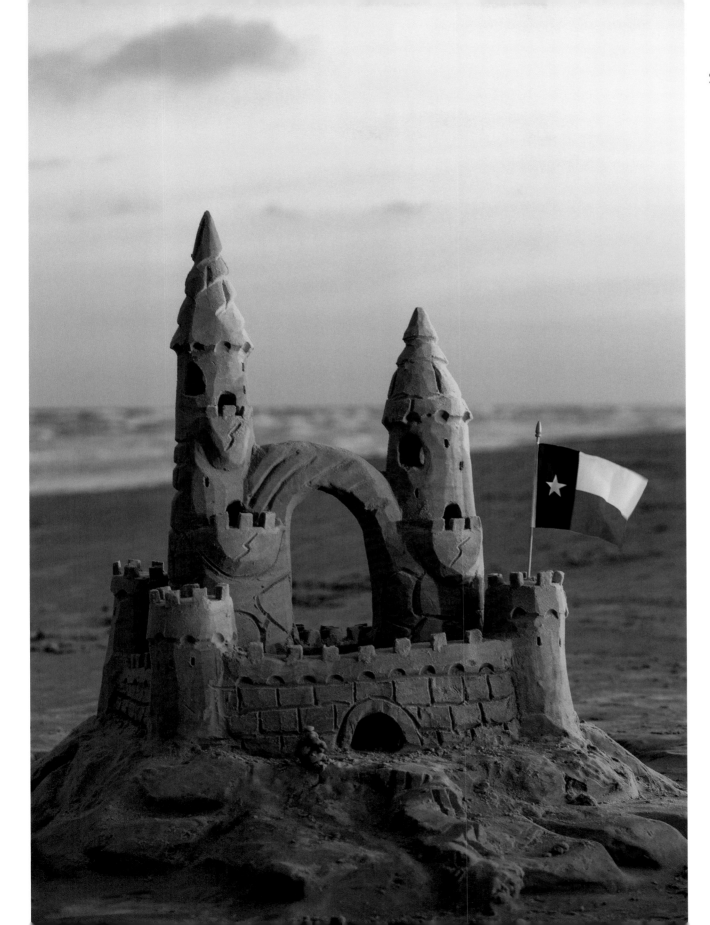

Sandcastle, Port Aransas.

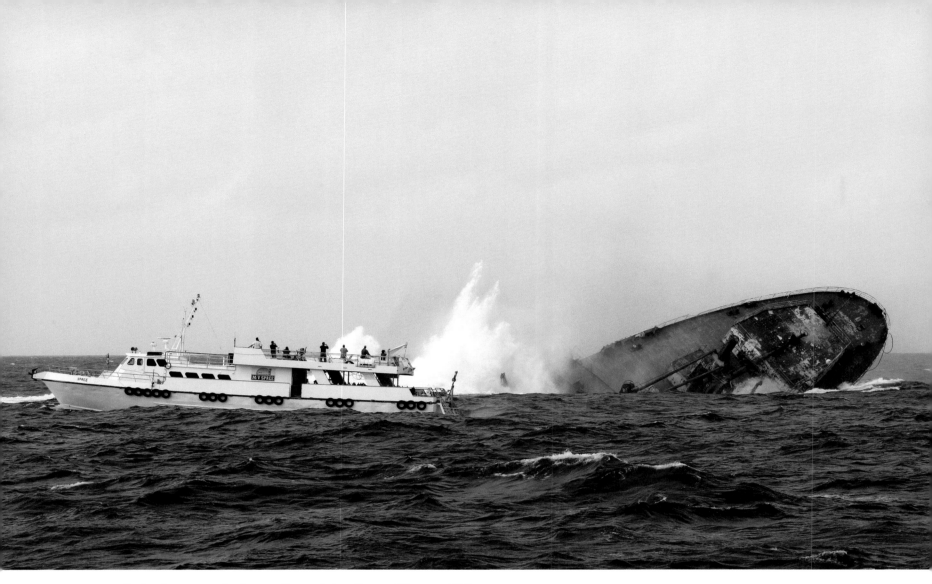

Onlookers watch the reefing of the *Texas Clipper* off Texas coast.

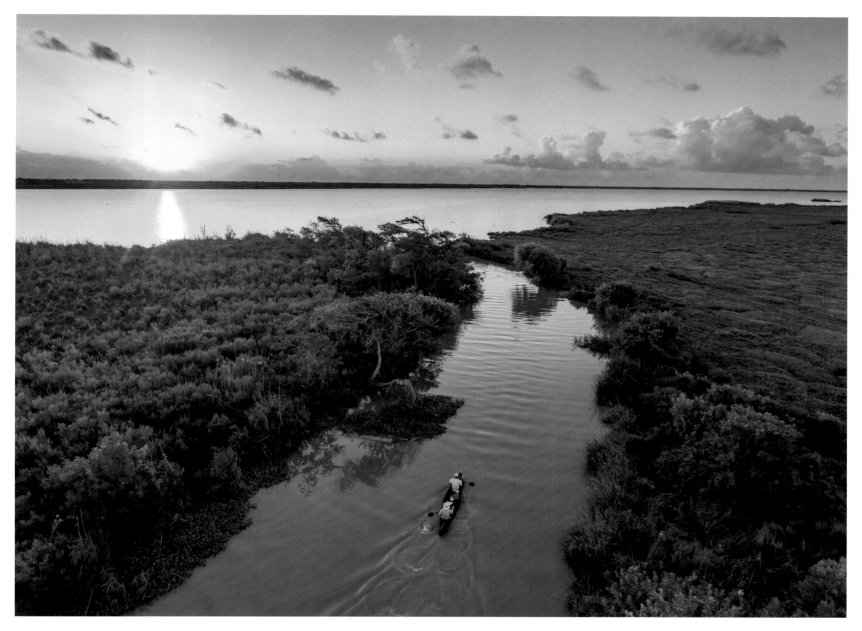

Last leg of the Texas Water Safari leaving the Guadalupe River into San Antonio Bay.

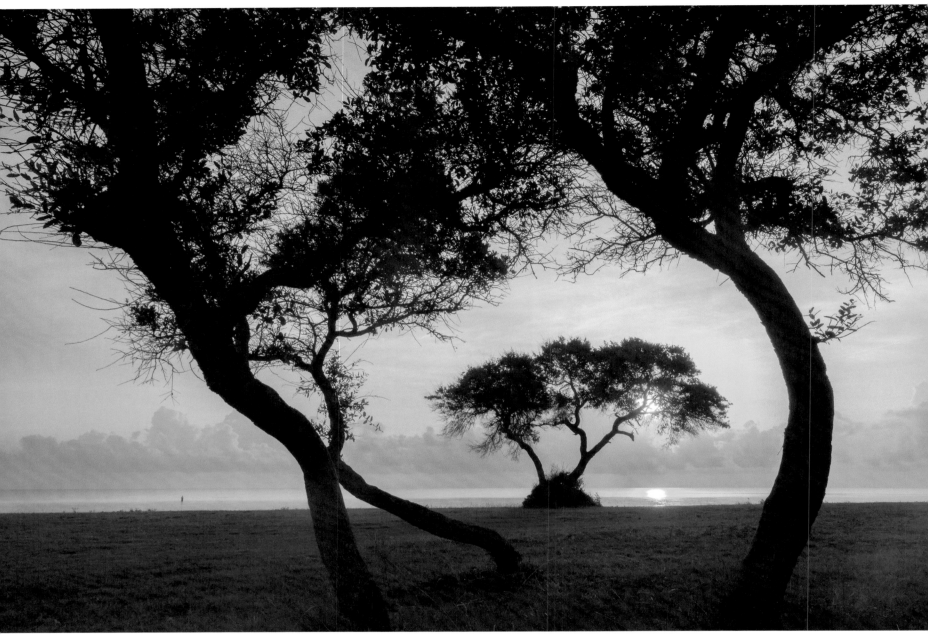

A lone fisherman wades Matagorda Bay at sunrise from Powderhorn Ranch Wildlife Management Area.

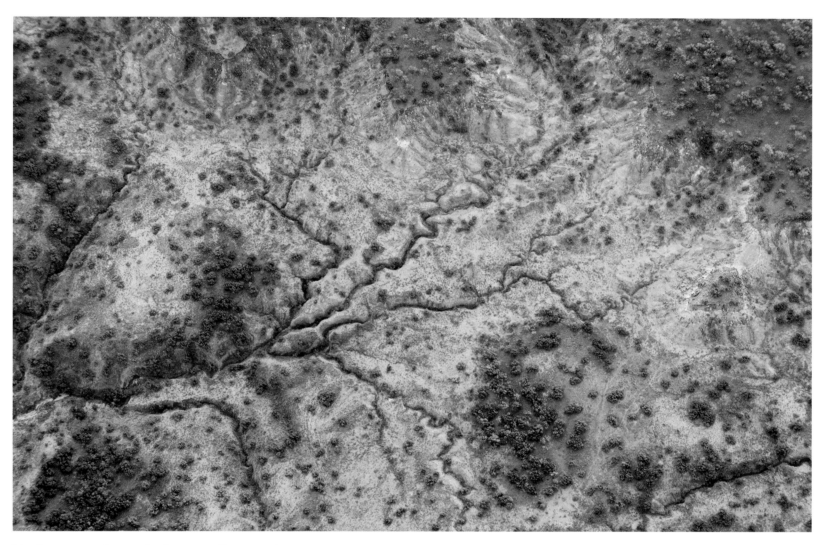

Drainages at Caprock Canyons State Park.

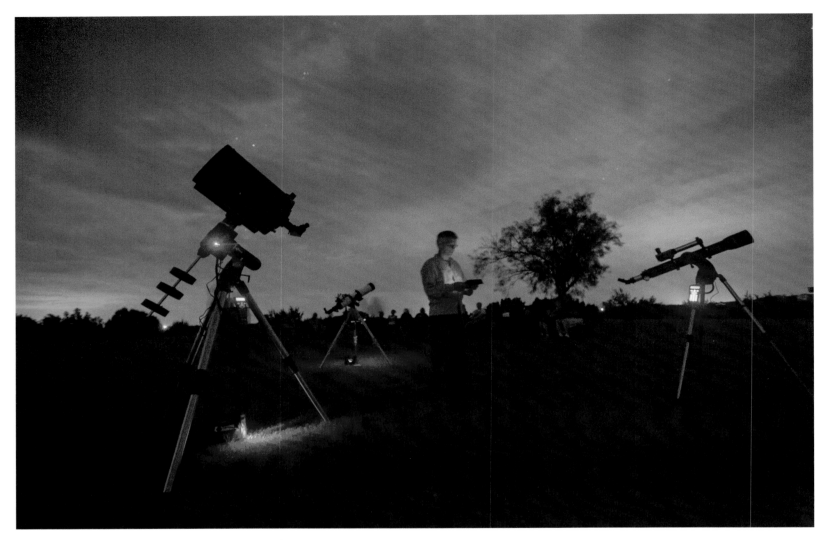

Astronomers at Copper Breaks State Park.

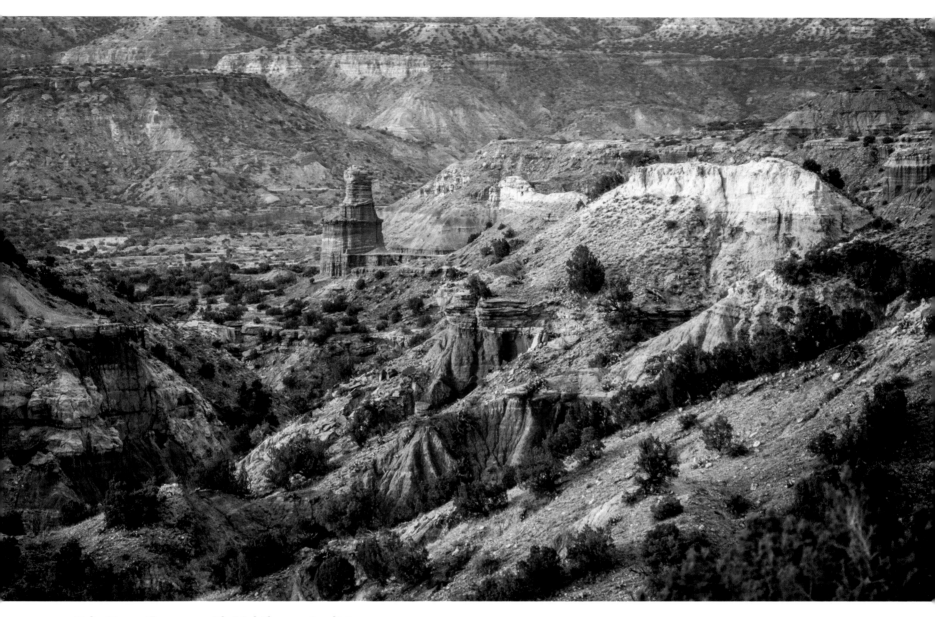

Palo Duro Canyon with Lighthouse in distance.

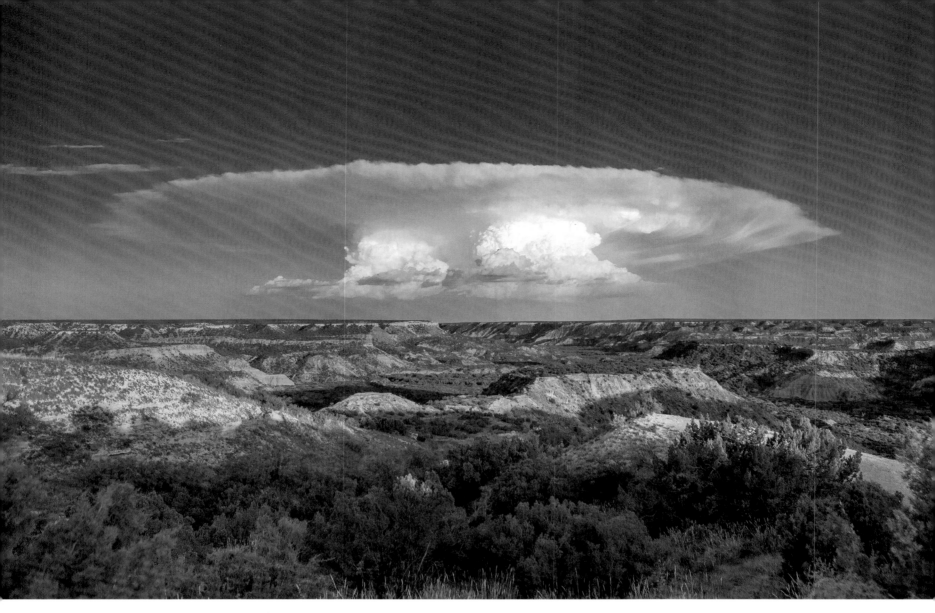

Distant thunderheads from Palo Duro Canyon State Park.

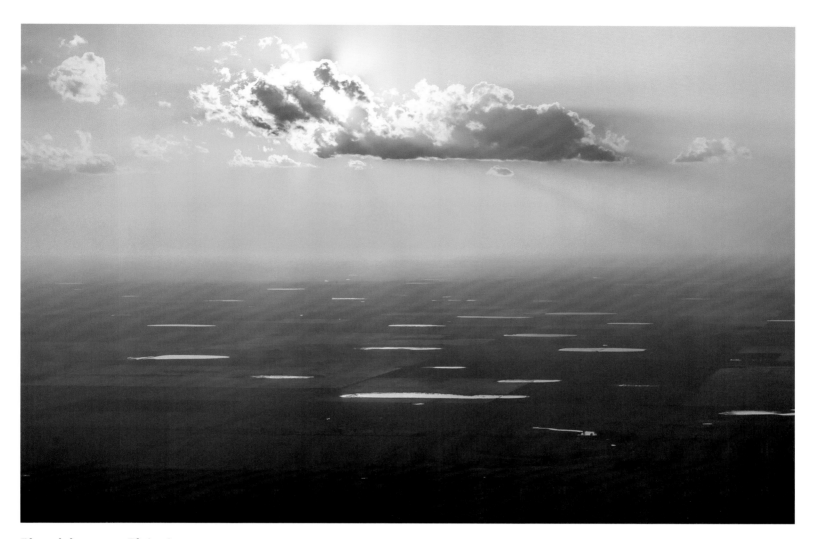

Playa lakes near Plainview.

Cattle funneling through a pasture gate to get to water, Henrietta.

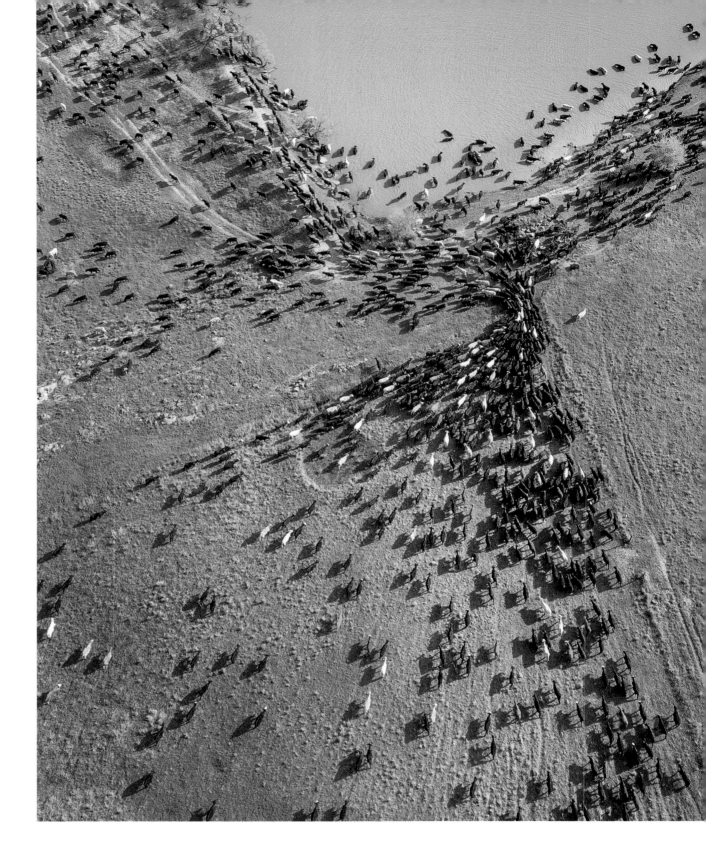

Dogwood in bloom
near Caldwell.

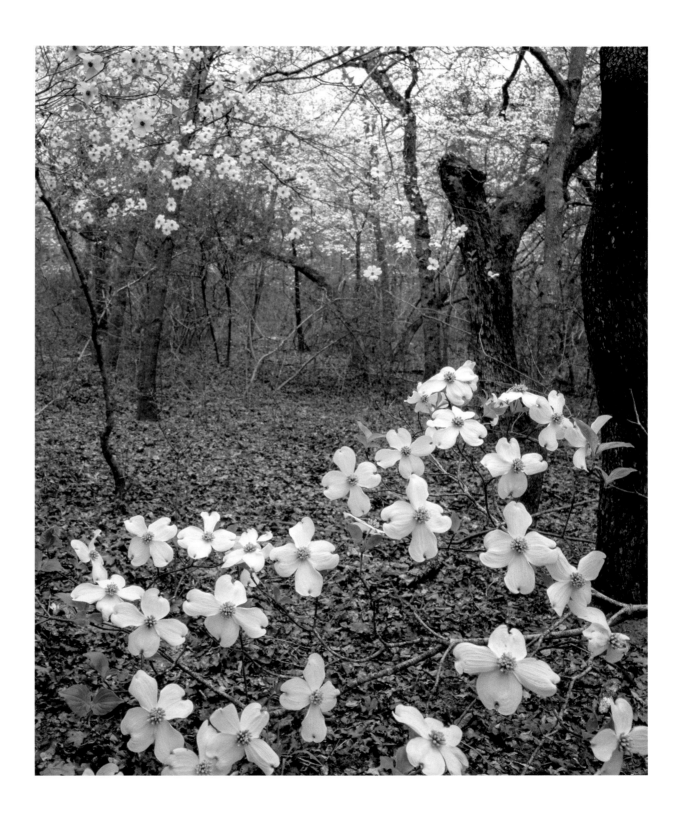

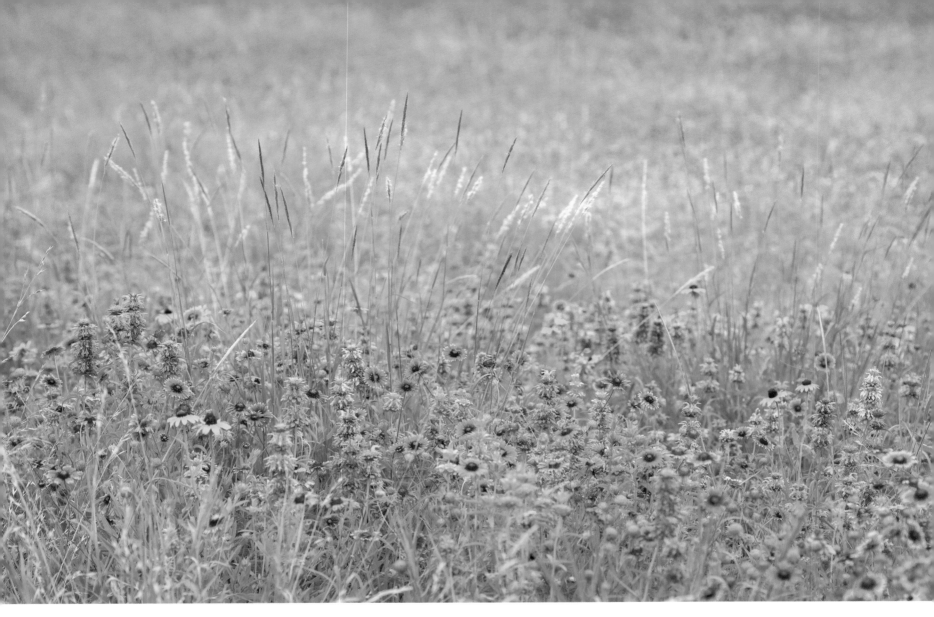

Mixed wildflowers, Bell County.

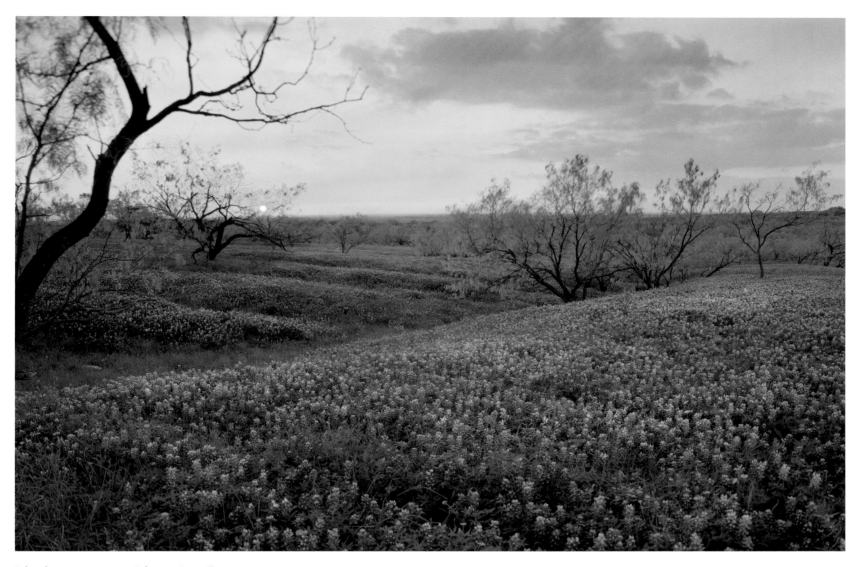

Bluebonnets near Blooming Grove.

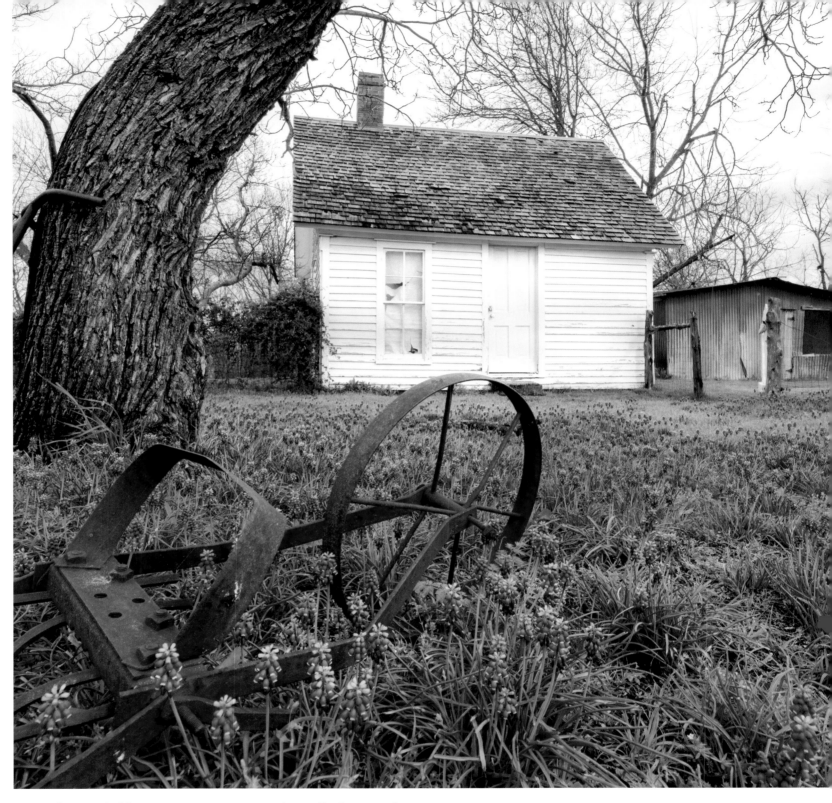

Grape hyacinth bloom at Penn Farm, Cedar Hills State Park.

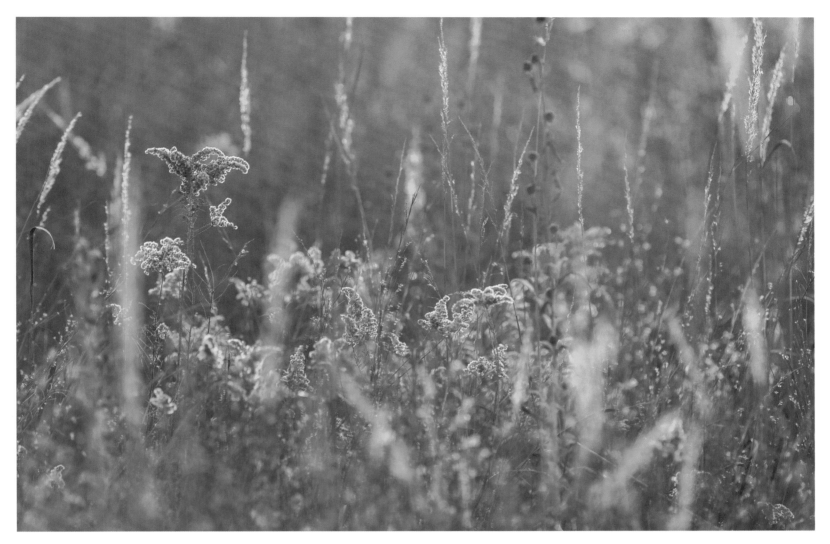

Blackland Prairie, Bell County.

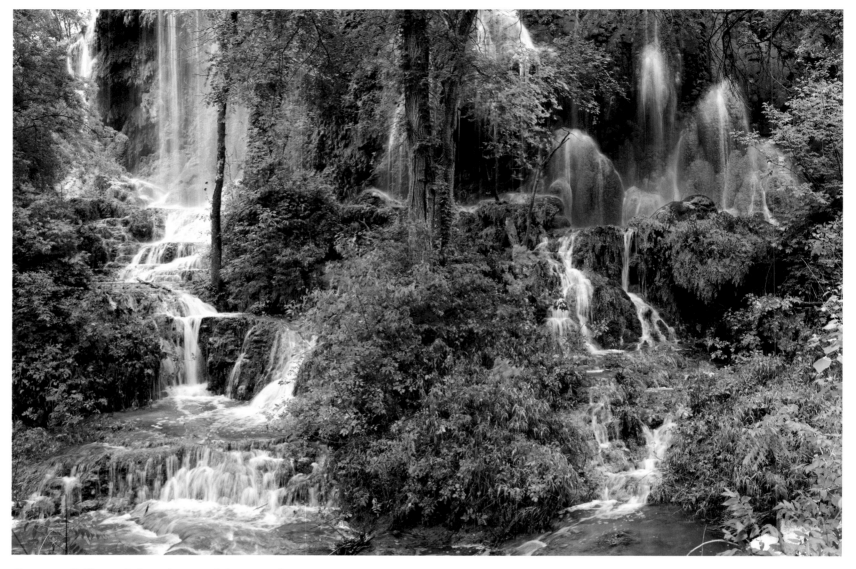

Gorman Falls at Colorado Bend State Park.

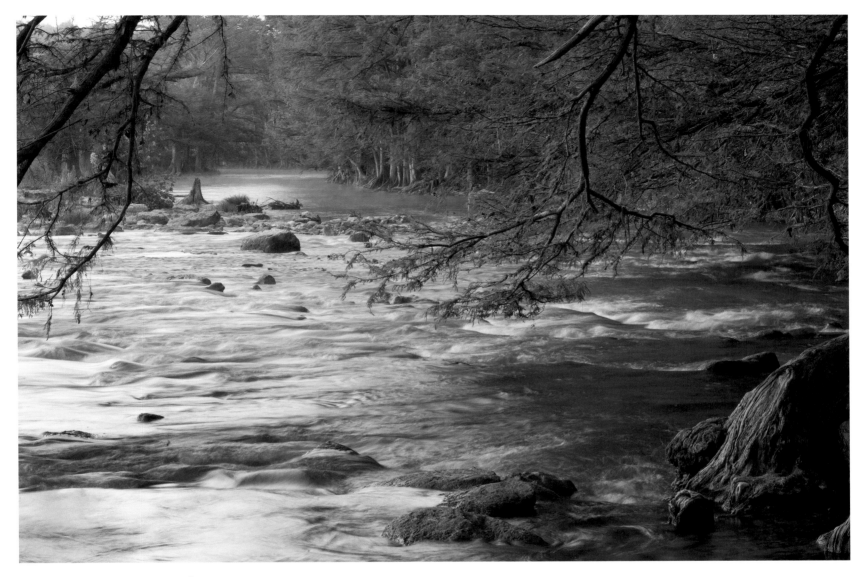

Guadalupe River State Park.

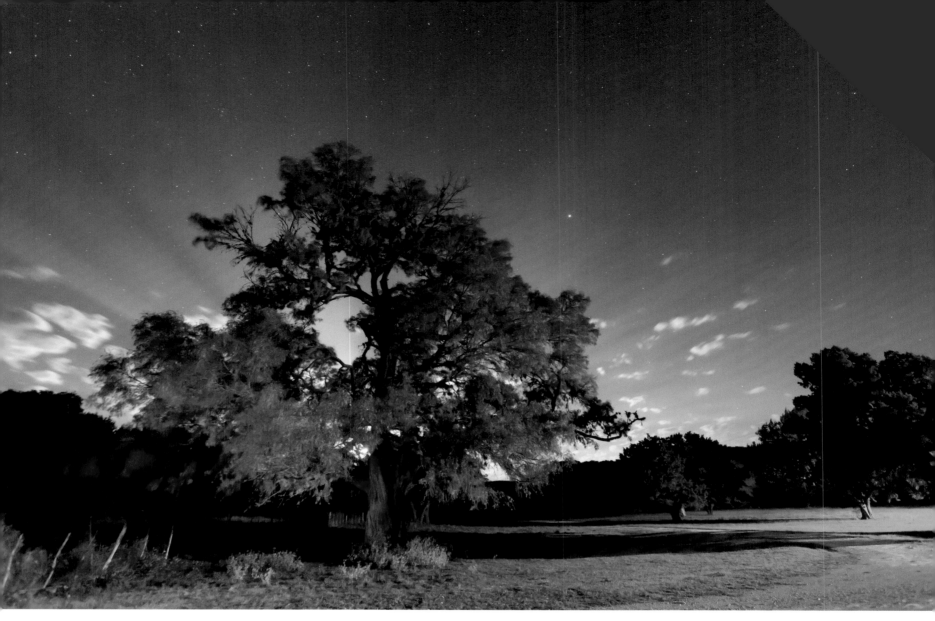

Champion mesquite tree at night near Leakey.

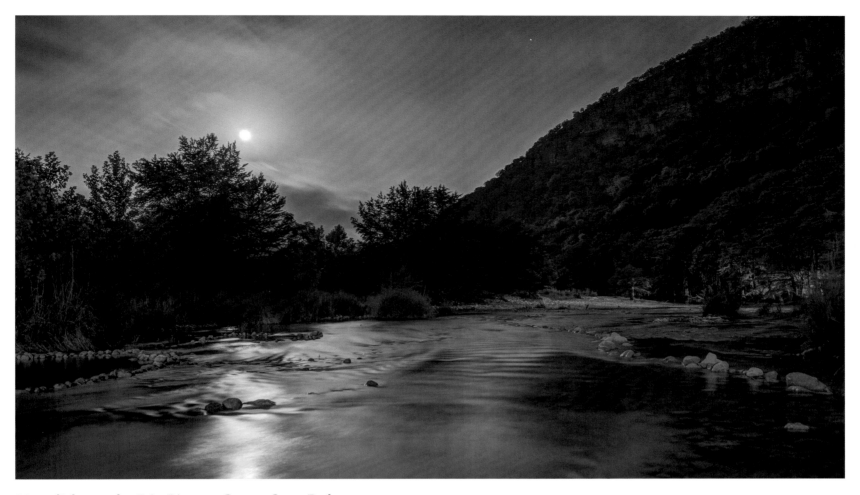

Moonlight on the Frio River at Garner State Park.

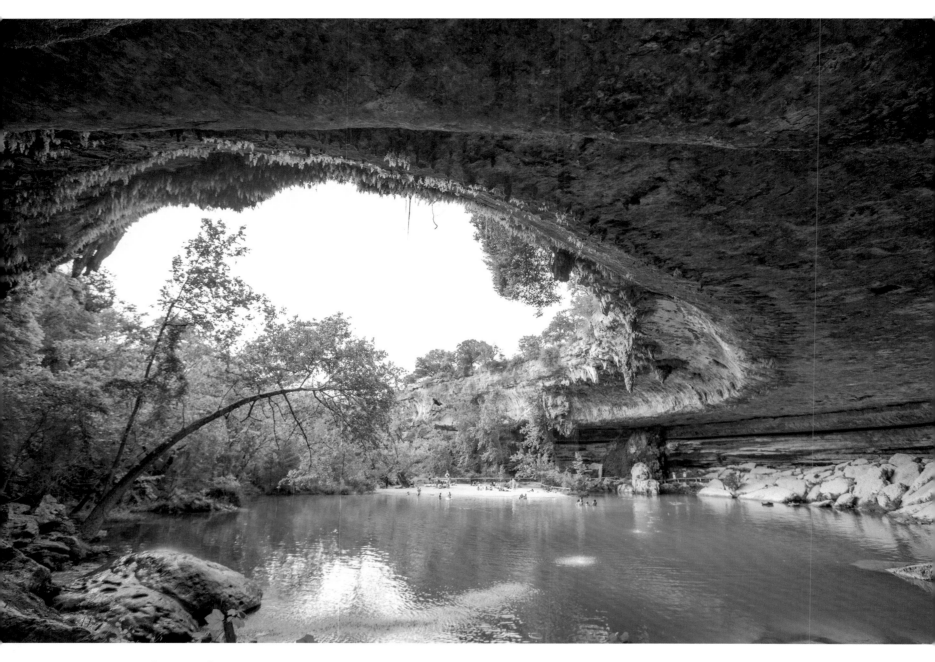

Hamilton Pool, Travis County.

Hill Country wildflowers
near Junction.

Krause Springs swimming hole near Spicewood.

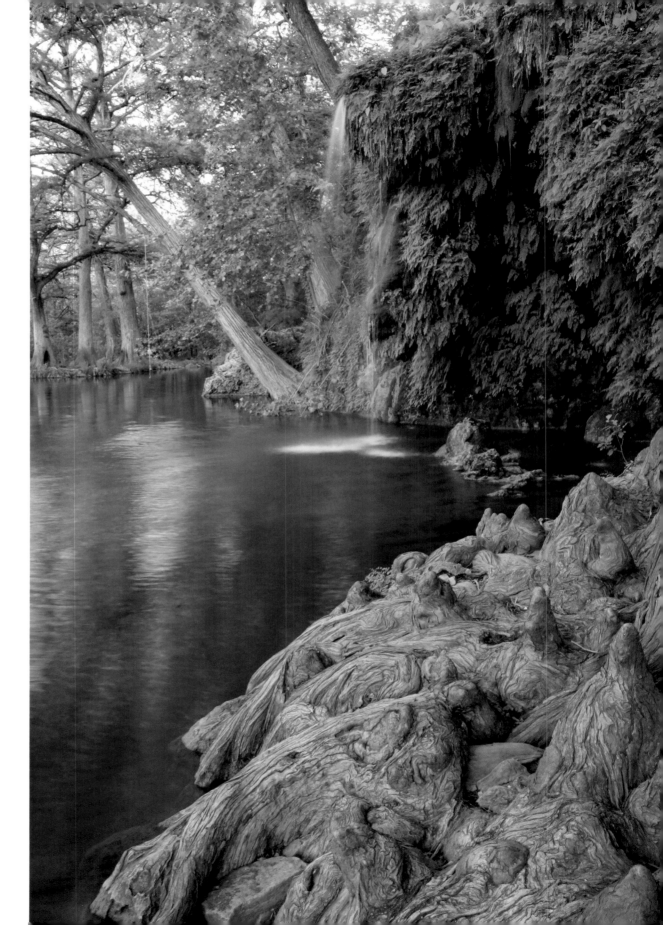

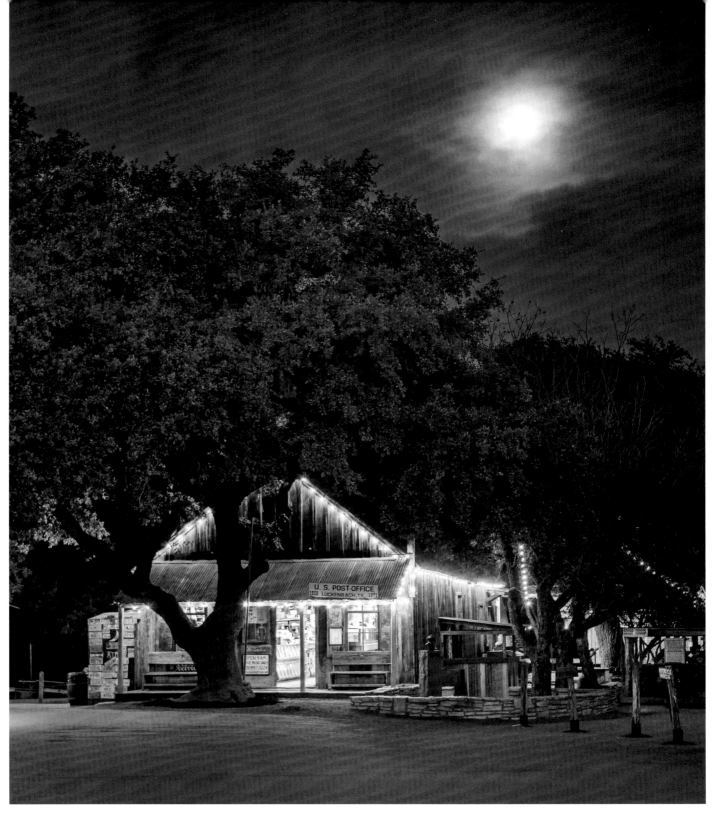

Full moon over Luckenbach.

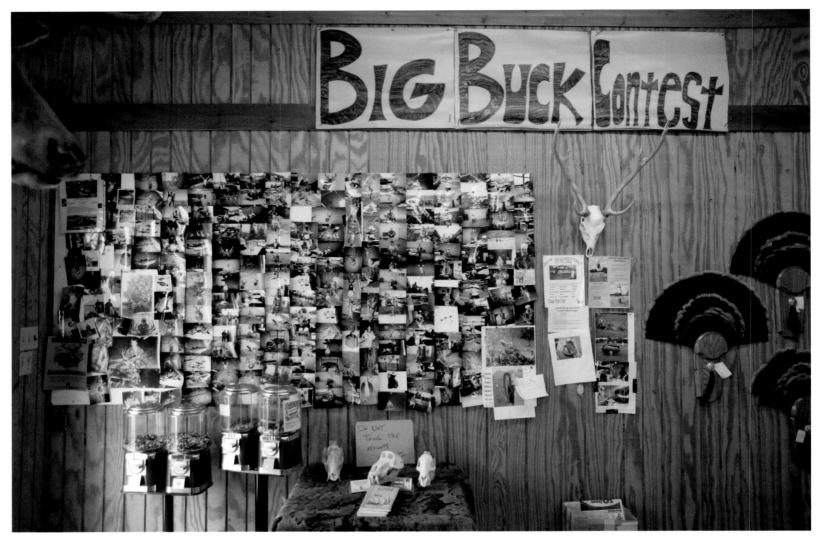

Big buck contest wall, Llano.

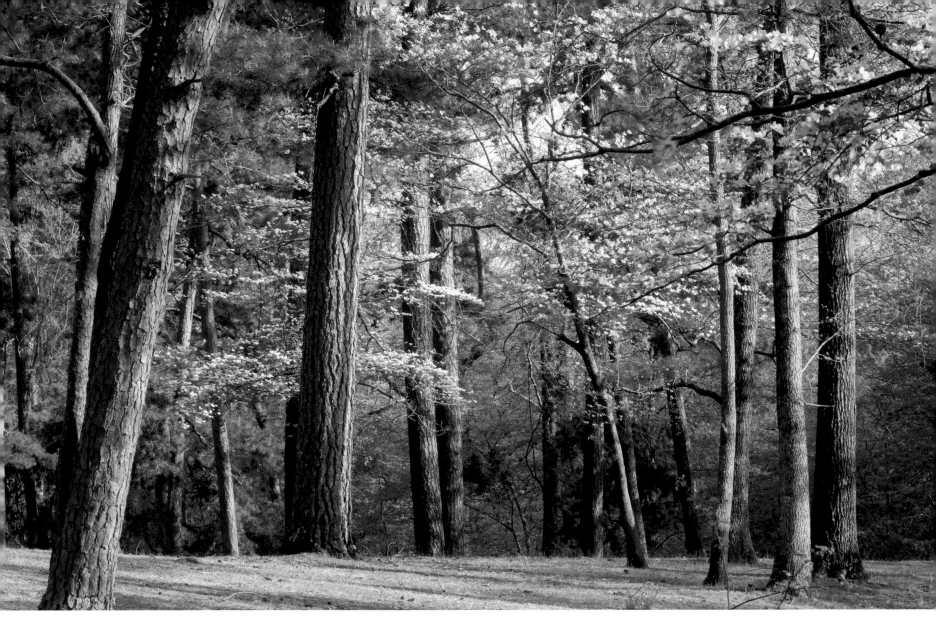

Pines and dogwood near Lufkin.

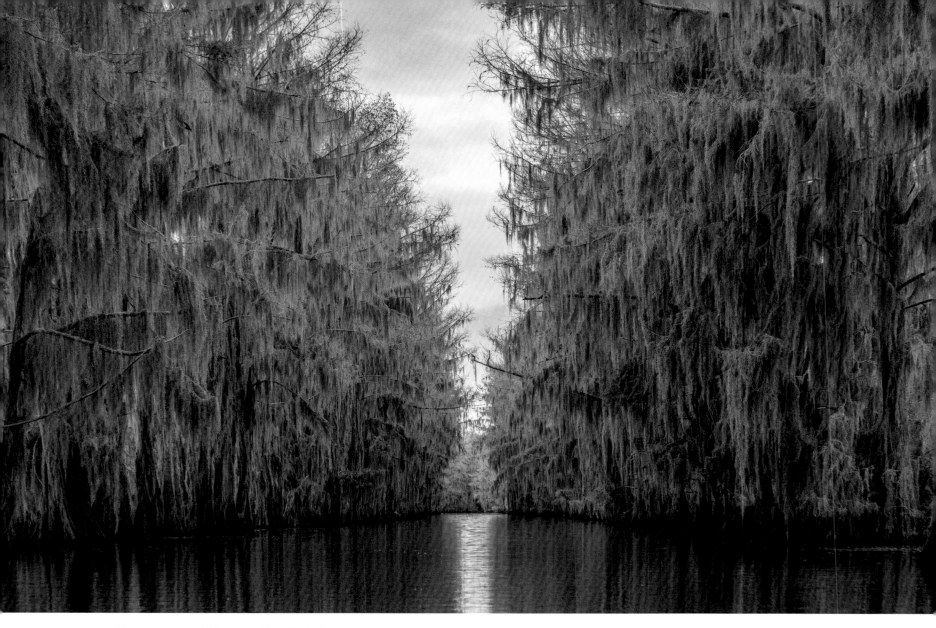

Government Ditch at Caddo Lake.

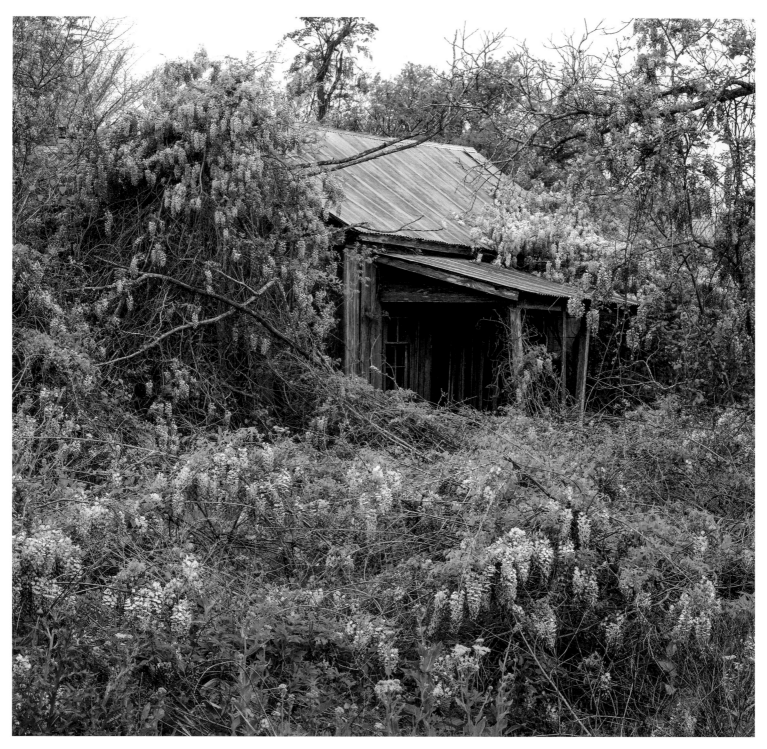

Old home and wisteria, Elgin.

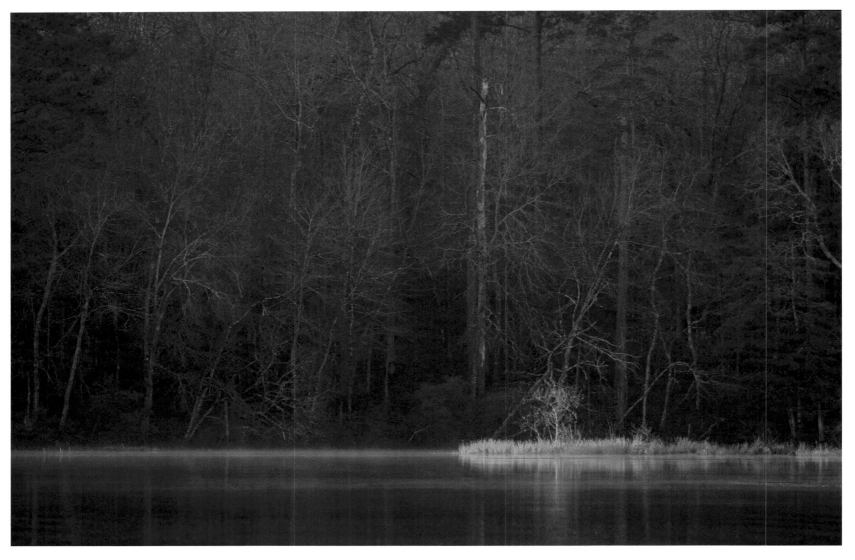

First light on Lake Raven, Huntsville State Park.

Canoes on Lake Raven, Huntsville State Park.

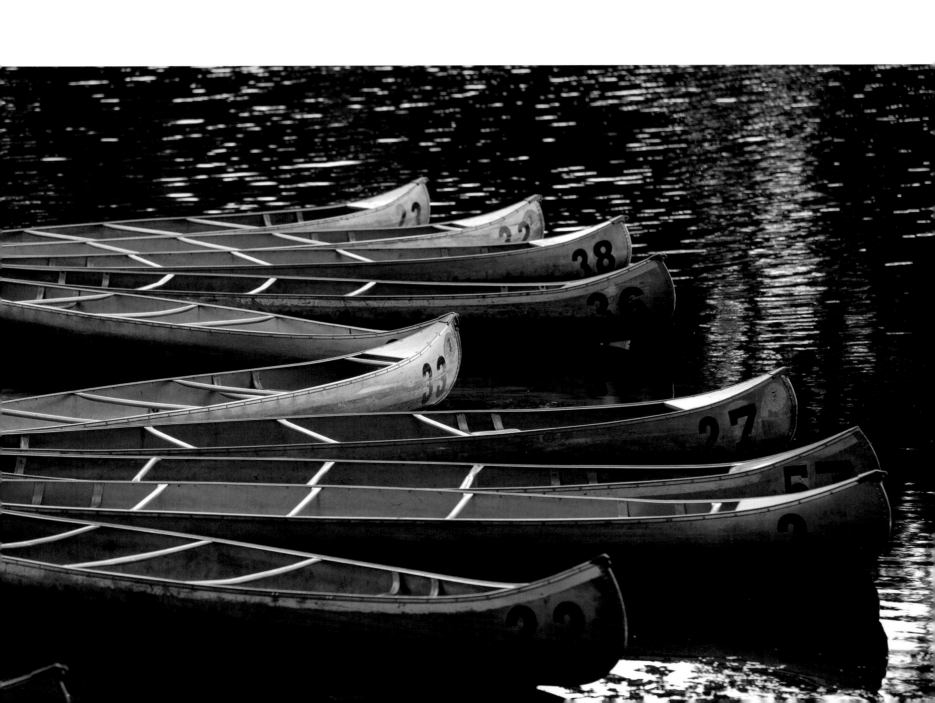

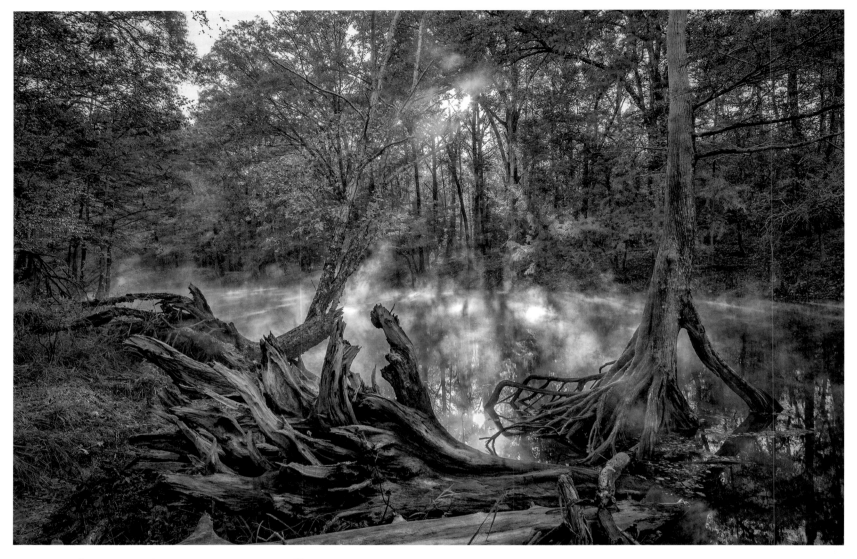

Morning fog on Big Cypress Bayou near Jefferson.

Indian paintbrush and crimson clover at BigWoods on the Trinity, Tennessee Colony.

Texas State Railroad between Rusk and Palestine.

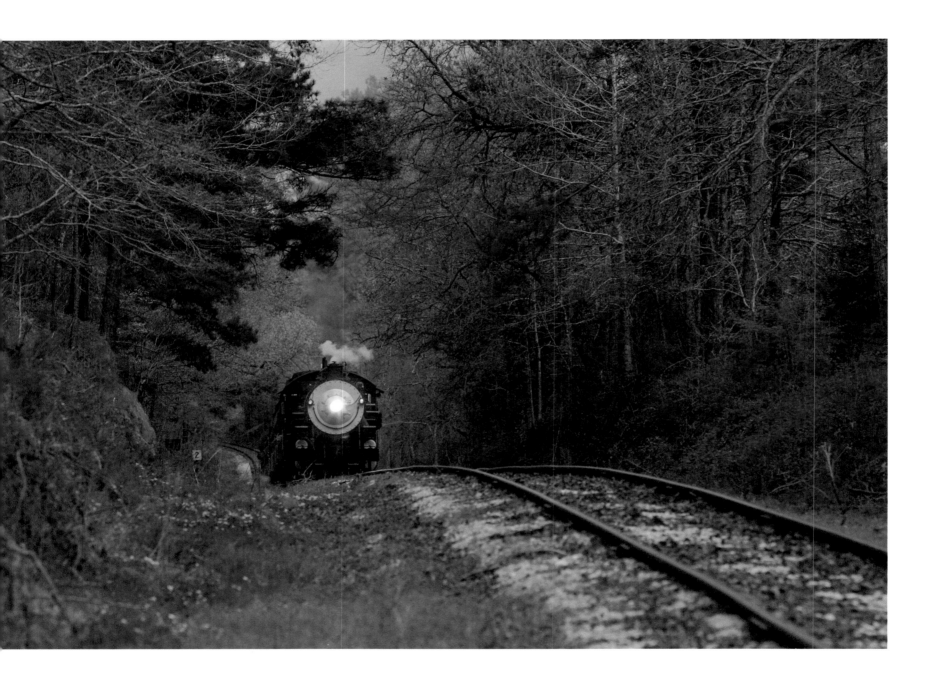

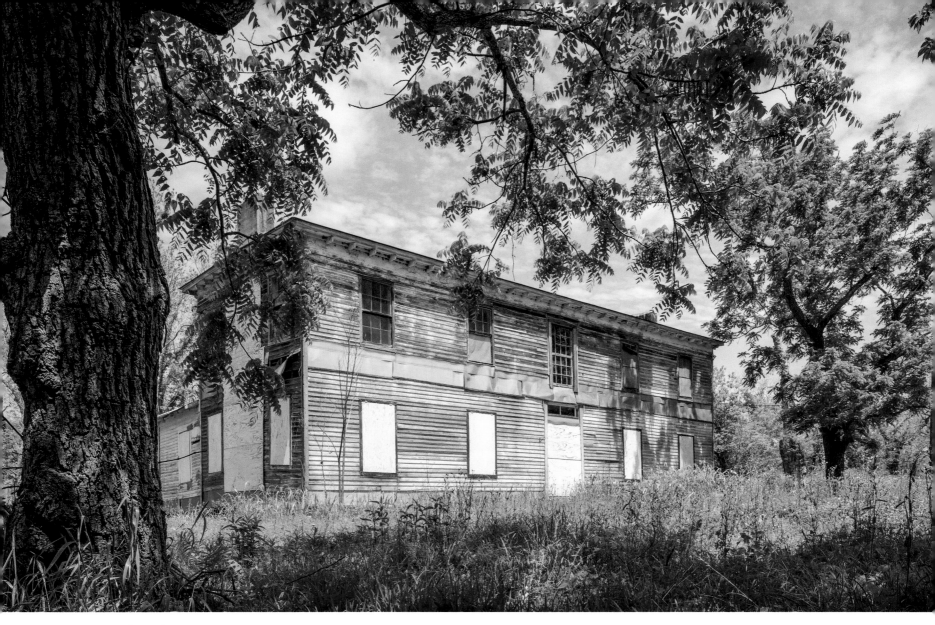

Levi Jordan Plantation near Brazoria.

Spider lily at Richland Creek
Wildlife Management Area.

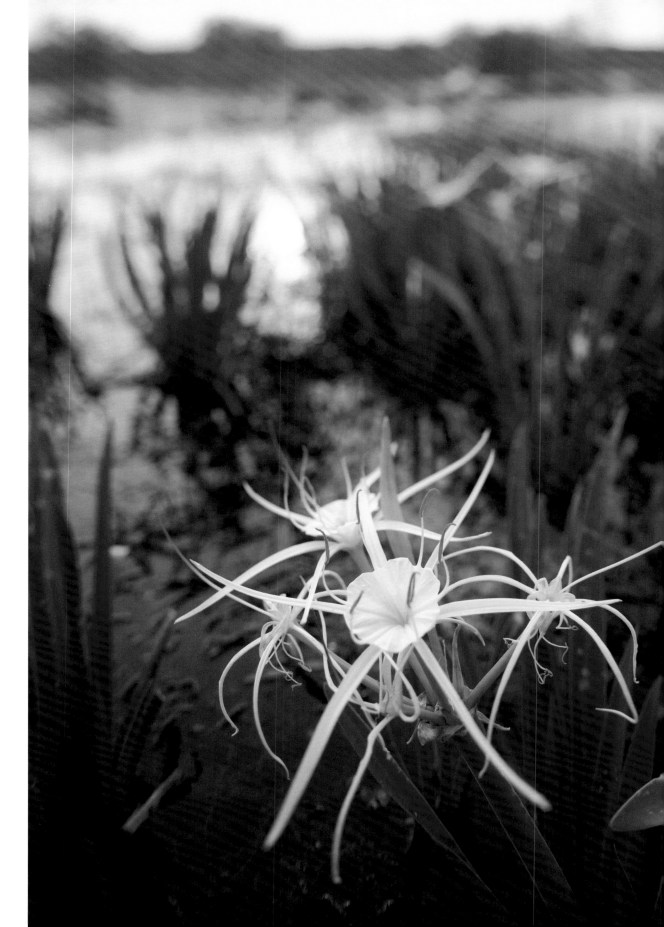

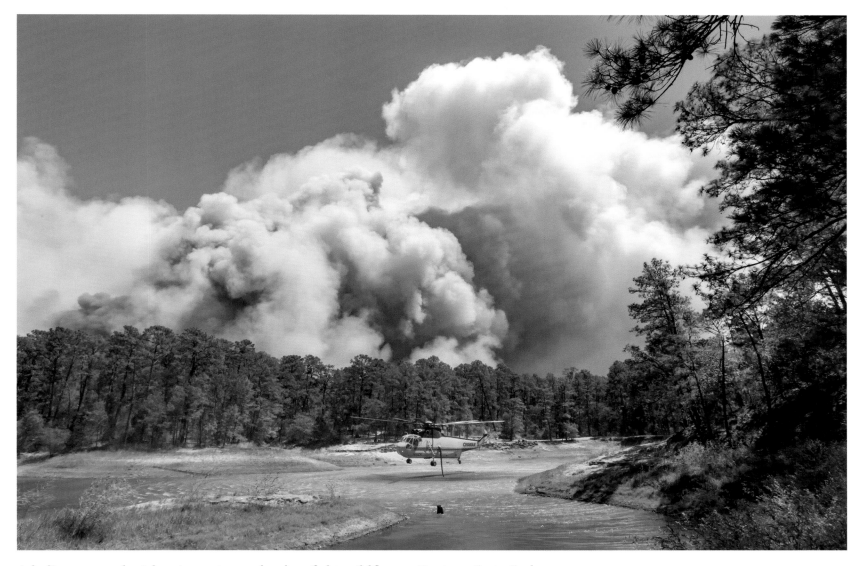

A helicopter replenishes its water payload to fight wildfires at Bastrop State Park.

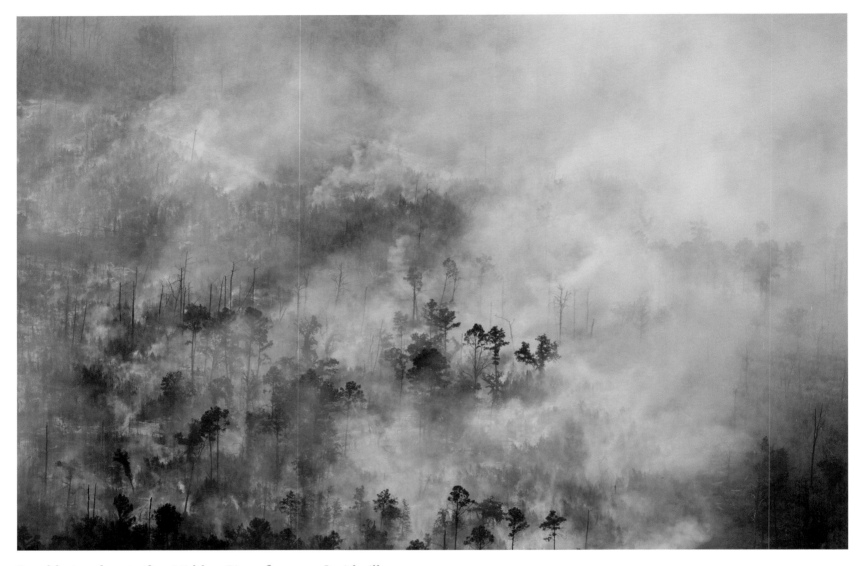

Smoldering forest after Hidden Pines fire near Smithville.

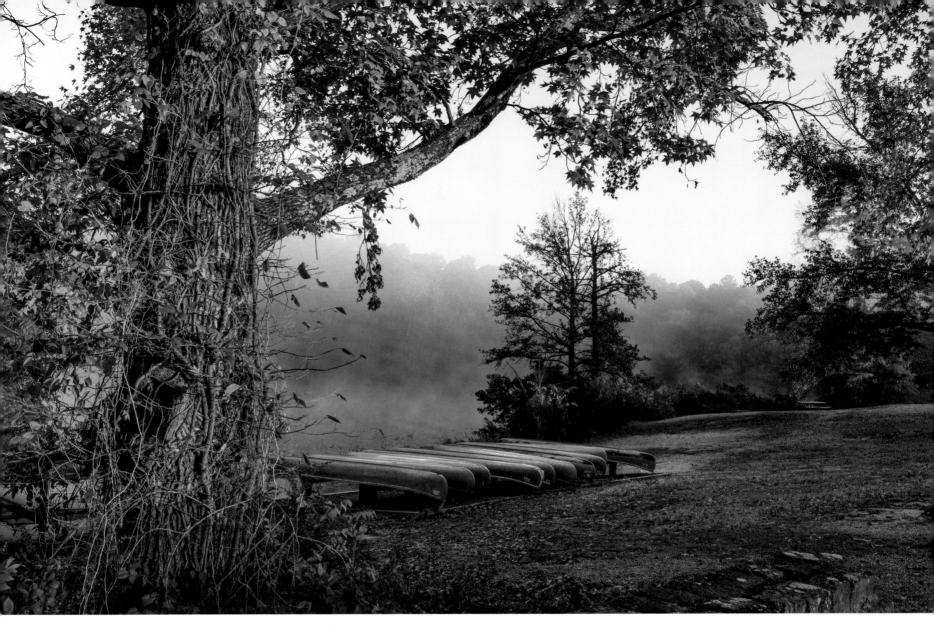

Foggy autumn morning at Daingerfield State Park.

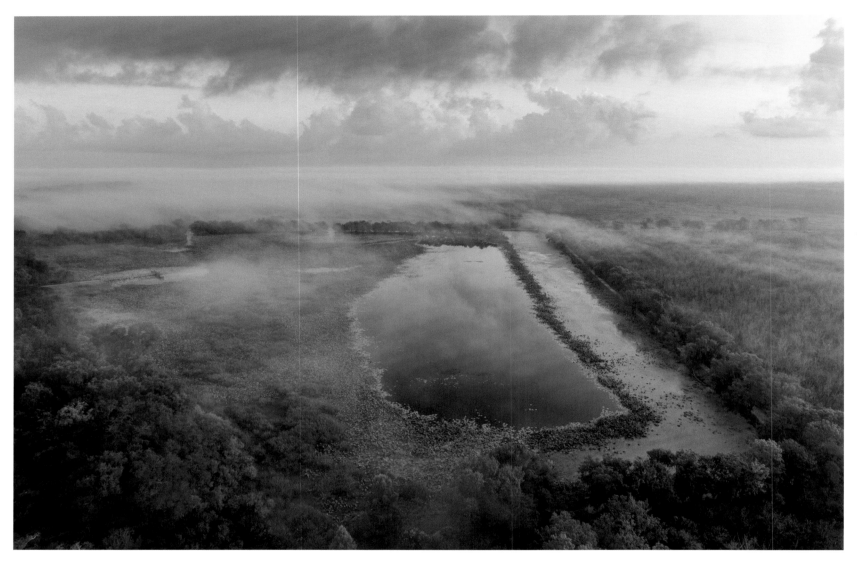

Morning fog over 40-Acre Lake, Brazos Bend State Park.

Twisted oaks at Goose Island State Park.

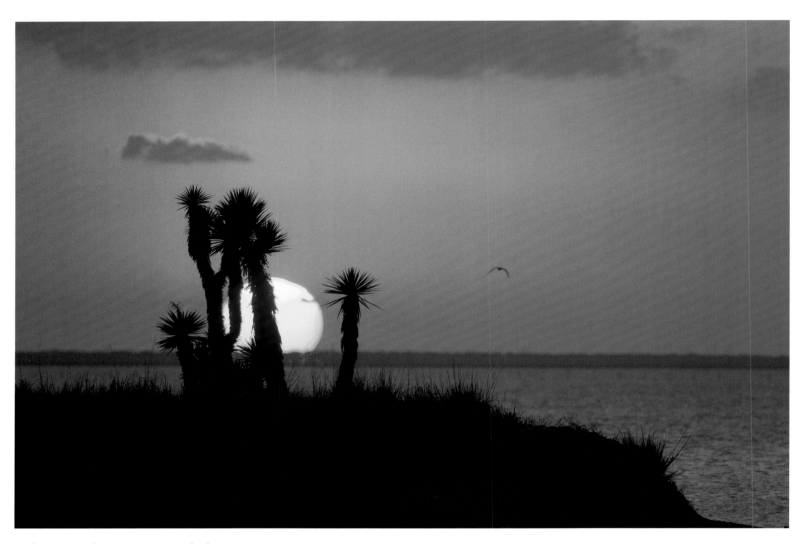

Bahia Grande near Port Isabel.

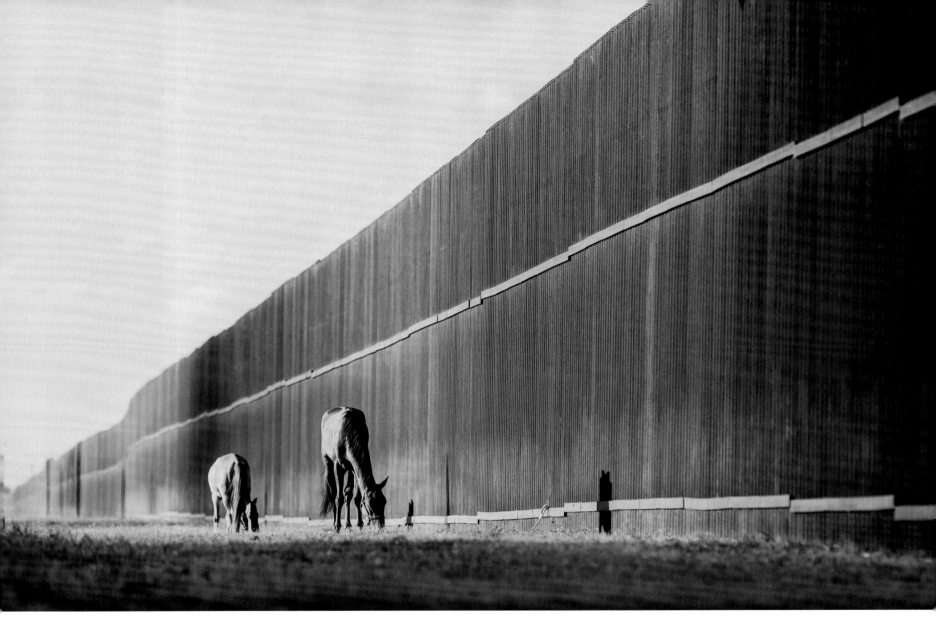

Horses graze at Texas–Mexico border wall near Brownsville.

Texas–Mexico border fence passes by a small cemetery near Brownsville.

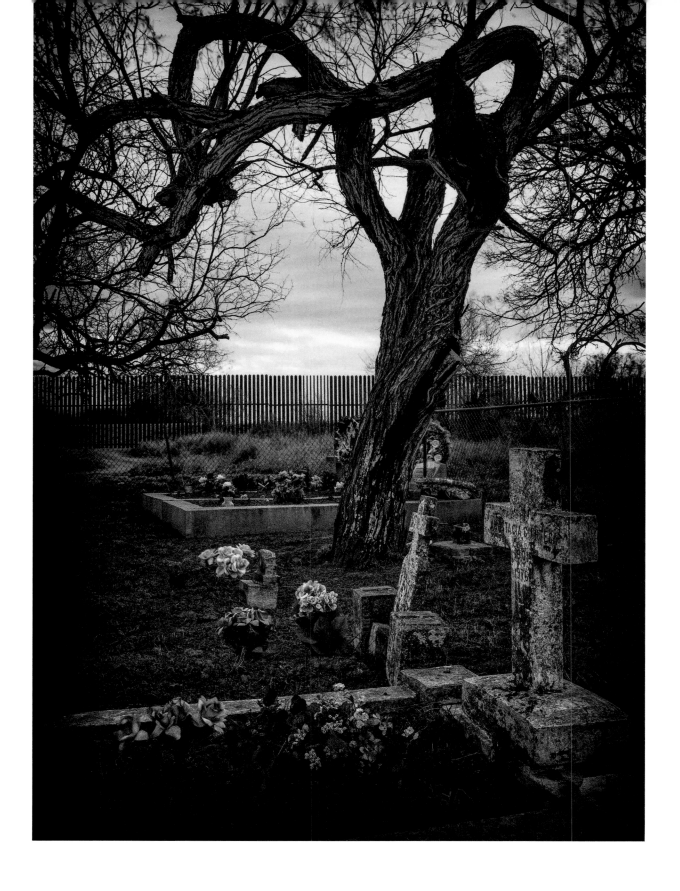

Part 2
Wild Things

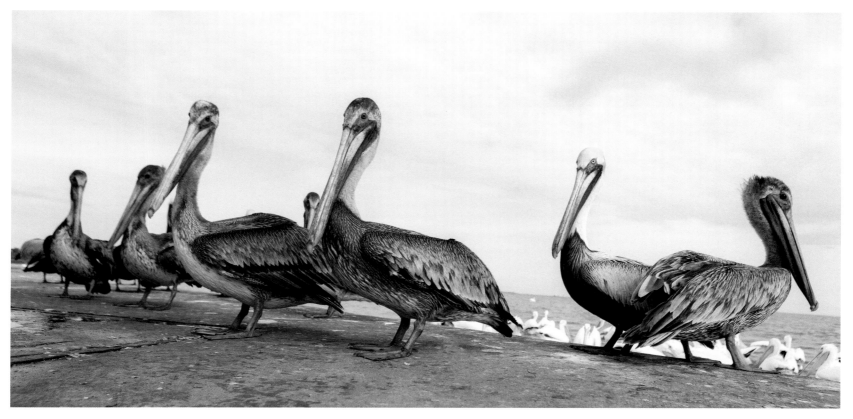

Brown pelicans hanging out at a fish-cleaning station, Goose Island State Park.

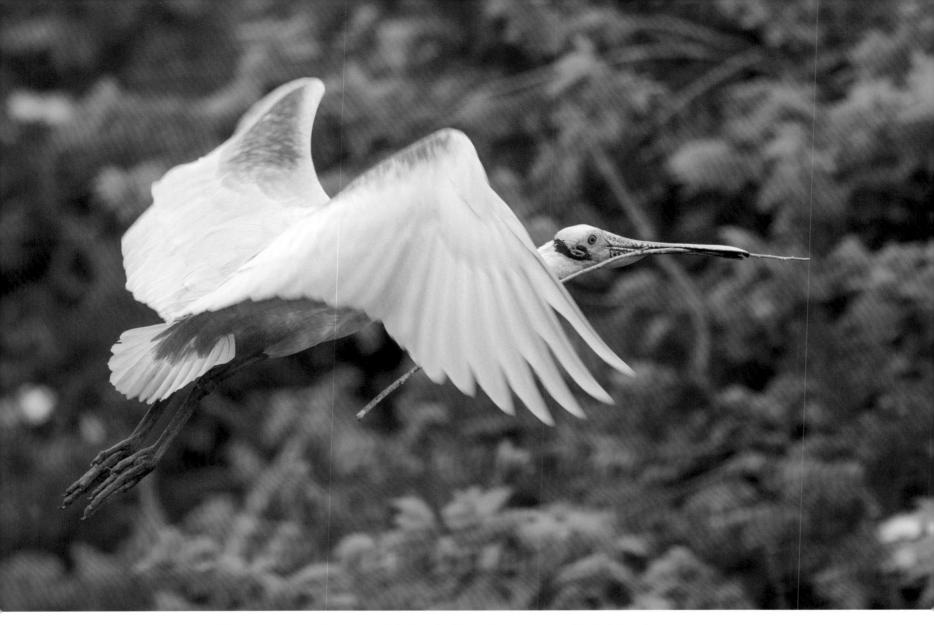

Roseate spoonbill carrying nesting material, Smith Oaks Sanctuary at High Island.

Young eastern bluebirds in box nest, Fairfield.

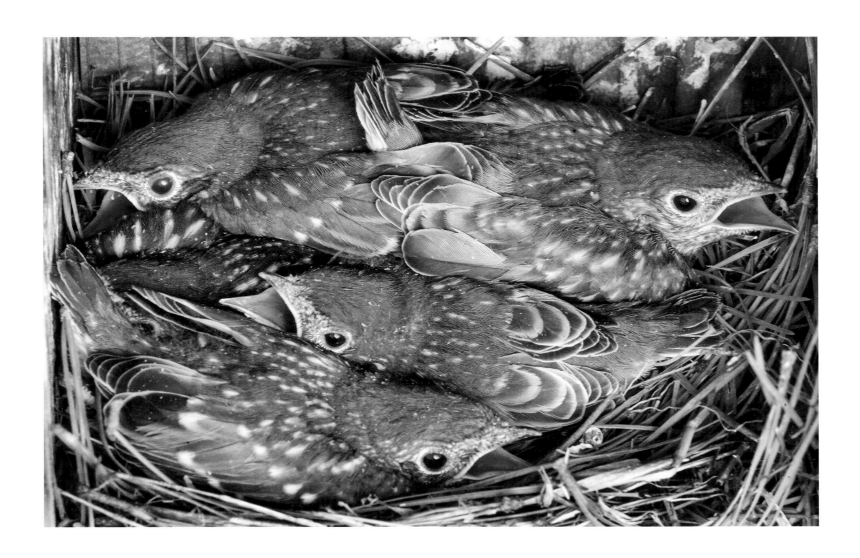

Purple martins on
TV antenna.

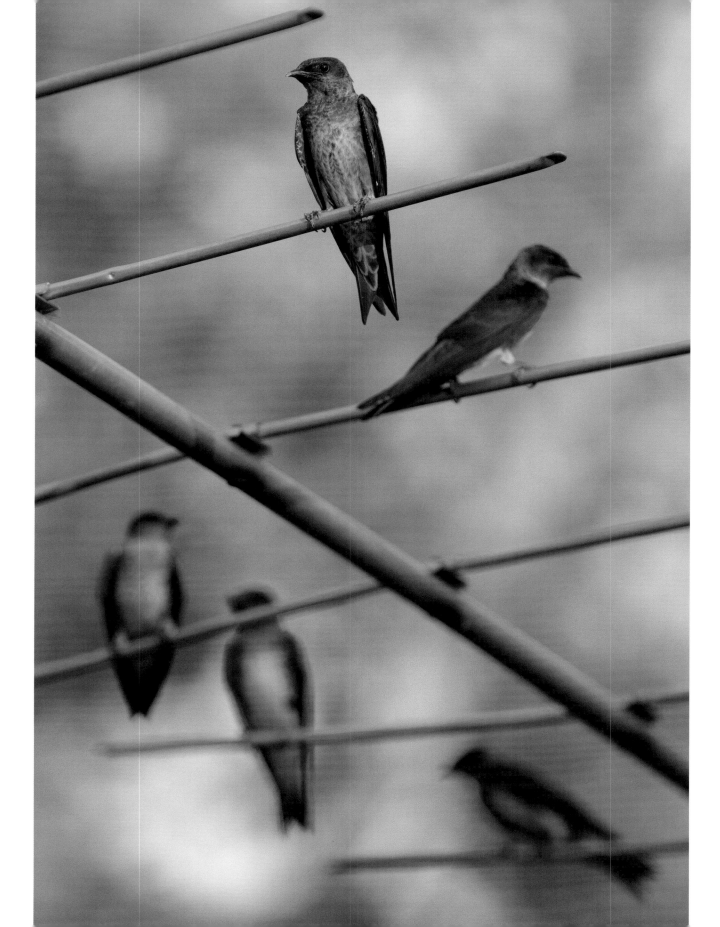

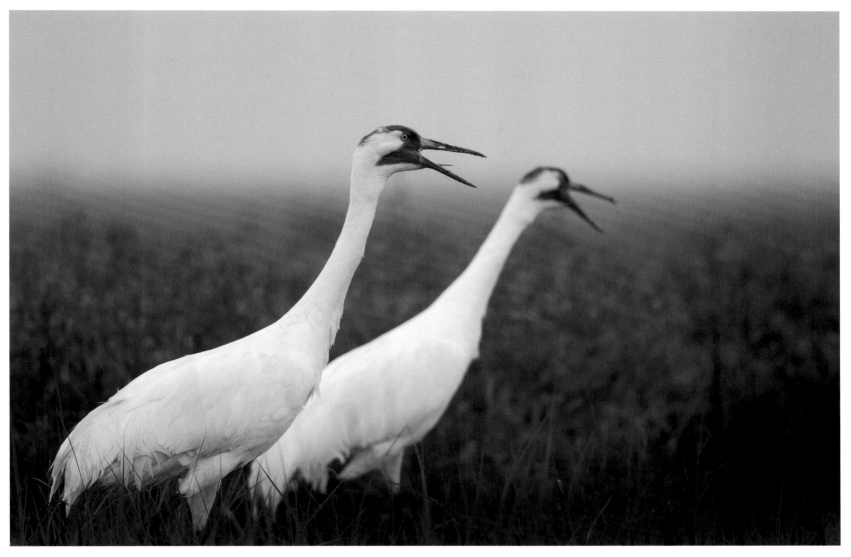

Whooping crane pair, Aransas National Wildlife Refuge.

Confiscated legs of
whooping crane as
illegal wildlife trafficking
evidence.

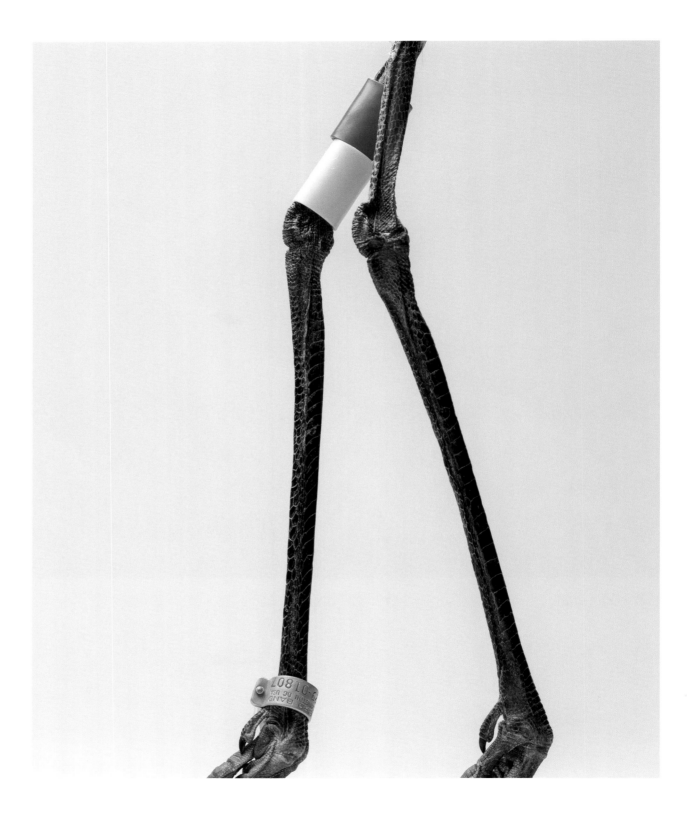

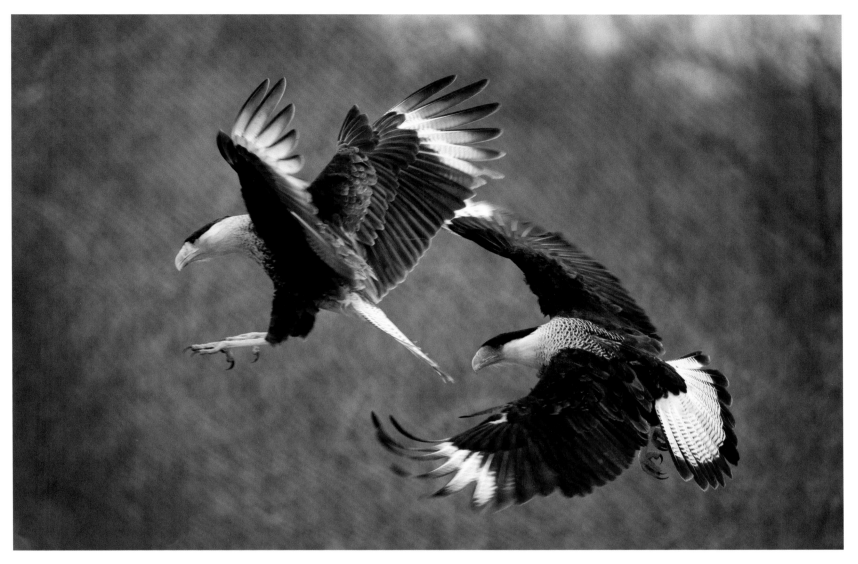

Crested caracara, Starr County.

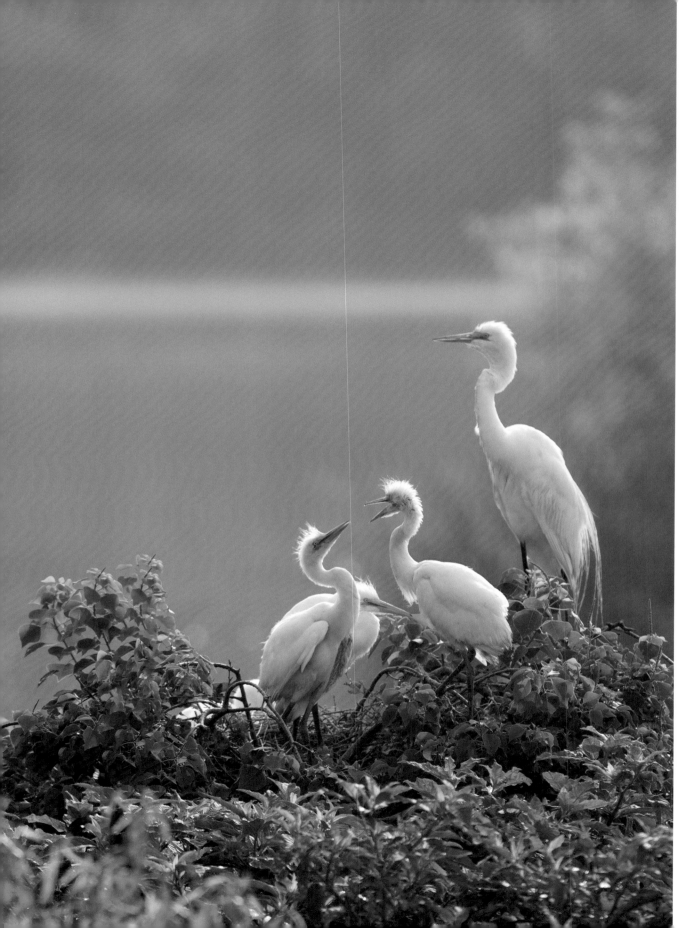

Snowy egrets in rookery
at Smith Oaks Sanctuary,
High Island.

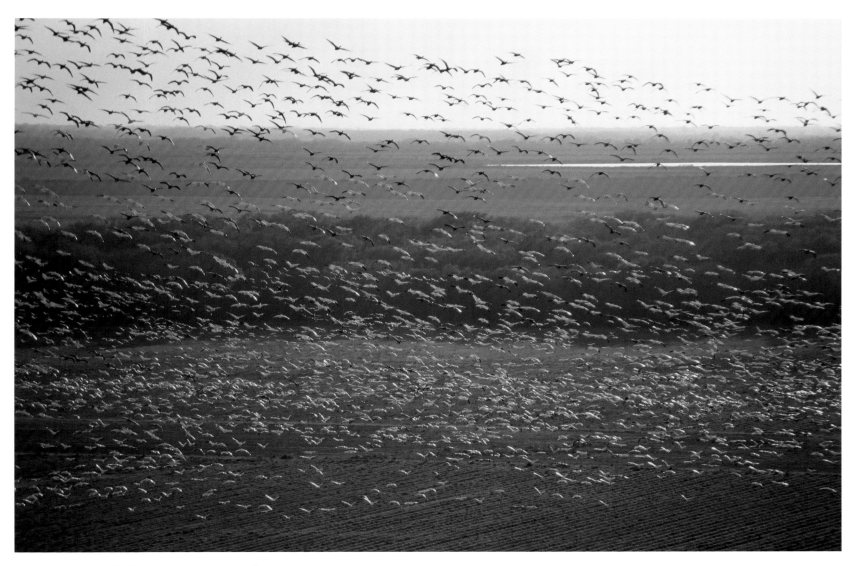

Snow geese in flight at sunset near El Campo.

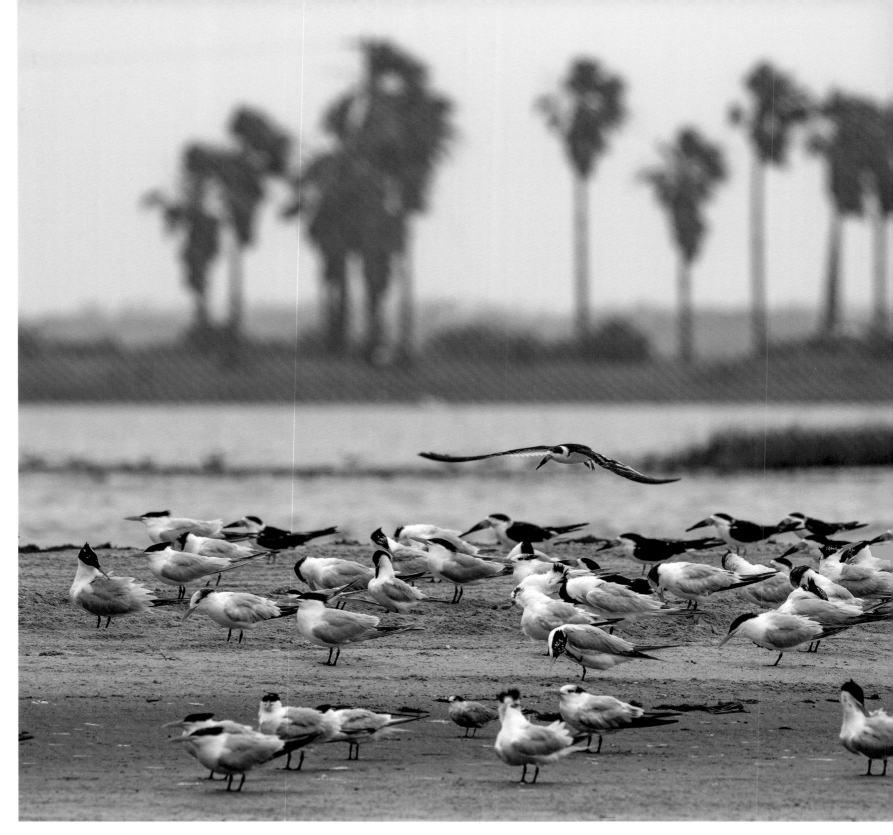

Royal terns on the Bolivar Peninsula.

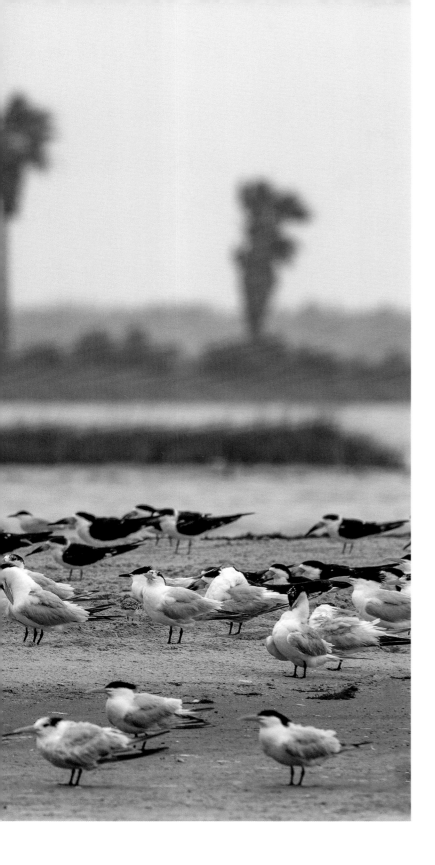

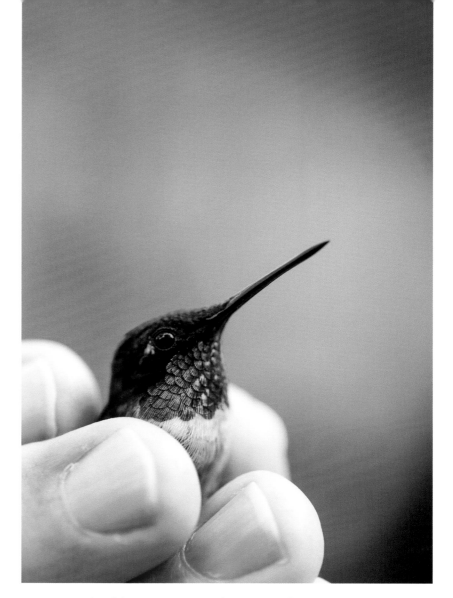

Hummingbird being examined as part of a capture, tagging, and release program, Rockport.

Red-crowned parrots in
palm trunk, Brownsville.

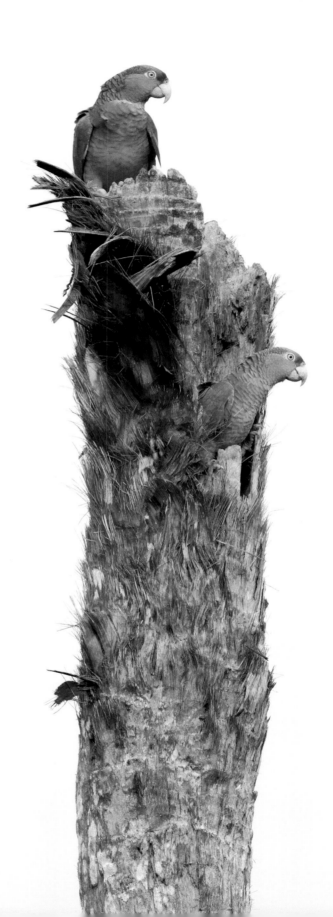

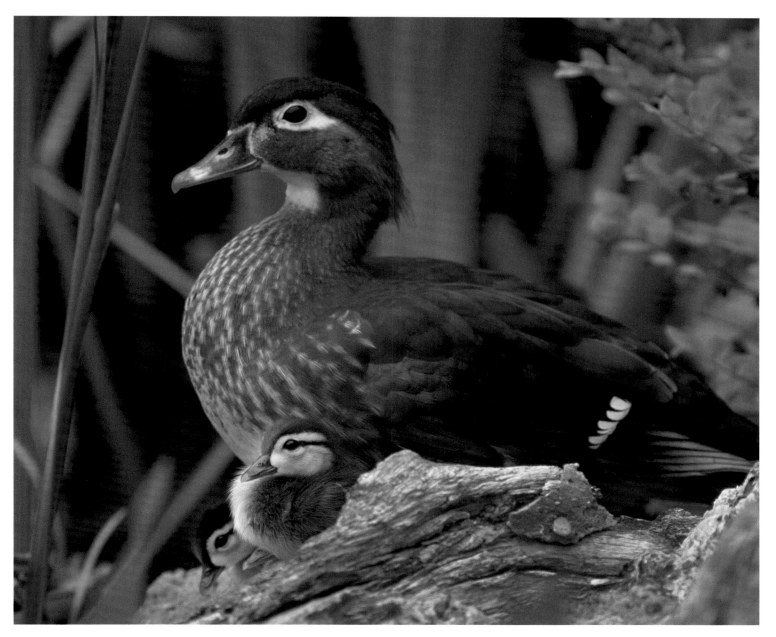

Female wood duck and ducklings, Texas Freshwater Fisheries Center, Athens.

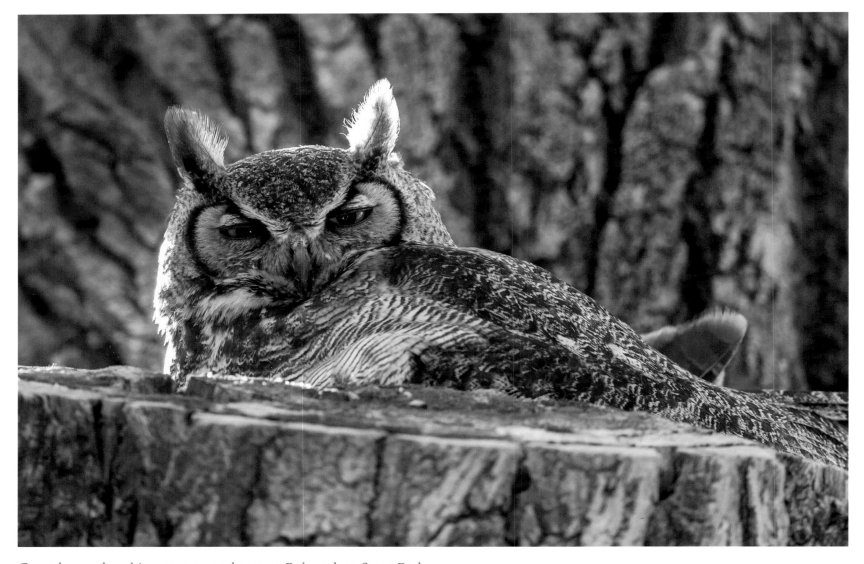

Great horned owl in cottonwood tree at Balmorhea State Park.

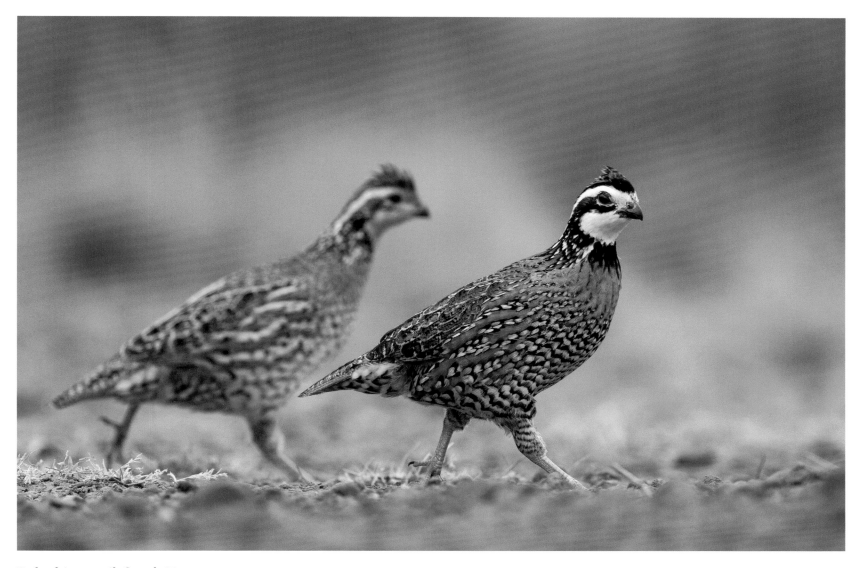

Bobwhite quail, South Texas.

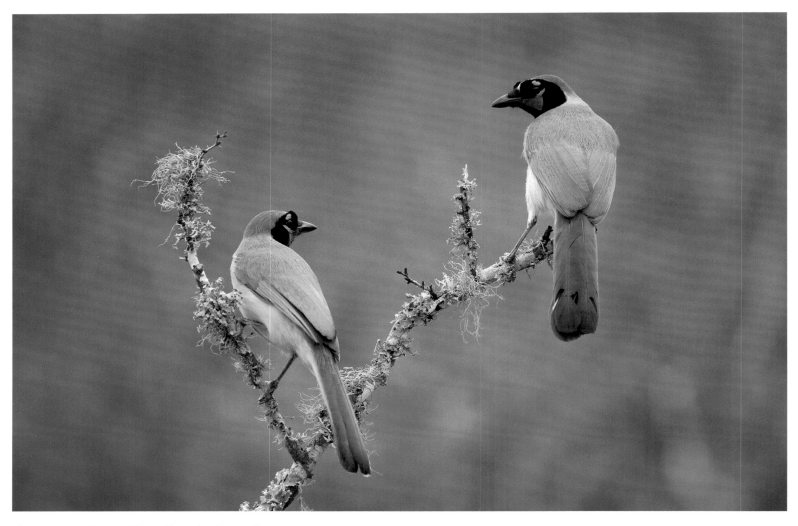

Green jays, Santa Clara Ranch, Starr County.

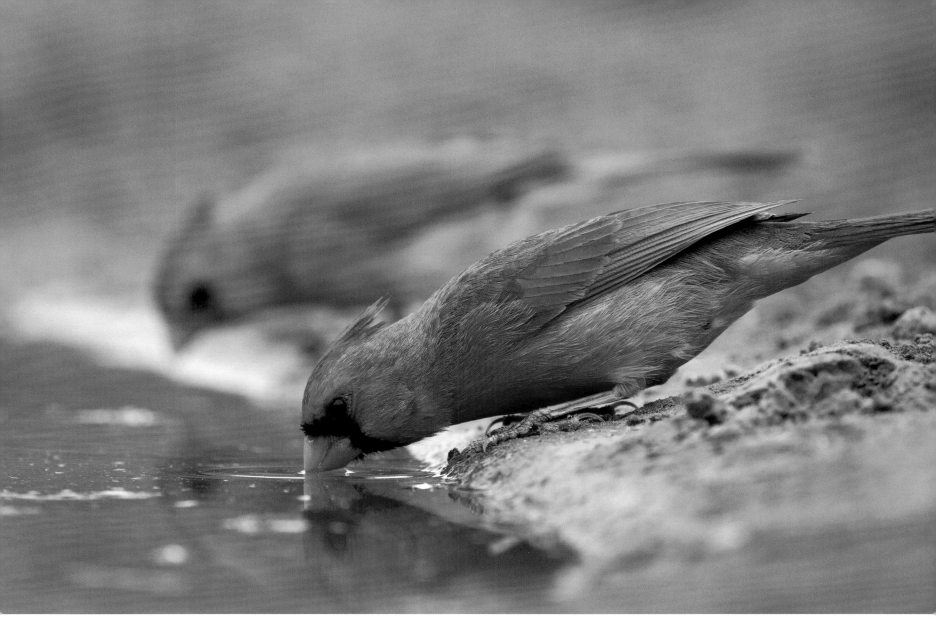

Cardinals at a South Texas waterhole.

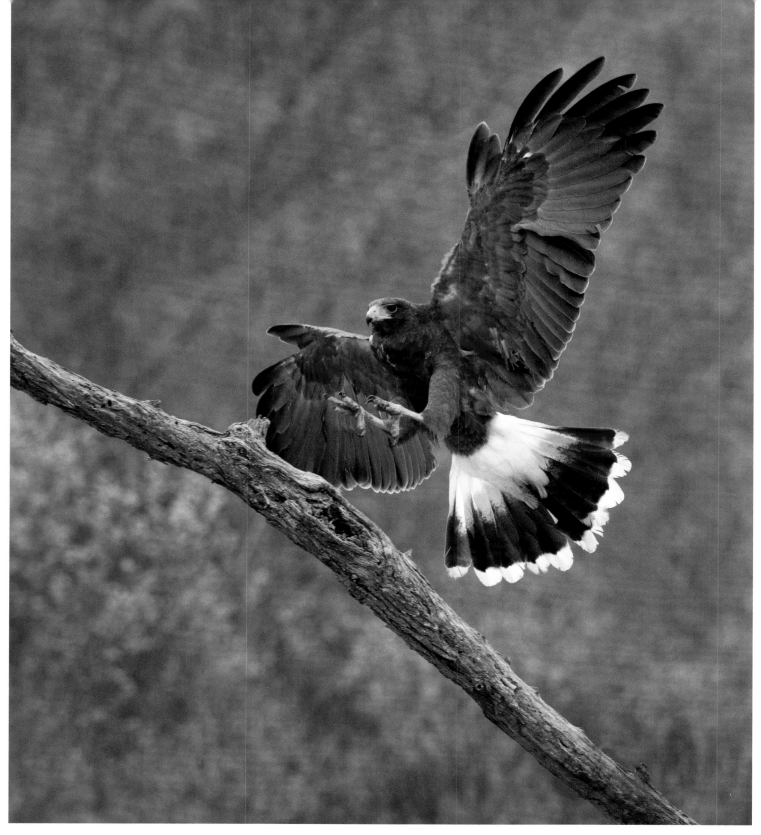

Harris's hawk, Santa Clara Ranch, Starr County.

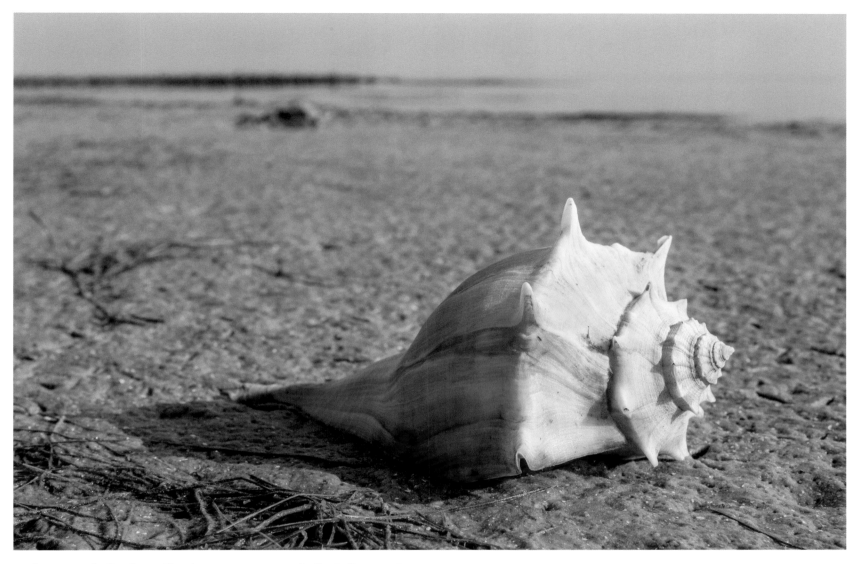

Lightning whelk, the official Texas state seashell, Calhoun County.

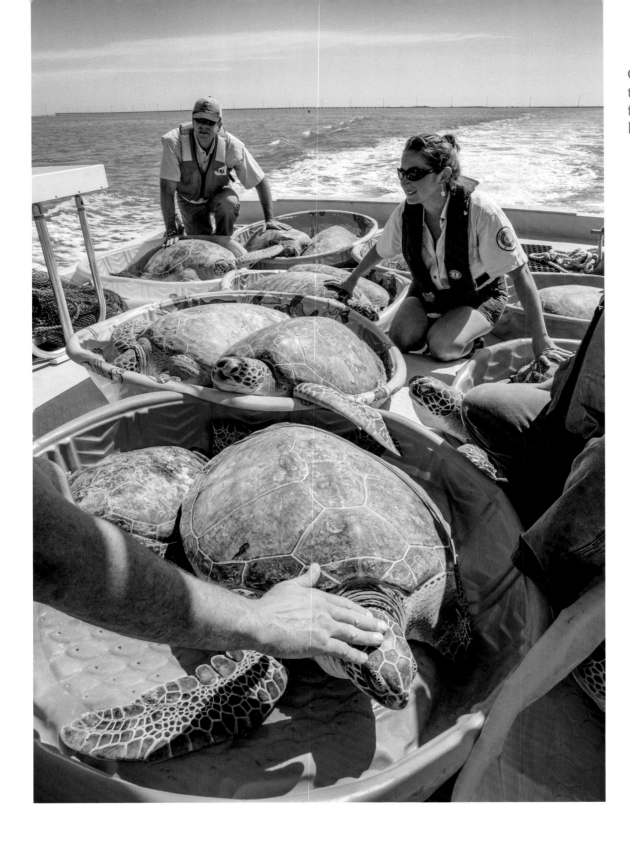

Green sea turtles are returned to the bay after recovering from becoming cold-stunned by frigid winter weather.

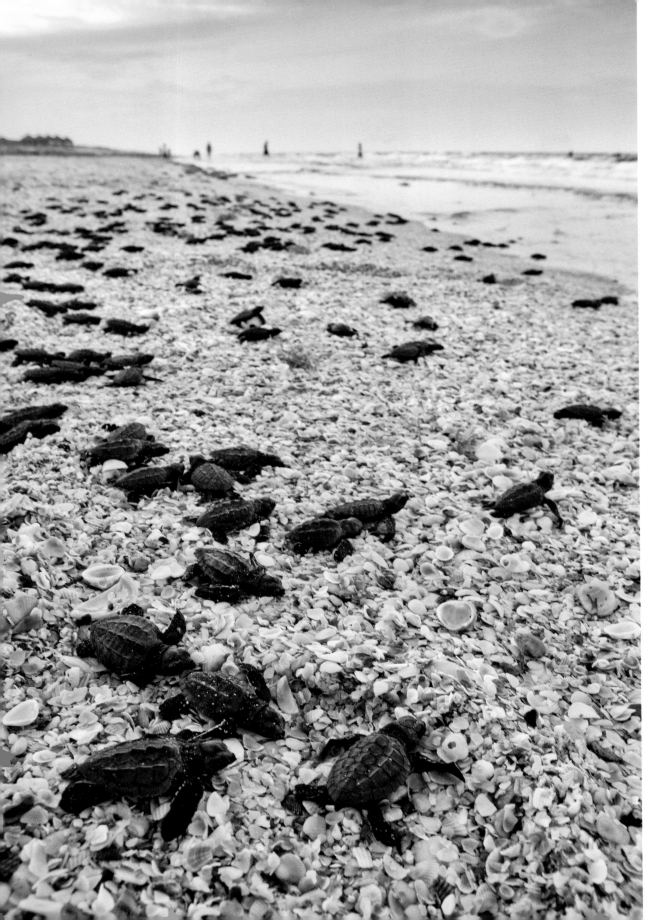

Young Kemp's ridley sea turtles released into Gulf of Mexico near Tepehuajes, Mexico.

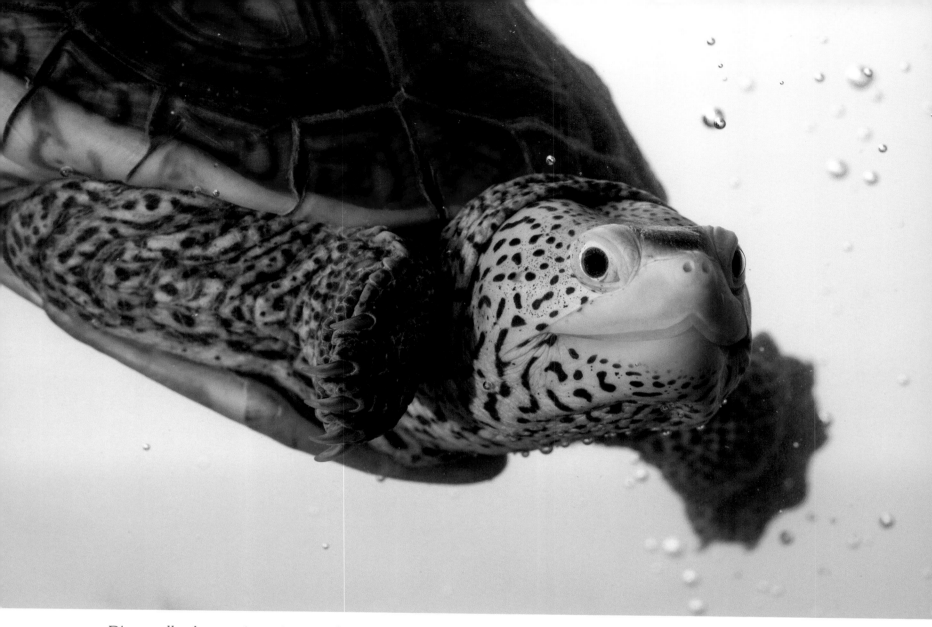

Diamondback terrapin at Amos Rehabilitation Keep (ARK), Port Aransas.

Local residents watch the release of several rehabilitated sea turtles, Galveston Island.

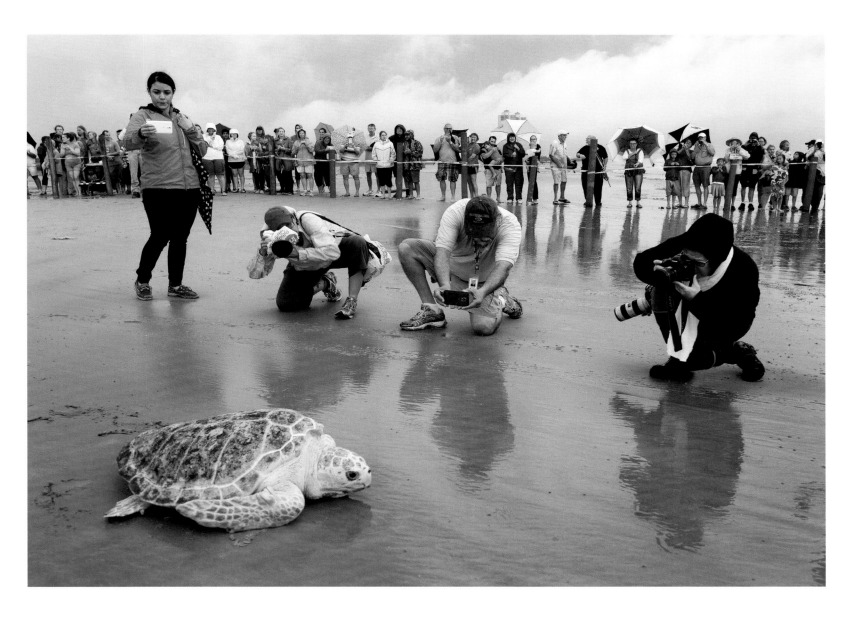

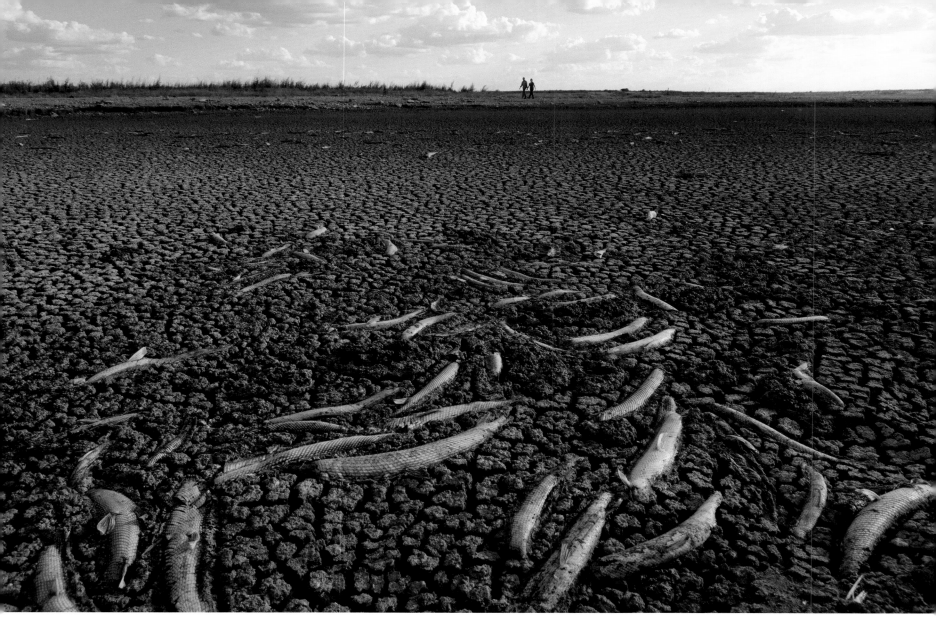

Dried lakebed and dead fish during drought at O .C. Fisher Lake in San Angelo.

At 121.5 pounds from Lake Texoma, "Splash" held the record for many years as the largest blue catfish ever caught.

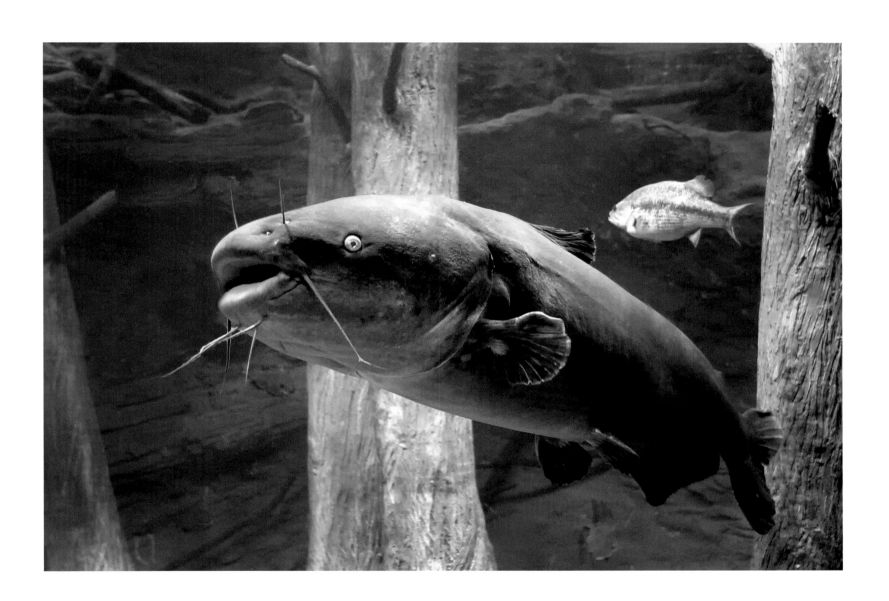

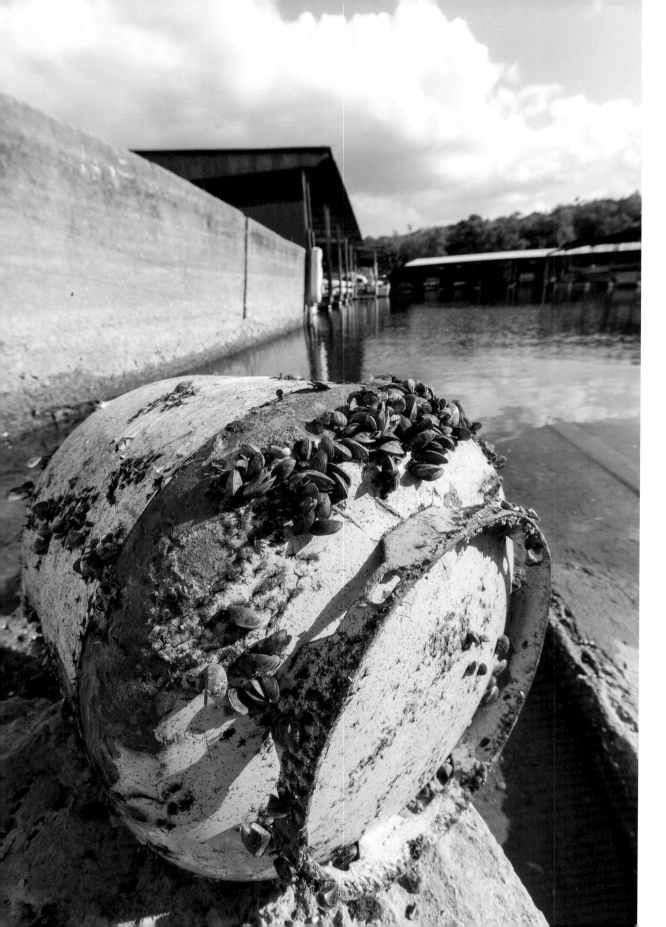

Invasive zebra mussels
attached to propane tank,
Lake Texoma.

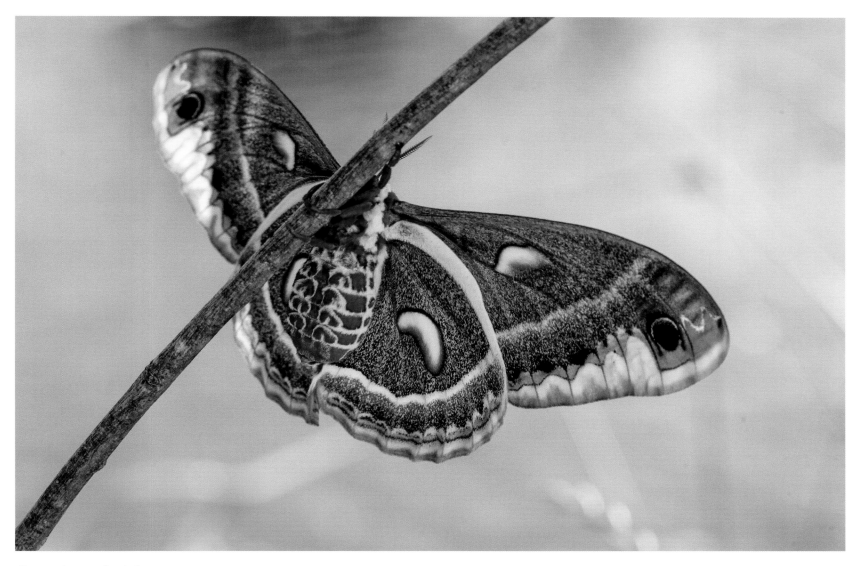

Cecropia moth, Athens.

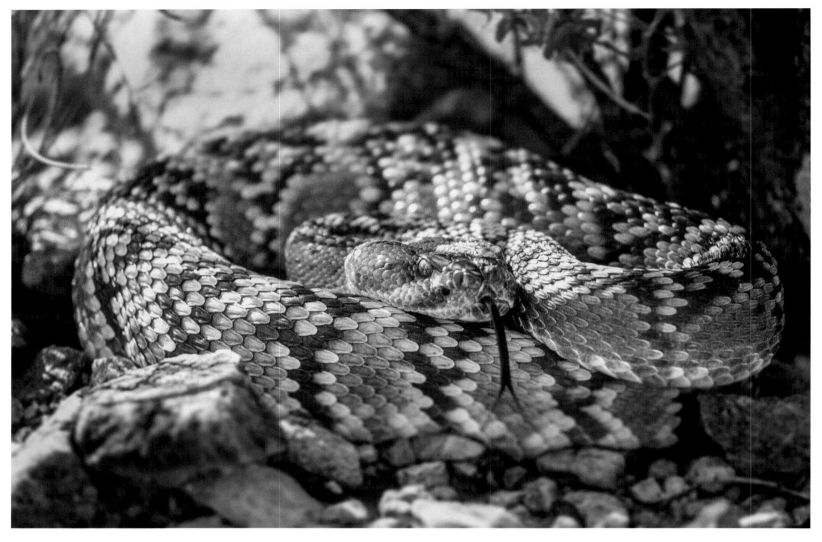

A black-tailed rattlesnake coils in the shade at Big Bend National Park.

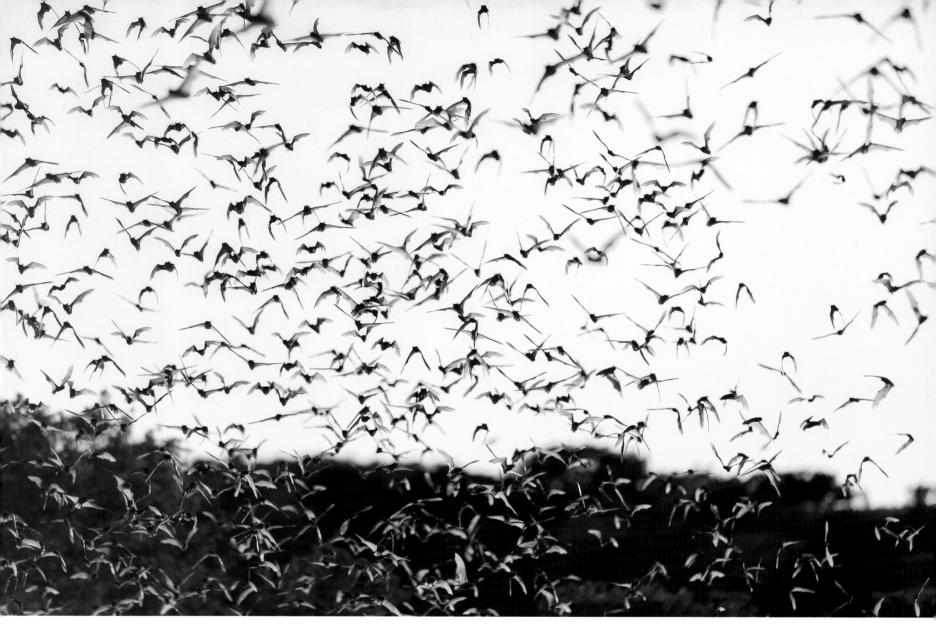

Bats emerge from Bracken Cave near San Antonio.

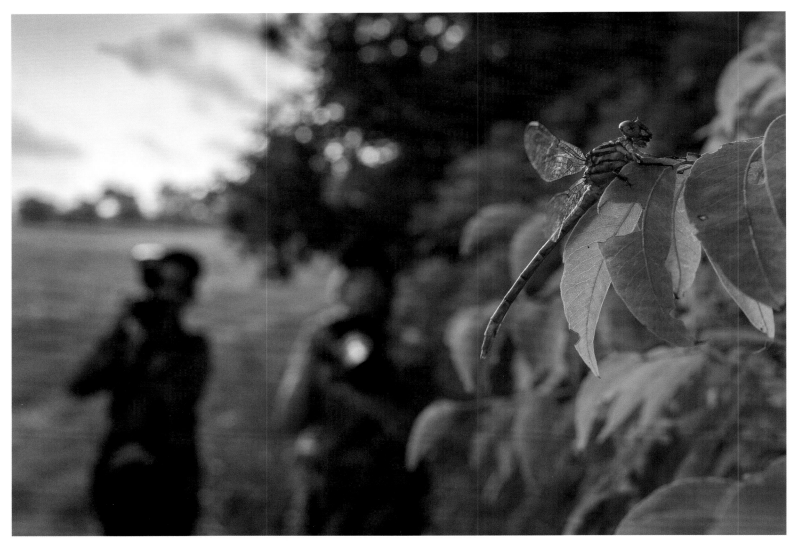

Dragonfly hunting at Hornsby Bend, Austin.

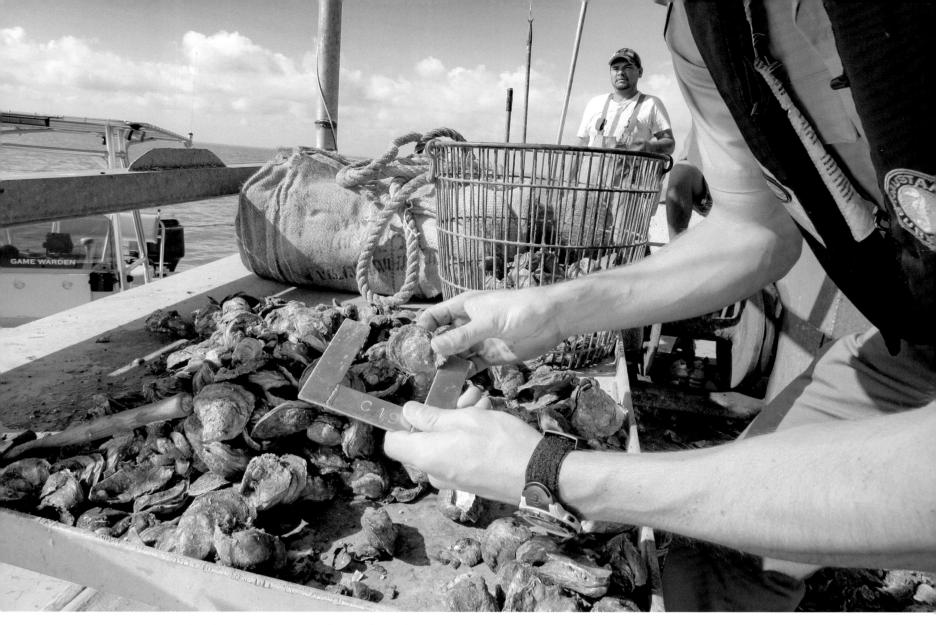

A game warden checks oysters for legal size aboard an oyster boat in Matagorda Bay.

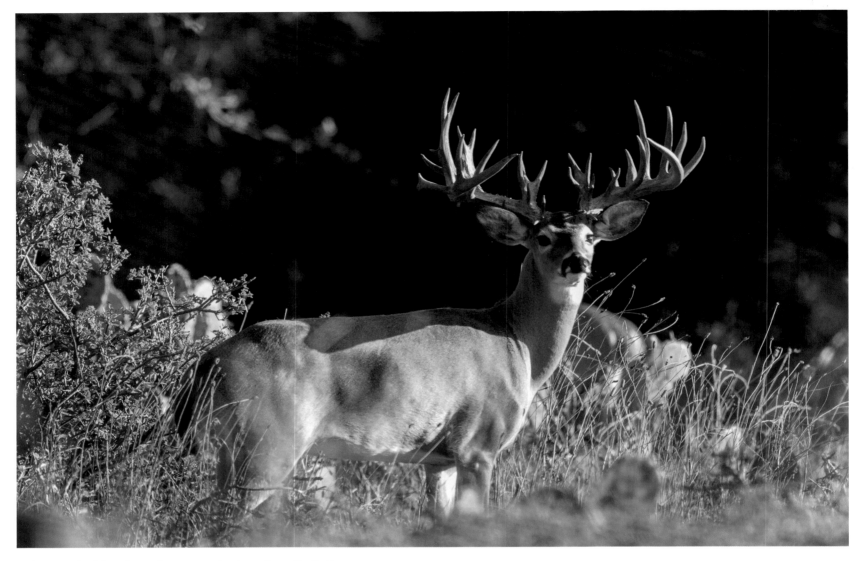

White-tailed buck with nontypical antlers, Bell County.

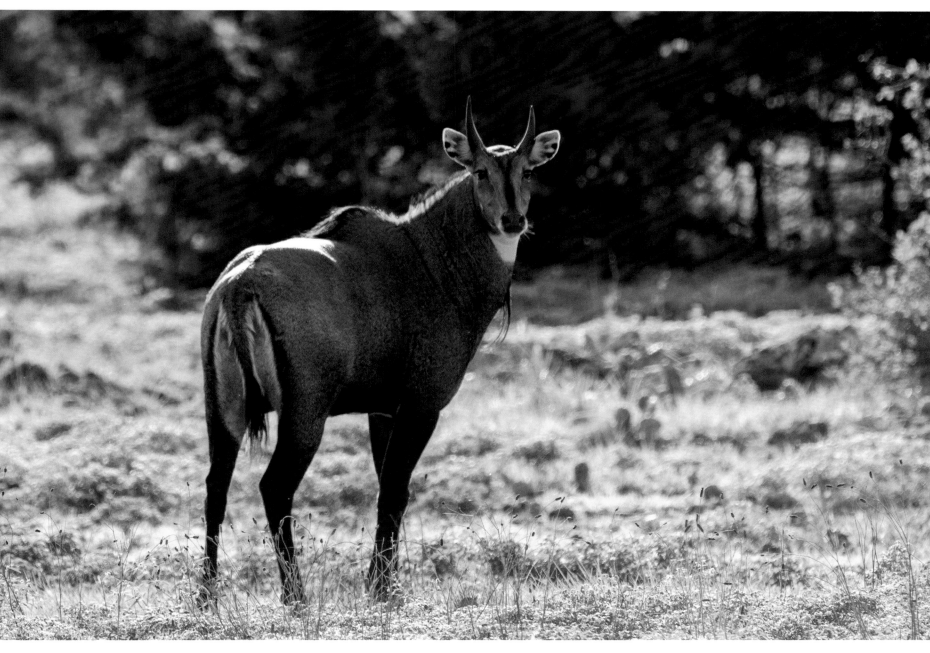

Exotic nilgai antelope on DaVine Springs Ranch, Bell County.

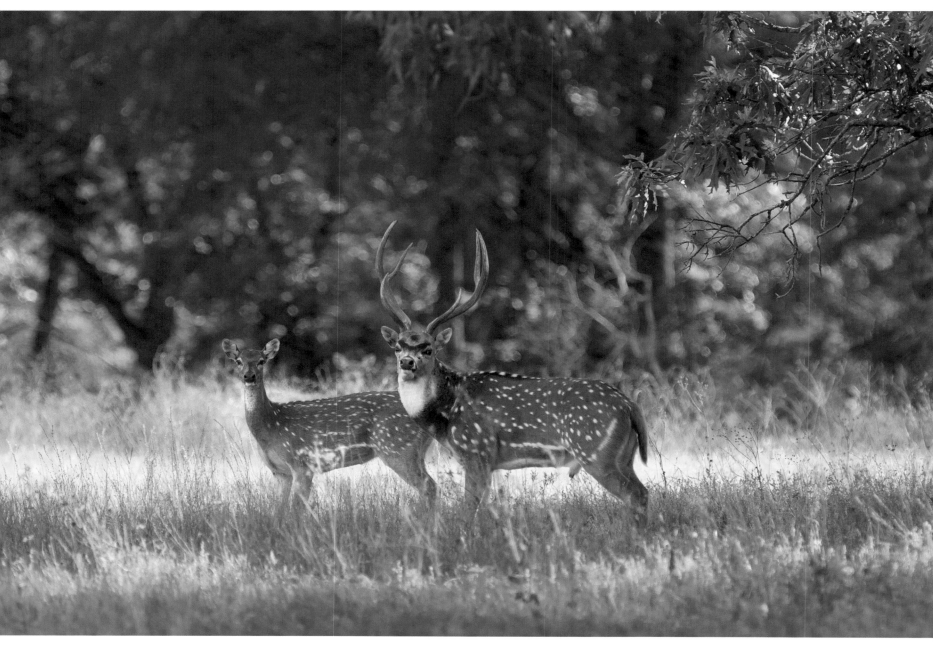

Axis deer at Cook's Branch Conservancy, Montgomery.

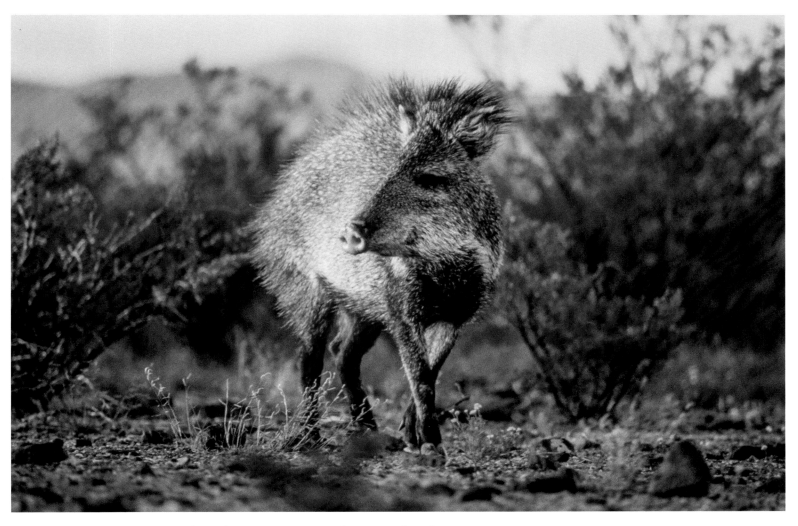

Javelina, also known as a collared peccary, Big Bend National Park.

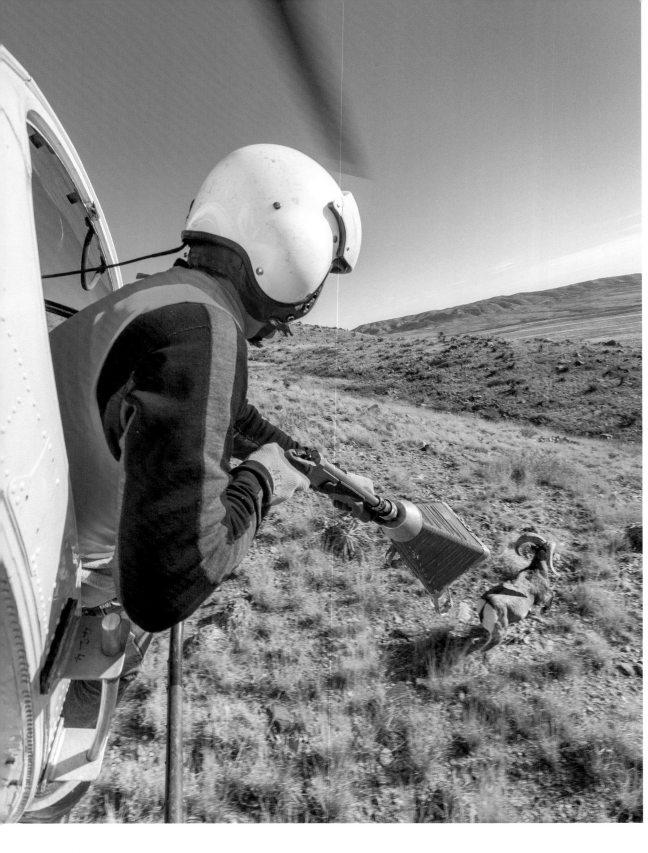

A helicopter and net gun are used to capture a desert bighorn sheep at Elephant Mountain Wildlife Management Area.

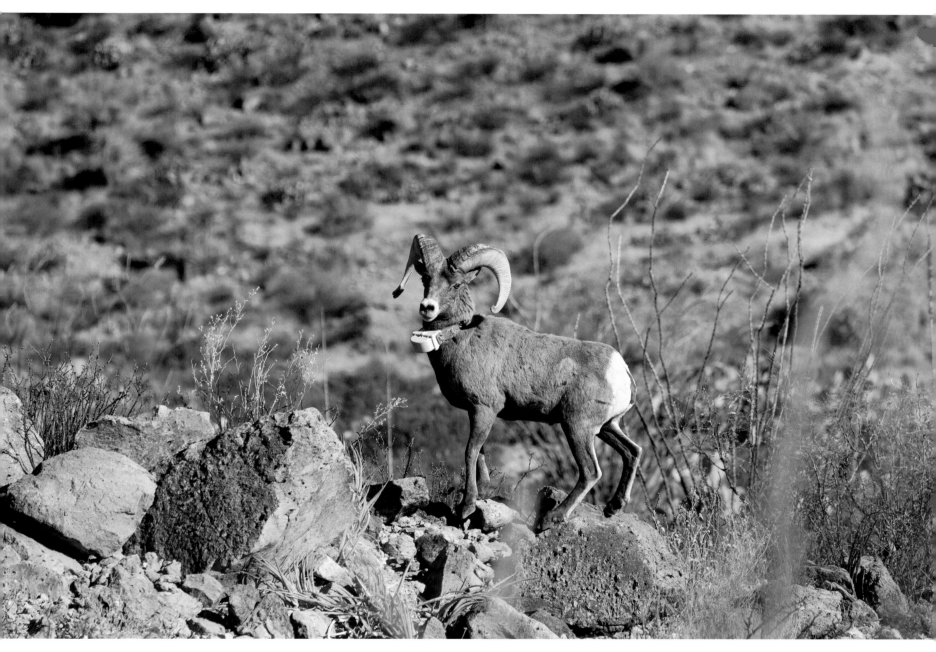

Released desert bighorn ram with radio collar, Brewster County.

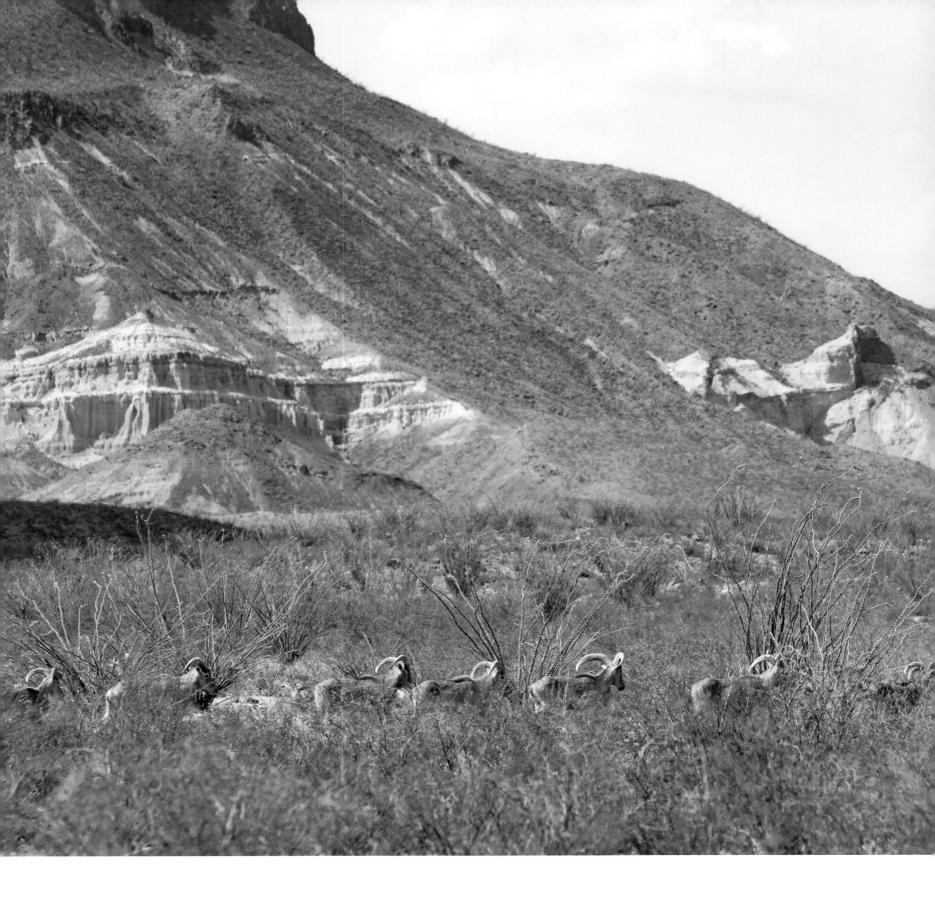

Exotic aoudad sheep, Big Bend Ranch State Park.

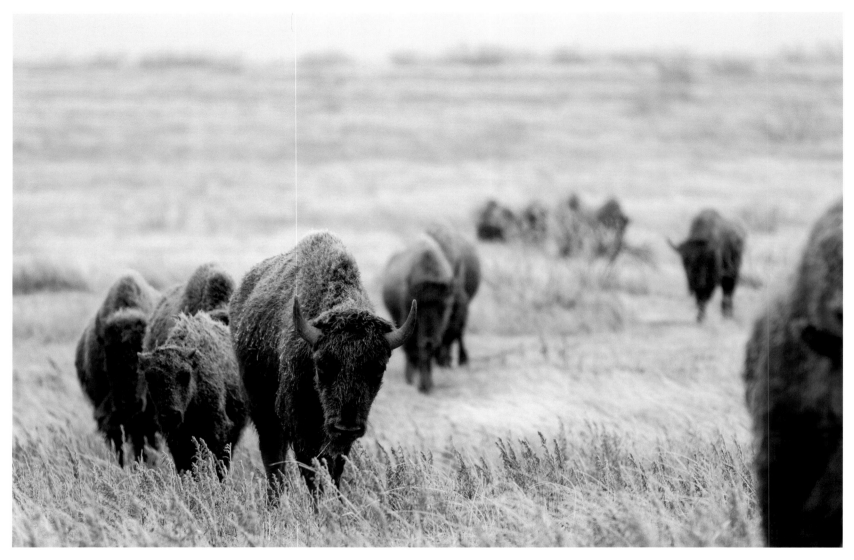

Bison brave the icy weather at Caprock Canyons State Park.

Part 3

Faces

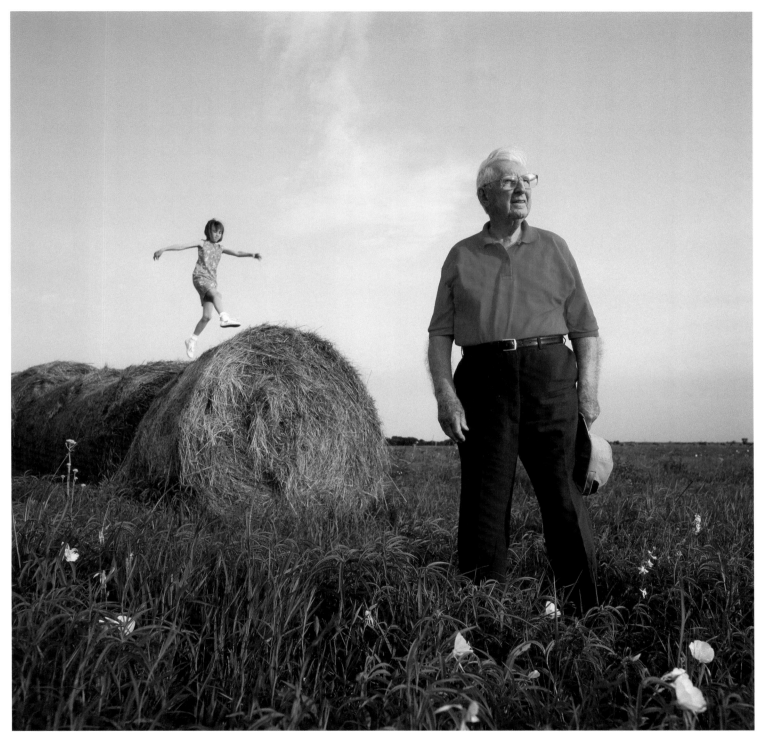

Lone Star Land Steward Award recipient Paul Mathews and granddaughter, Hunt County.

Former TPWD commissioner Mickey Burleson tends to the reintroduced prairie on her family farm near Troy.

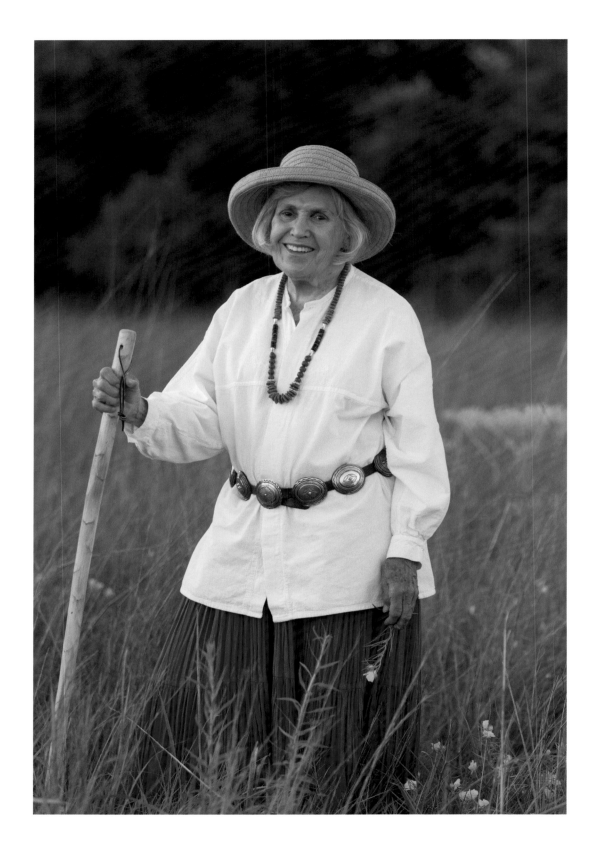

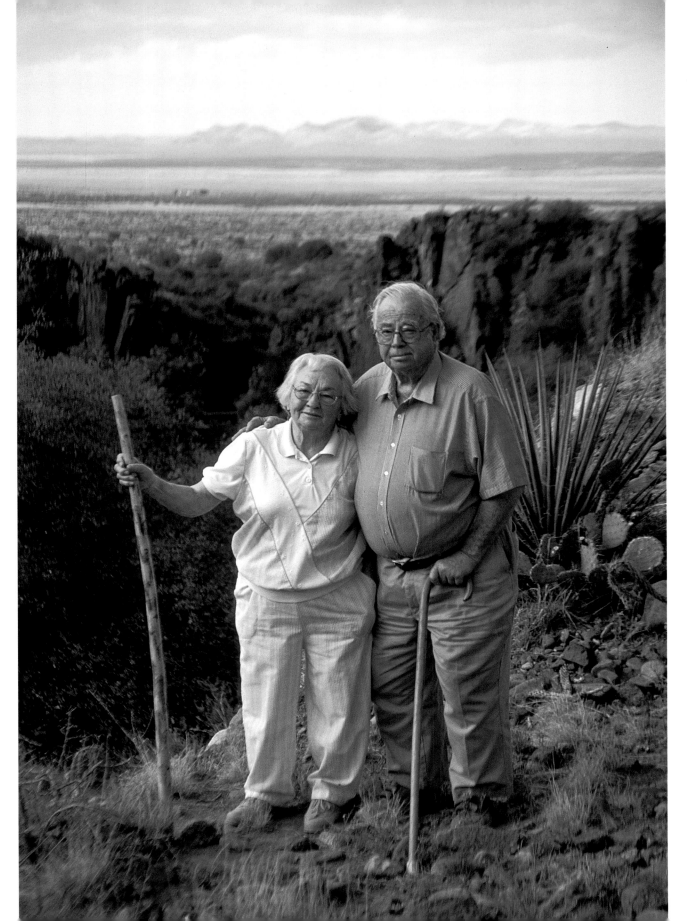

Jody and Clay Miller on their ranch outside Valentine.

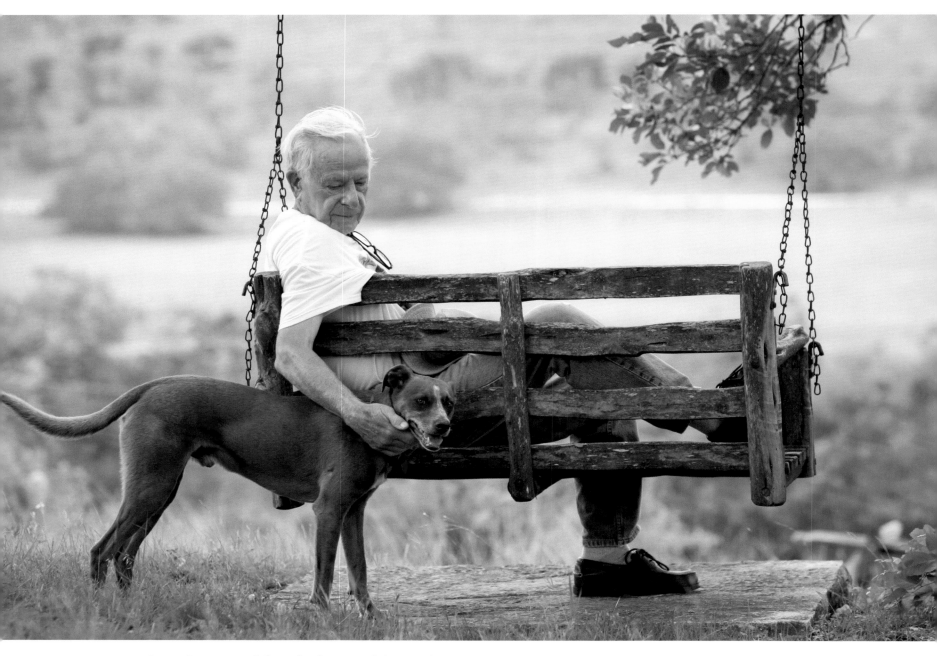

David Bamberger and friend relax at Selah, Bamberger Ranch Preserve, Blanco County.

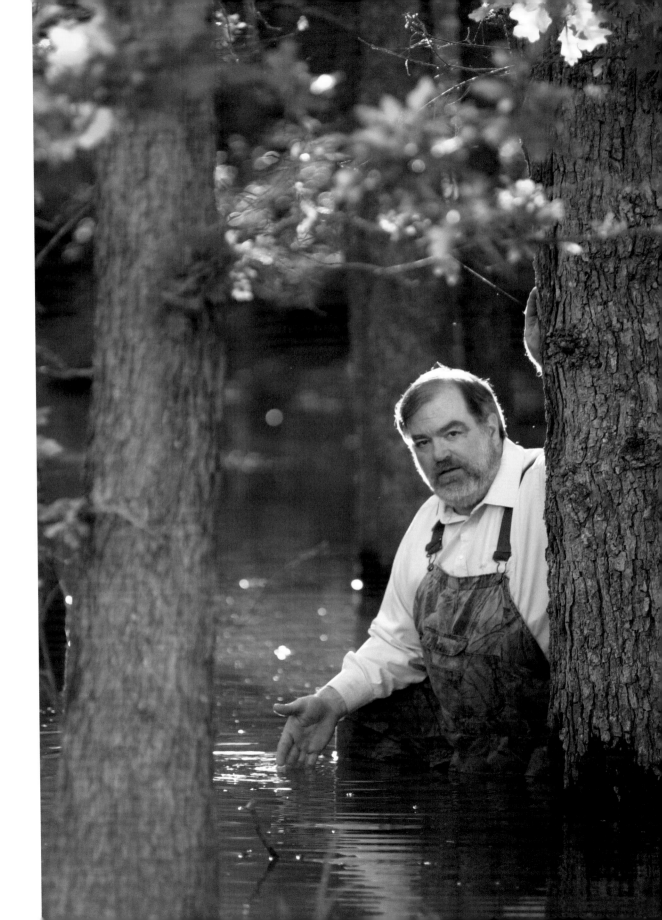

Robert McFarlane in flooded
bottomlands of BigWoods
on the Trinity near Tennessee
Colony.

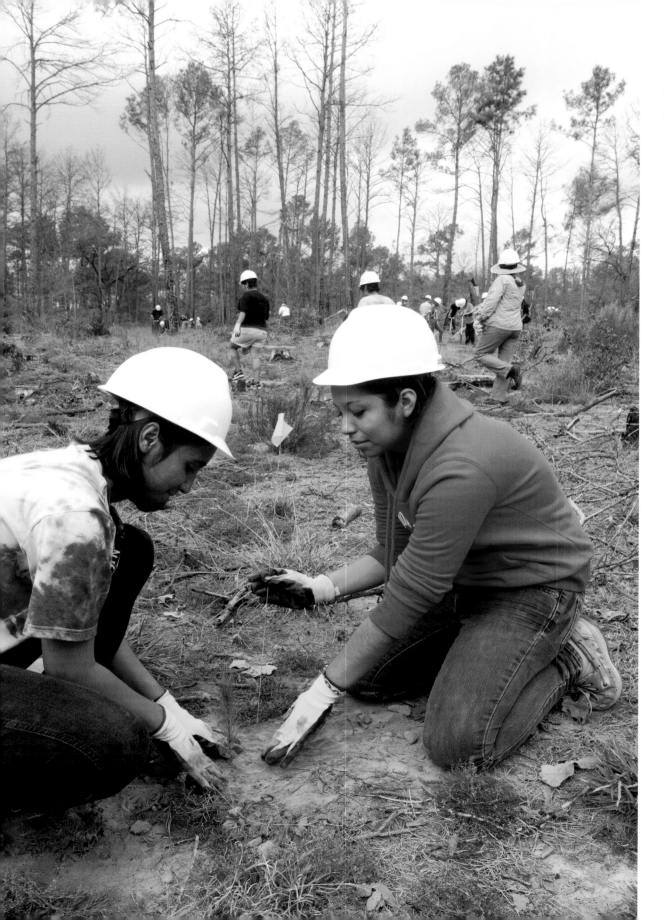

Student volunteers plant new pine seedlings in the aftermath of Bastrop State Park wildfires.

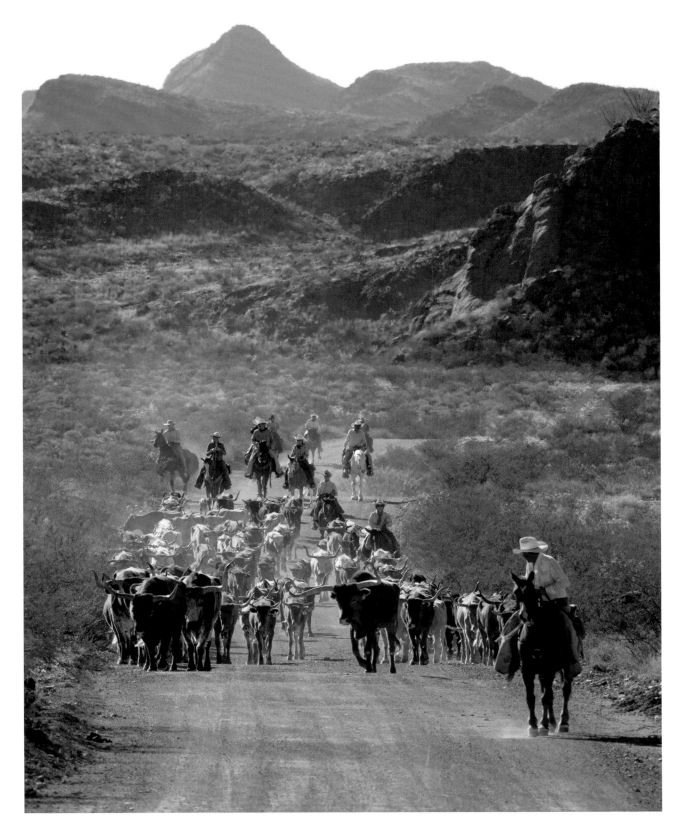

Cattle drive at Big Bend Ranch State Park.

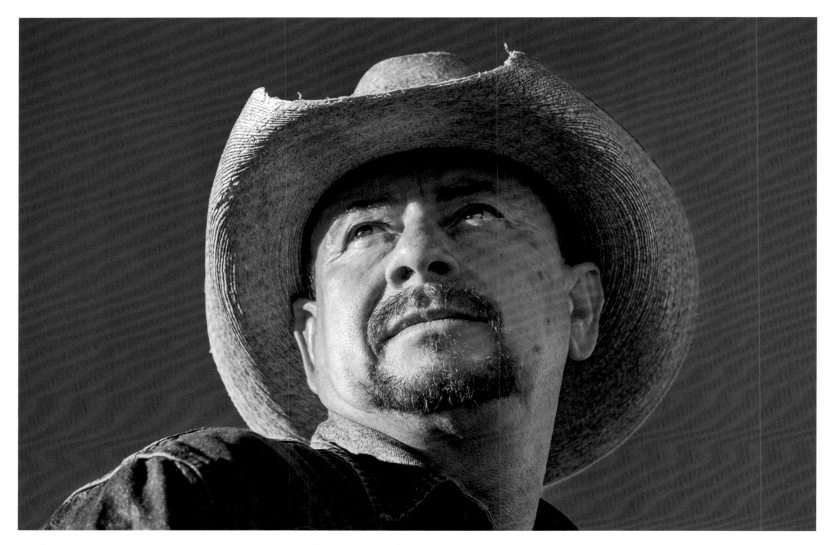

Raul Martinez, cowboy extraordinaire, at Big Bend Ranch State Park.

Doug Baum leads a camel trek through the rugged terrain of Big Bend Ranch State Park.

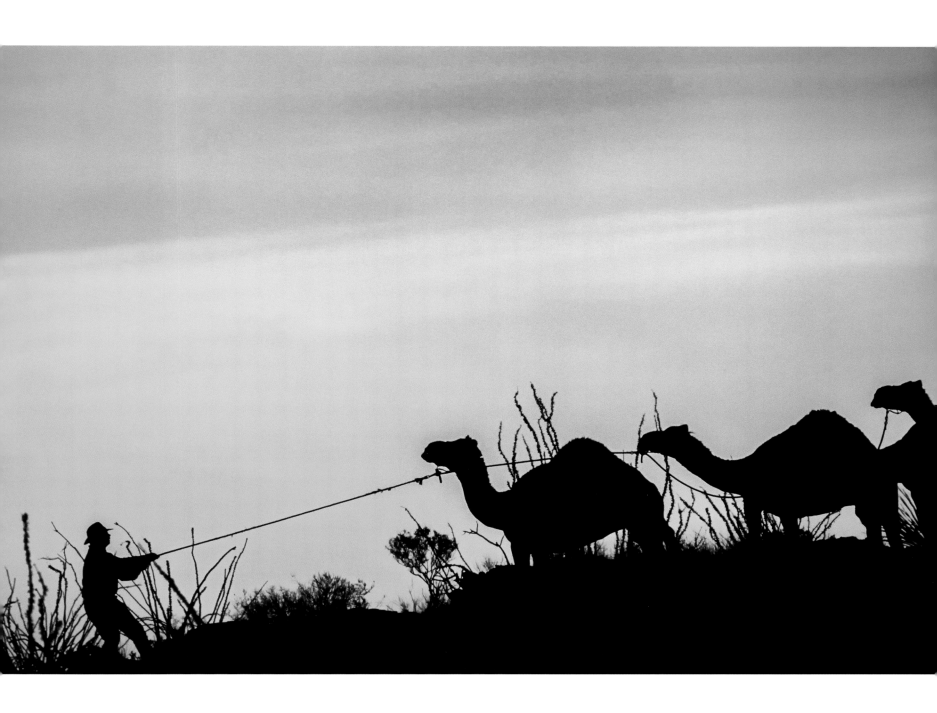

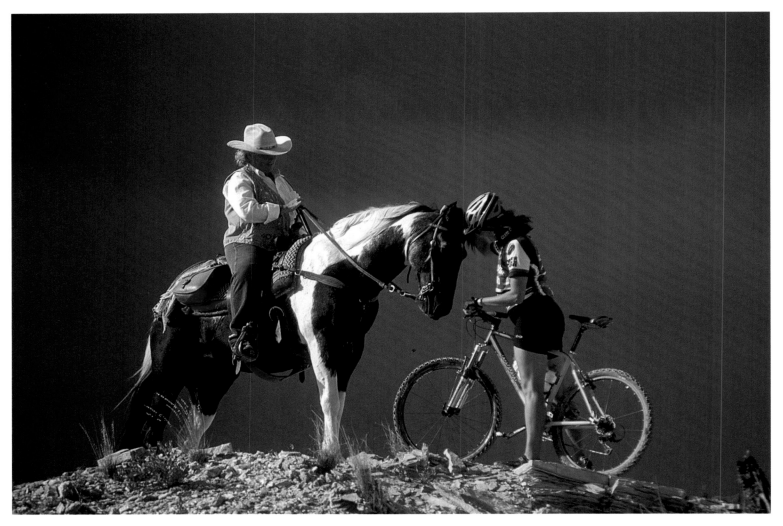

Equestrian and cyclist share the trail, Big Bend Ranch State Park.

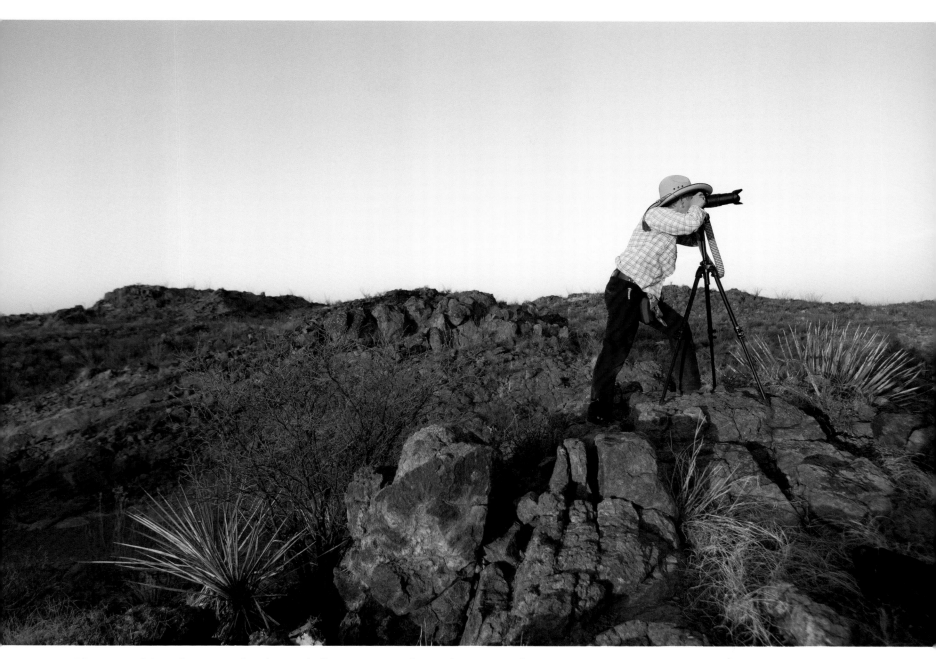

Photographing the rugged volcanic hills at Big Bend Ranch State Park.

Kayaker on Beaver Pond paddling trail below Lake Lewisville.

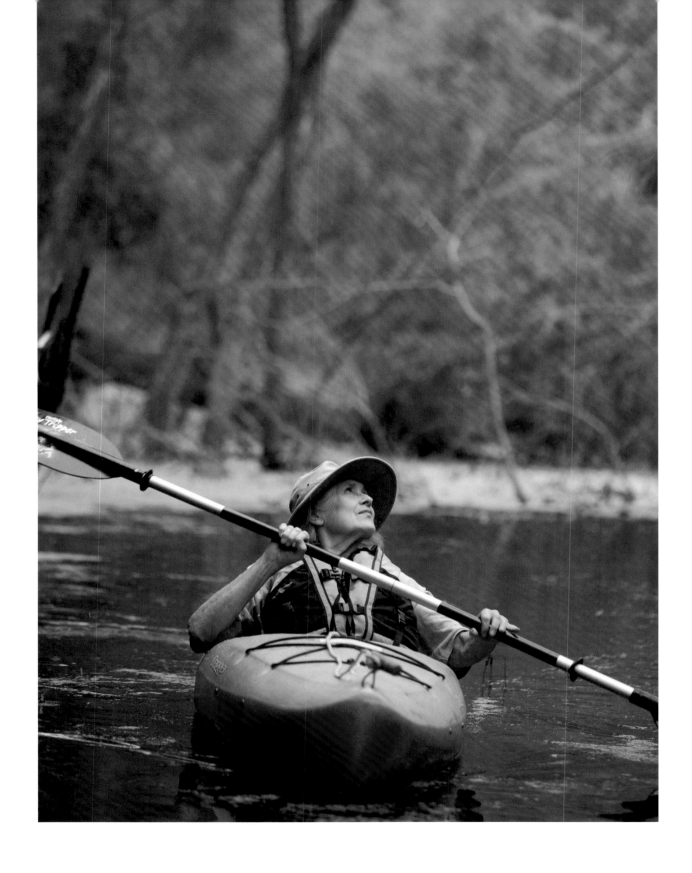

Coastal Fisheries biologist Bill Balboa samples fish from Matagorda Bay.

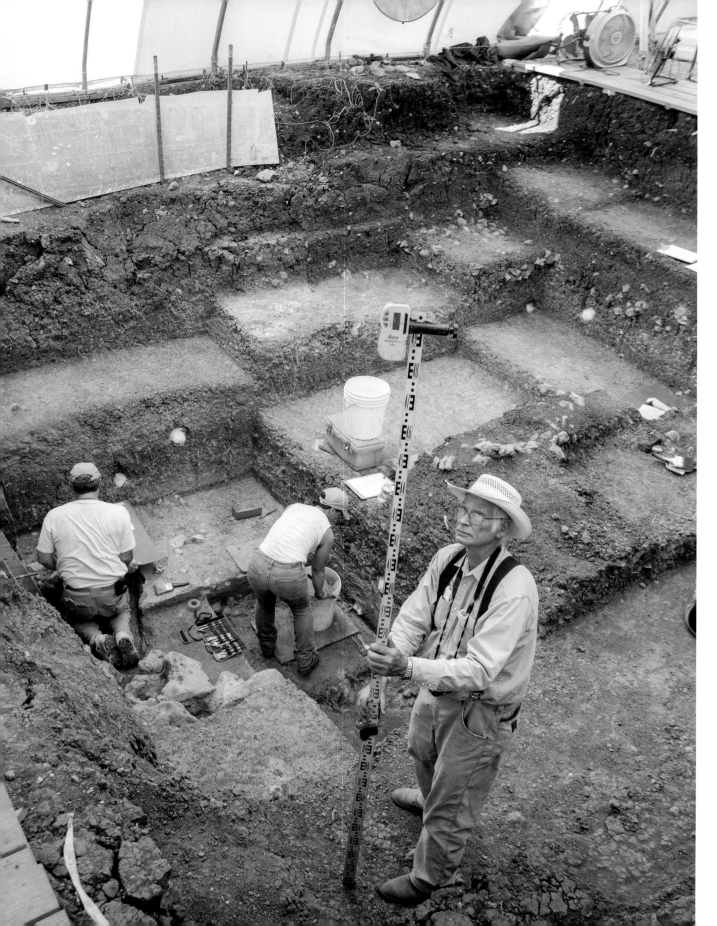

Archaeologist Michael Collins directs a team of researchers at the Gault site in Bell County.

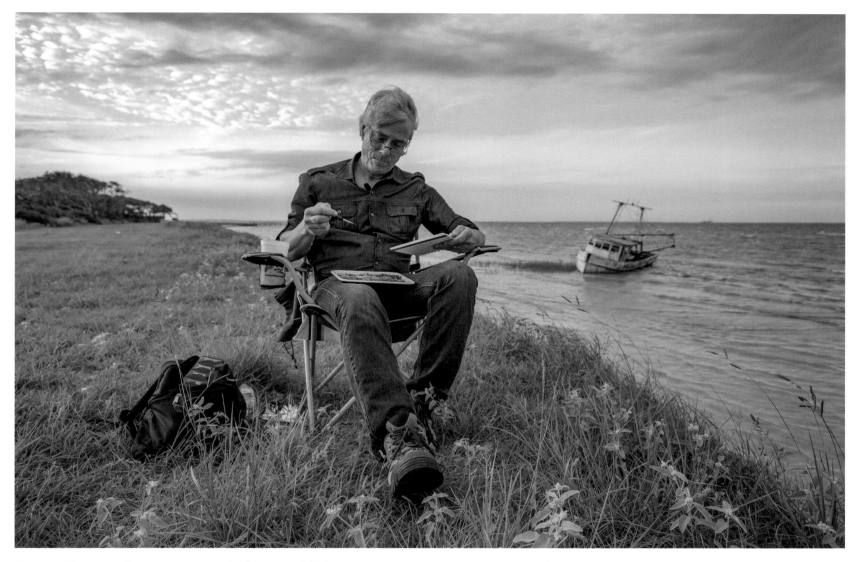

Artist Billy Hassell paints at Powderhorn Wildlife Management Area on Matagorda Bay.

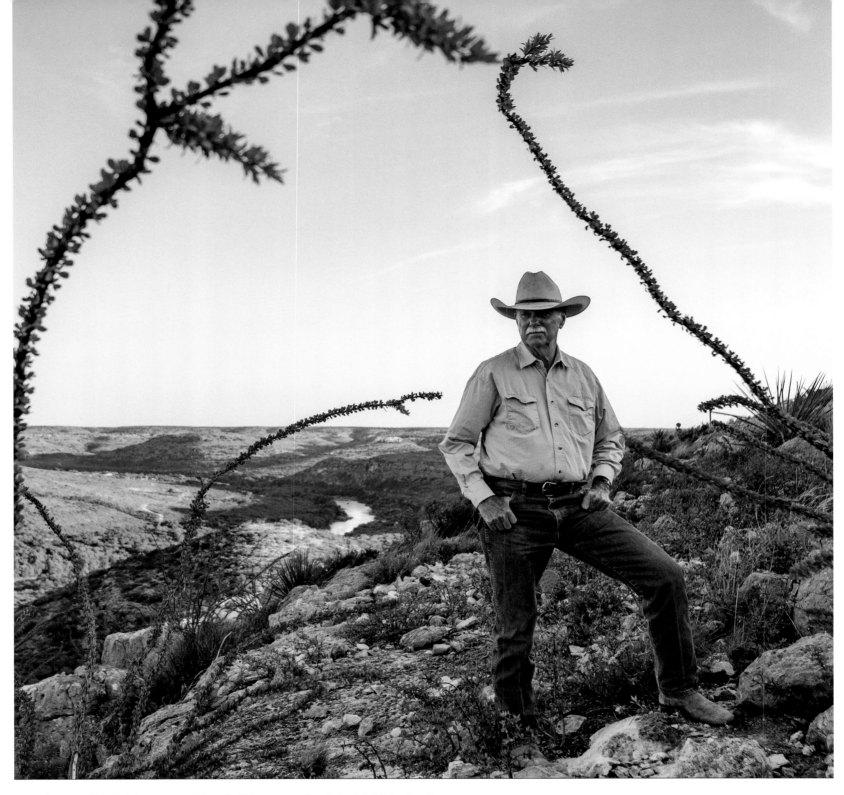

Rancher Dell Dickinson on Devils River overlook in Val Verde County.

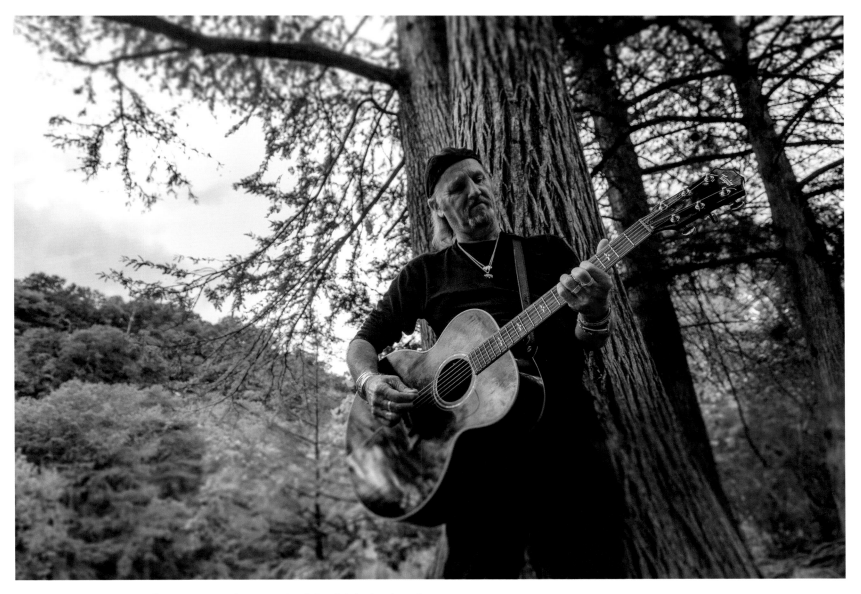

Jimmy LaFave sings about Texas rivers at Red Bud Isle in Austin.

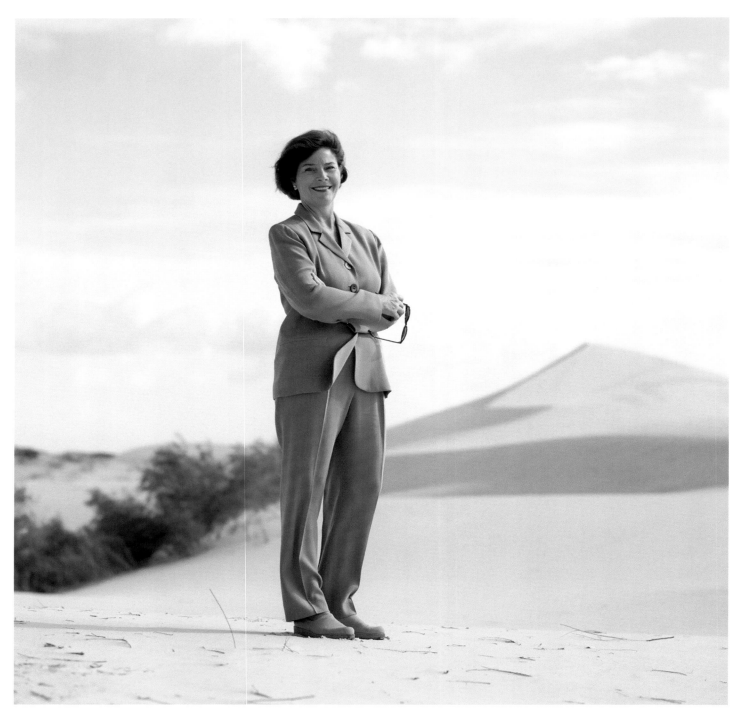

Laura Bush, former first lady of Texas and the United States, at Monahans Sandhills State Park.

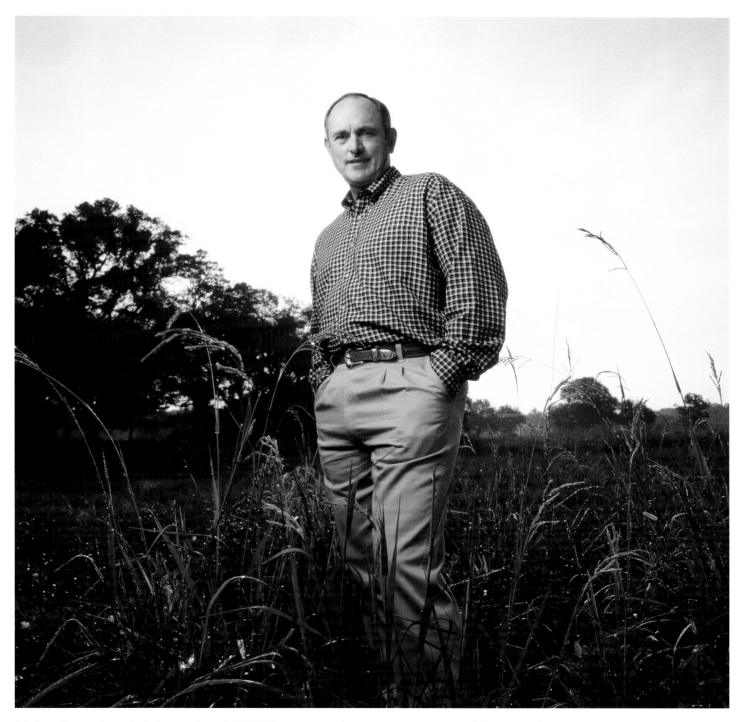

Nolan Ryan, baseball legend and TPWD commissioner, at Brazos Bend State Park.

River ranger Marcos Paredes at Santa Elena Canyon in Big Bend National Park.

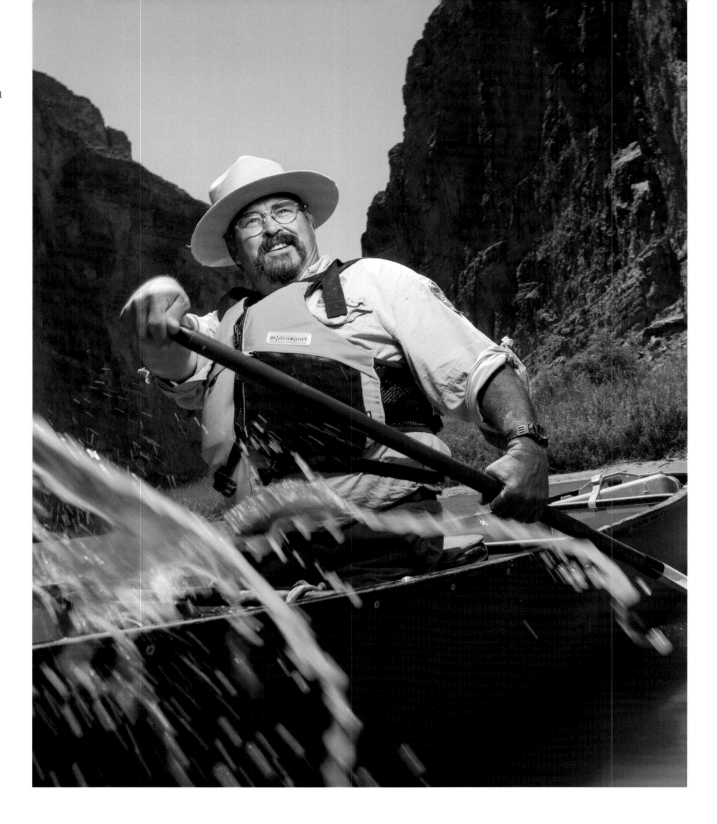

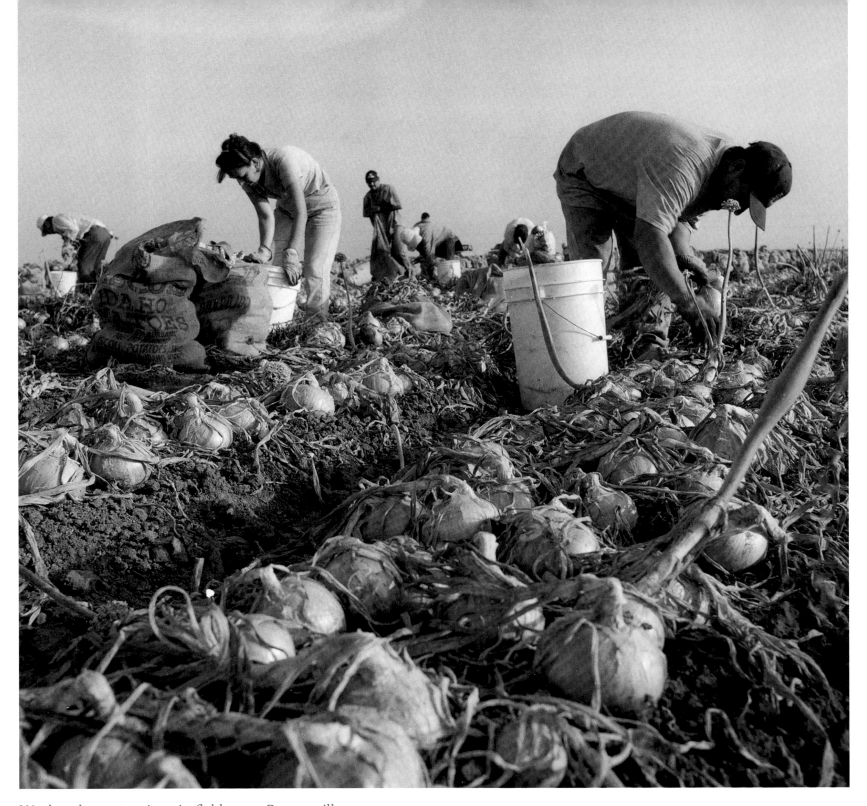

Workers harvest onions in fields near Brownsville.

Country singer and
local resident Johnny
Rodriguez entertains at
Garner State Park.

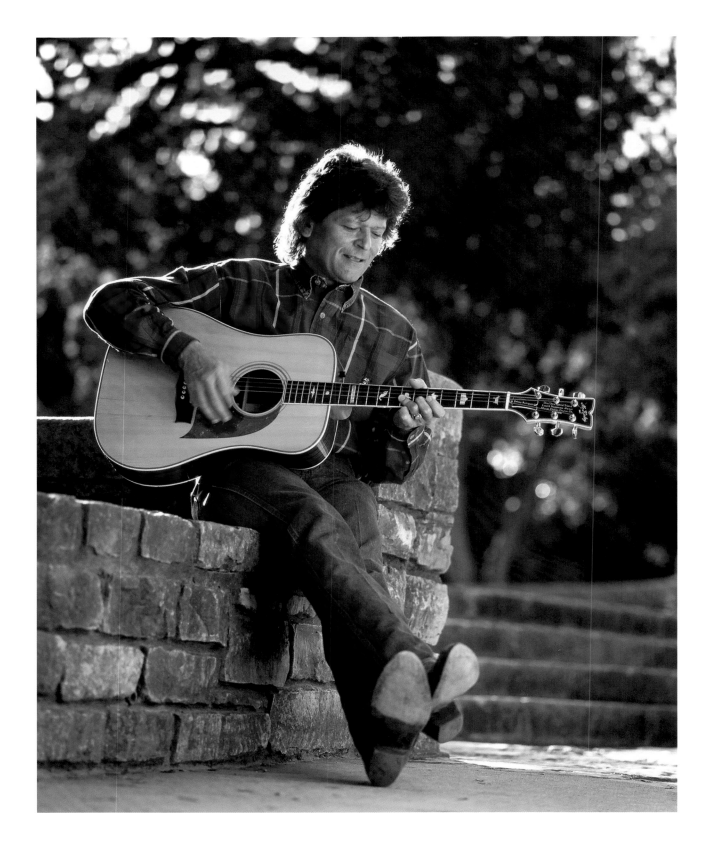

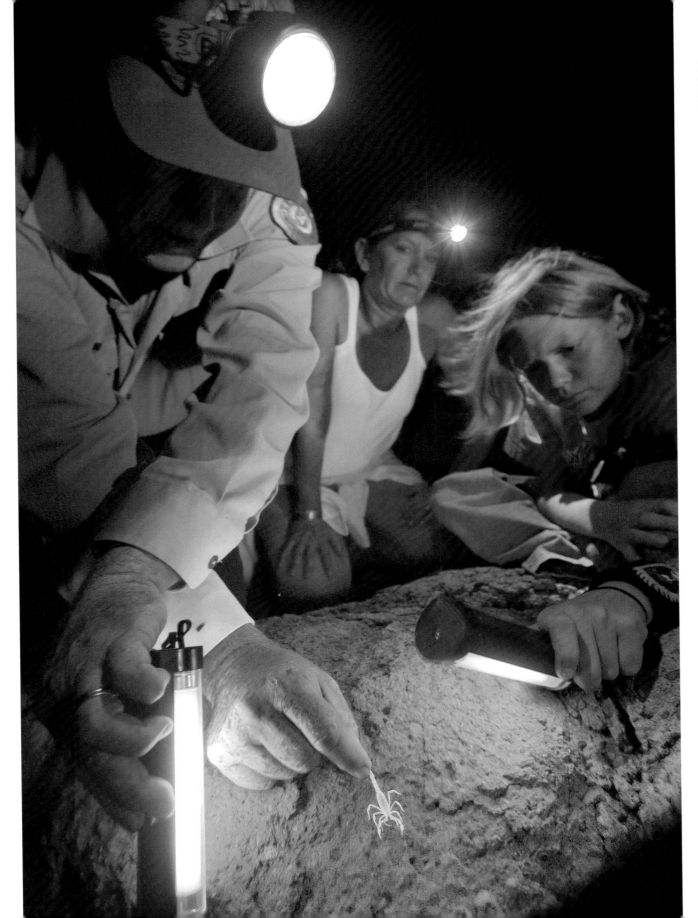

Scorpion hunting with
UV light, Big Bend
Ranch State Park.

Michael "Shorty" Powers conceived and developed Turning POINT (Paraplegics on Independent Nature Trips), which provided hunting and other outdoor activities for wheelchair-bound young people.

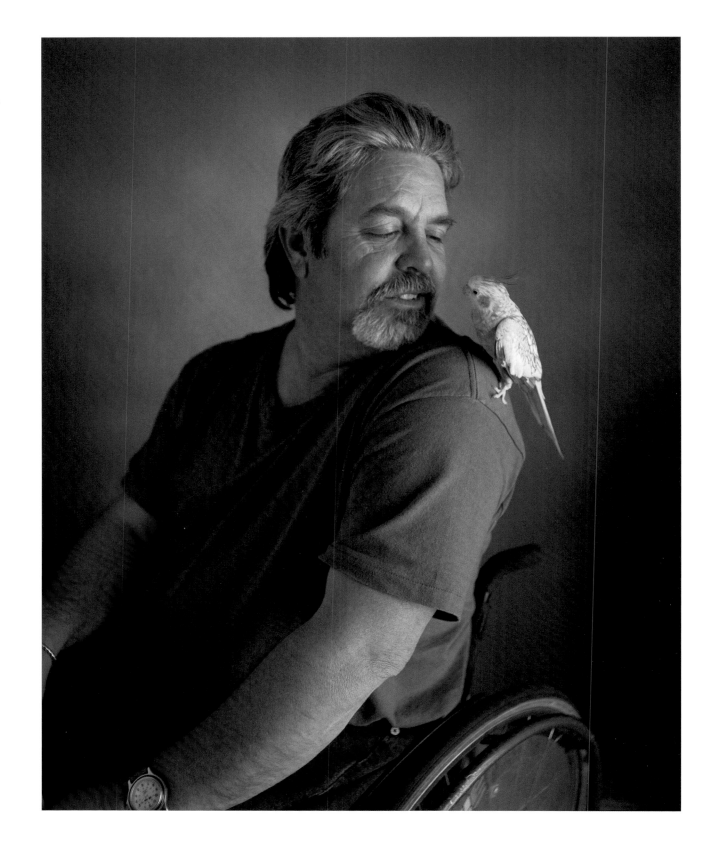

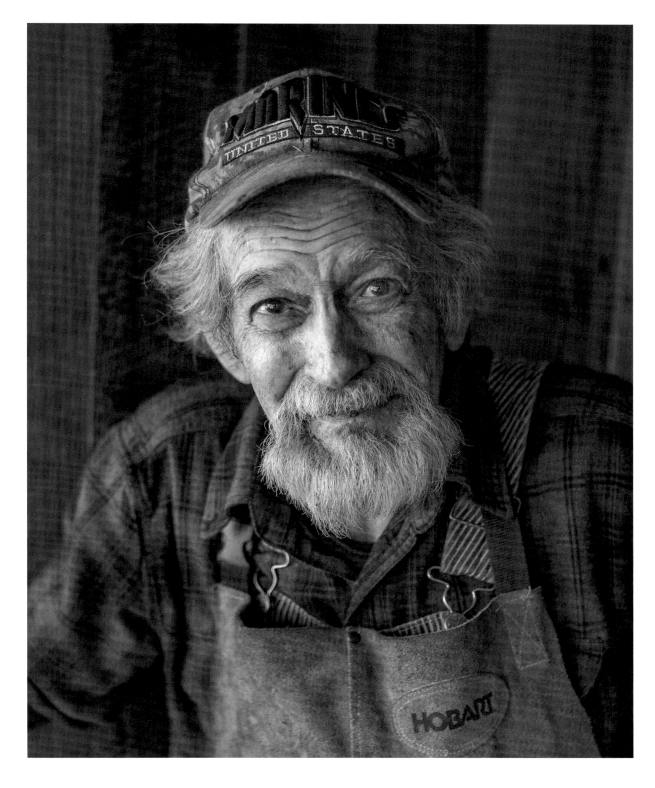

Dan Harrison, knifemaker,
Ben Wheeler in Van Zandt
County.

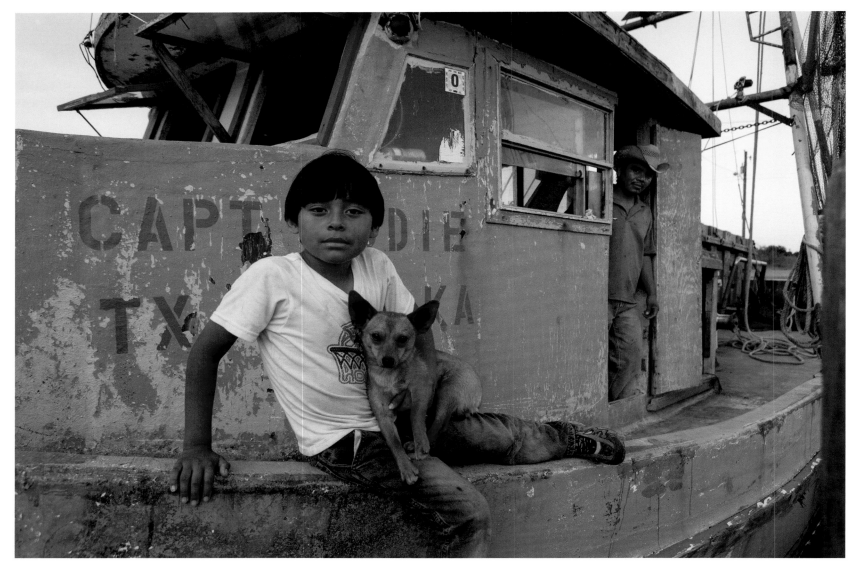

Shrimping family on their boat at Port Lavaca.

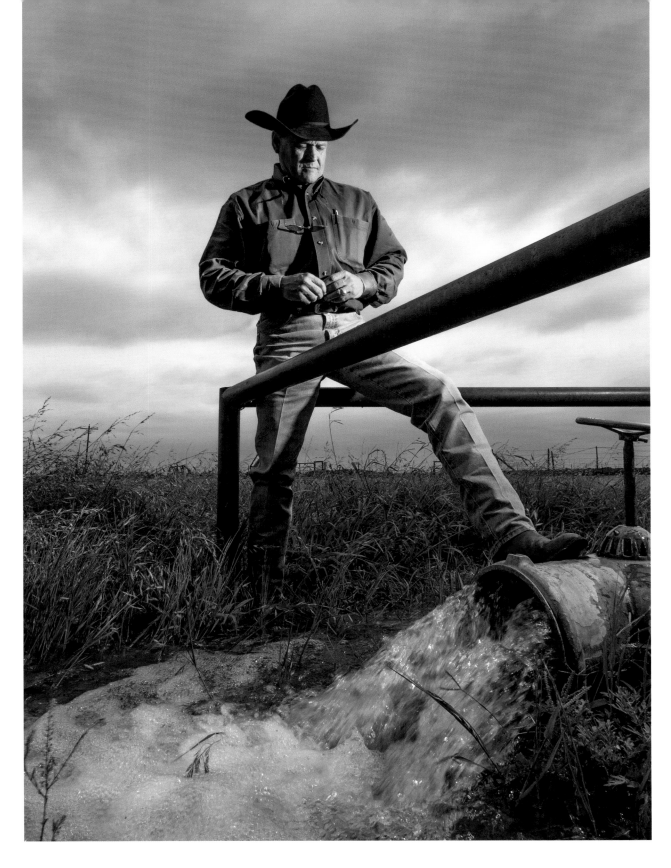

Rancher Zack Davis inspects artesian well used for irrigation, Kinney County.

Oceanographer Tony Amos
on beach at Port Aransas.

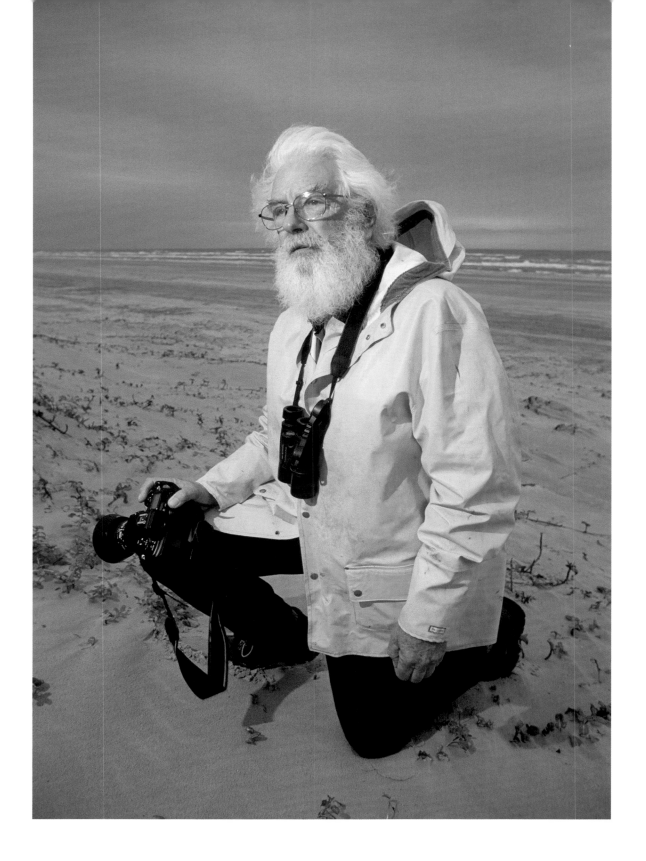

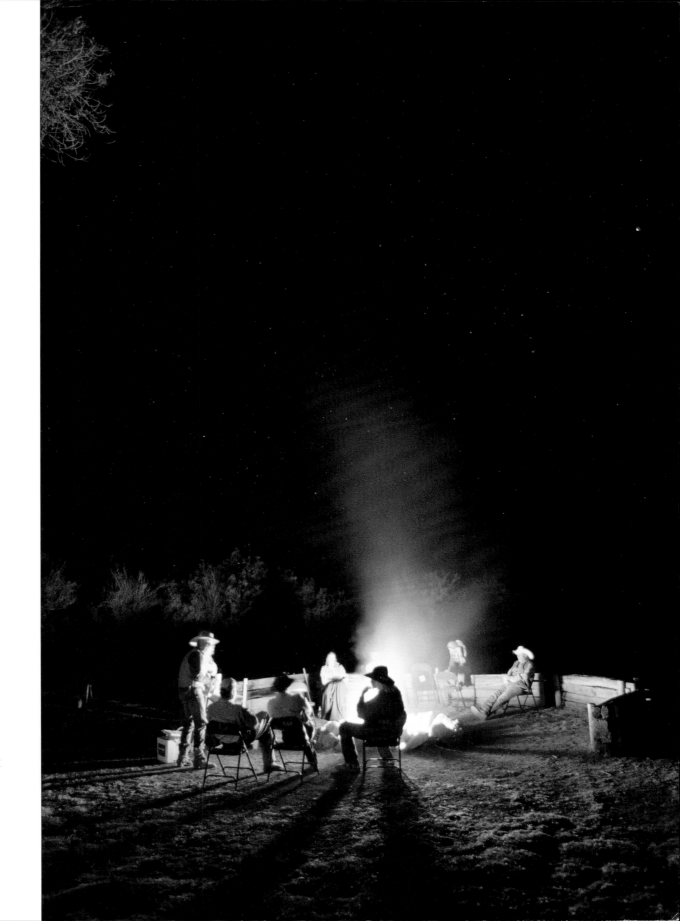

Campfire under the stars at
Big Bend Ranch State Park.

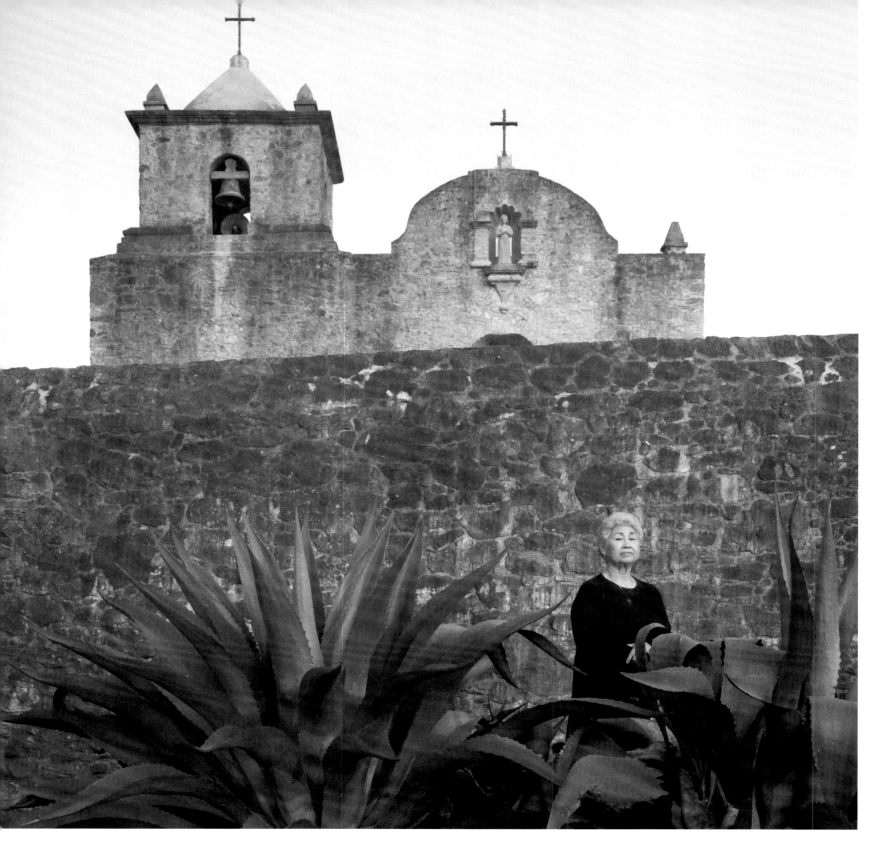

Lifelong resident Estella Zermeno at Presidio La Bahía, Goliad.

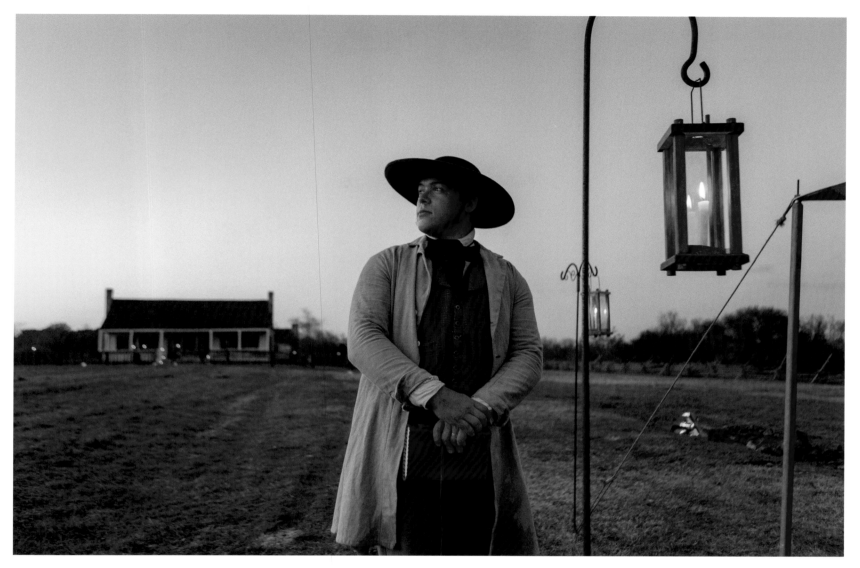

A park interpreter serves as "The Preacher" during Christmas activities at
Barrington House, Washington on the Brazos State Historic Site.

Young interpretive volunteer and pet rooster at Barrington Farm, Washington on the Brazos State Historic Site.

Rosileetta Reed portrays William Cathey, aka Cathey Williams, the only documented female Buffalo Soldier.

TPWD employee Selton Williams volunteers as a Buffalo Soldier.

Young reenactors of the Republic of Texas period at San Jacinto Monument.

A reenactment of the World War II attack on Mount Suribachi, recreated by the National Museum of the Pacific War, Fredericksburg.

Military veterans ride in a parade in Kerrville that commemorates the sixtieth anniversary of the attack on Pearl Harbor.

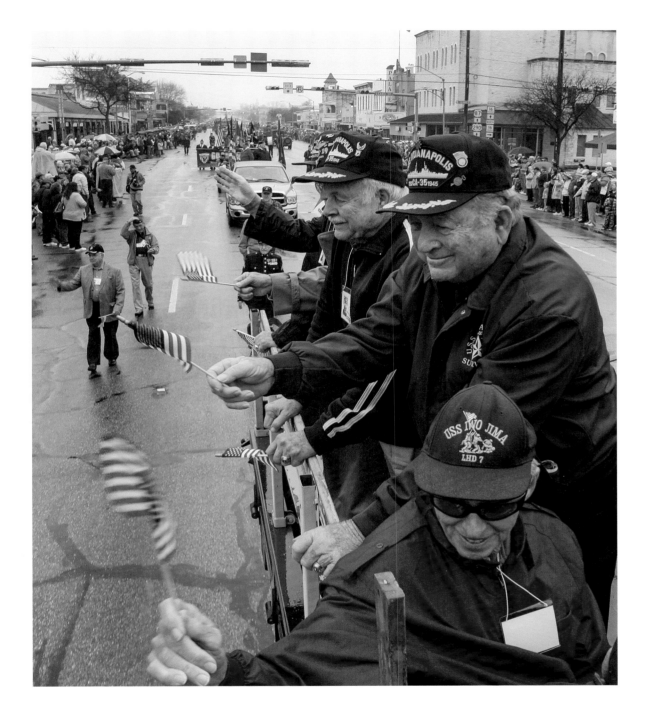

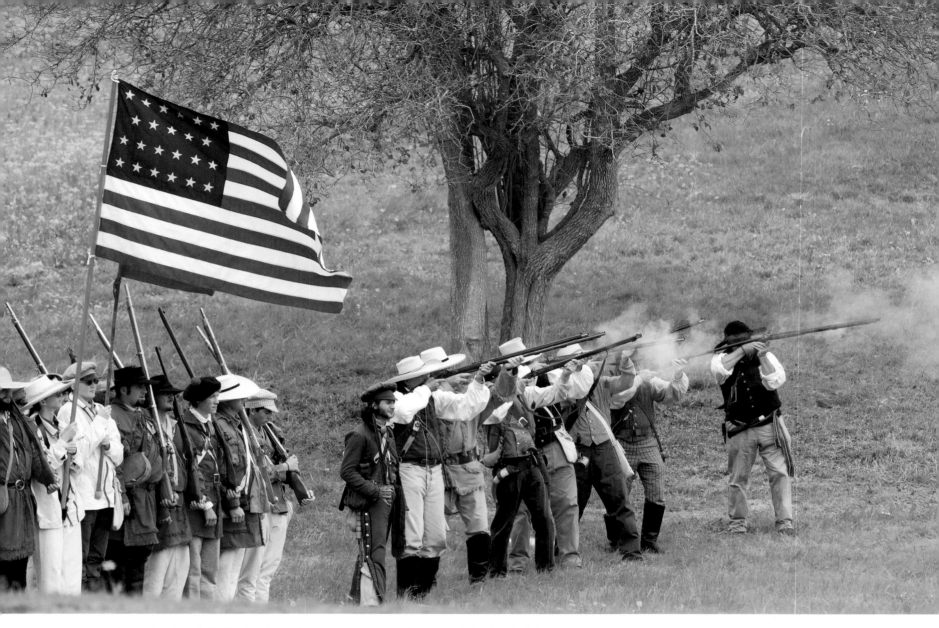

The Battle of Goliad skirmishes are reenacted at Presidio La Bahía.

Blacksmithing demonstration at Sauer Beckmann Living History Farm, LBJ State Park.

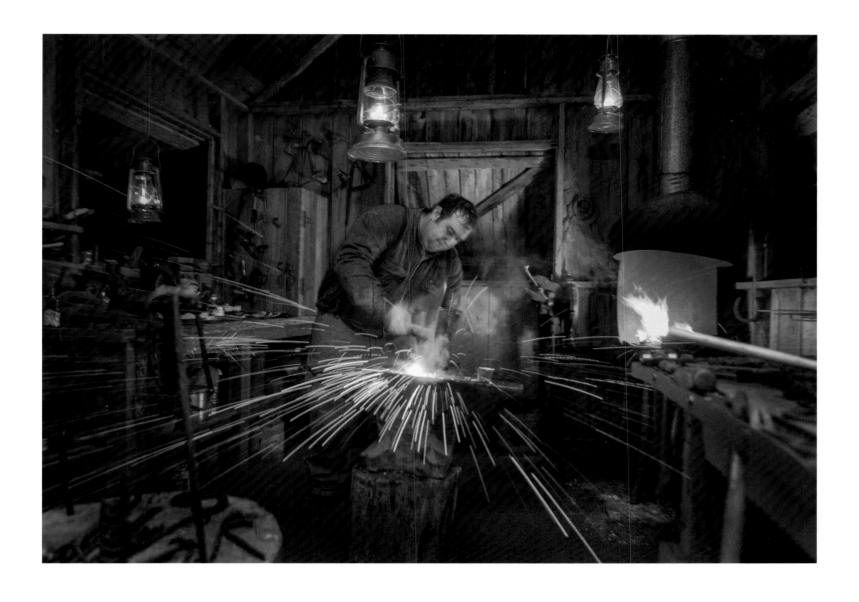

Nature tour leader and conservationist Victor Emanuel, Austin.

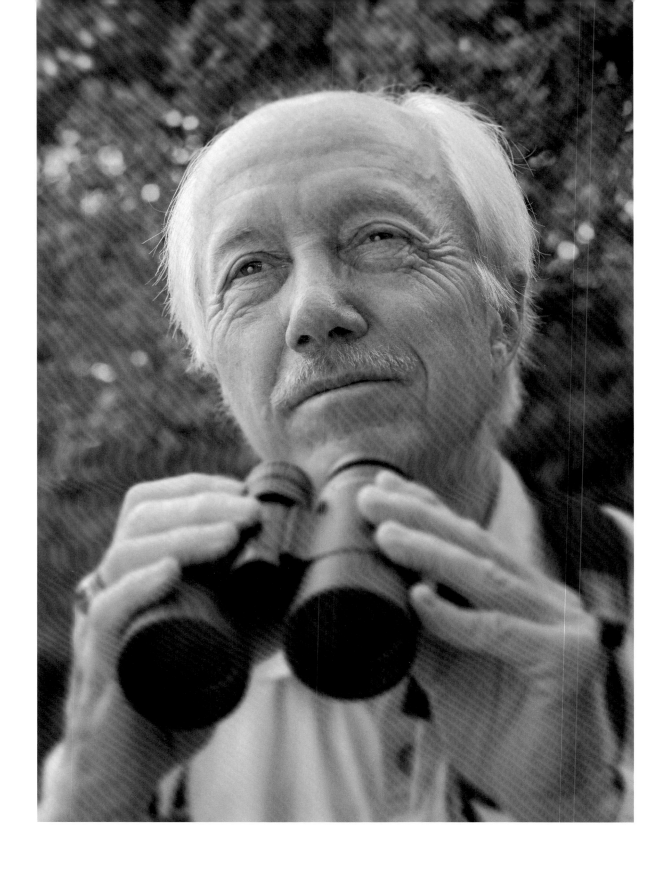

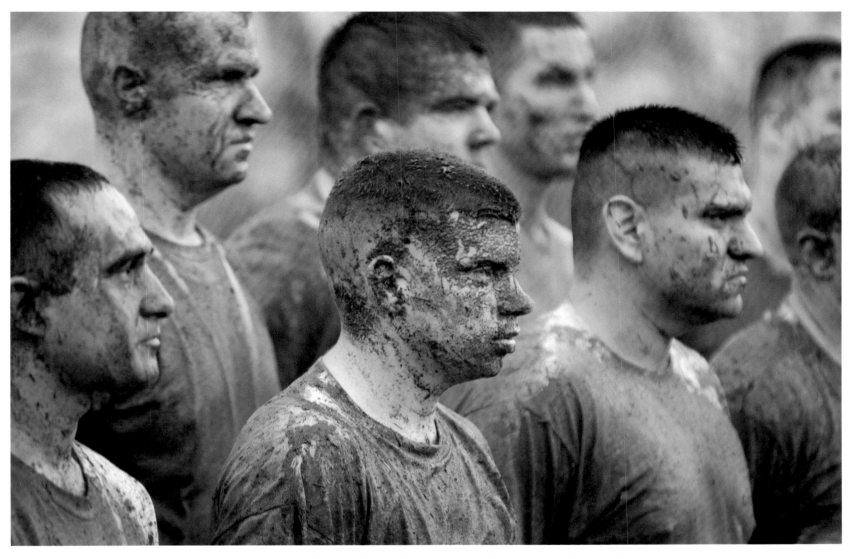

Game warden cadets experience "Mud Day" during physical training at the academy in Austin.

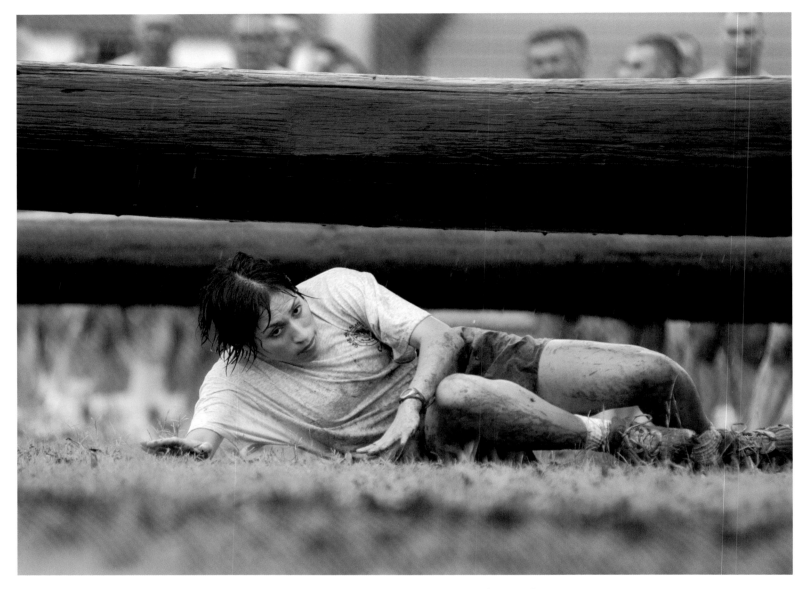

Female game warden cadets train alongside their male counterparts at the academy.

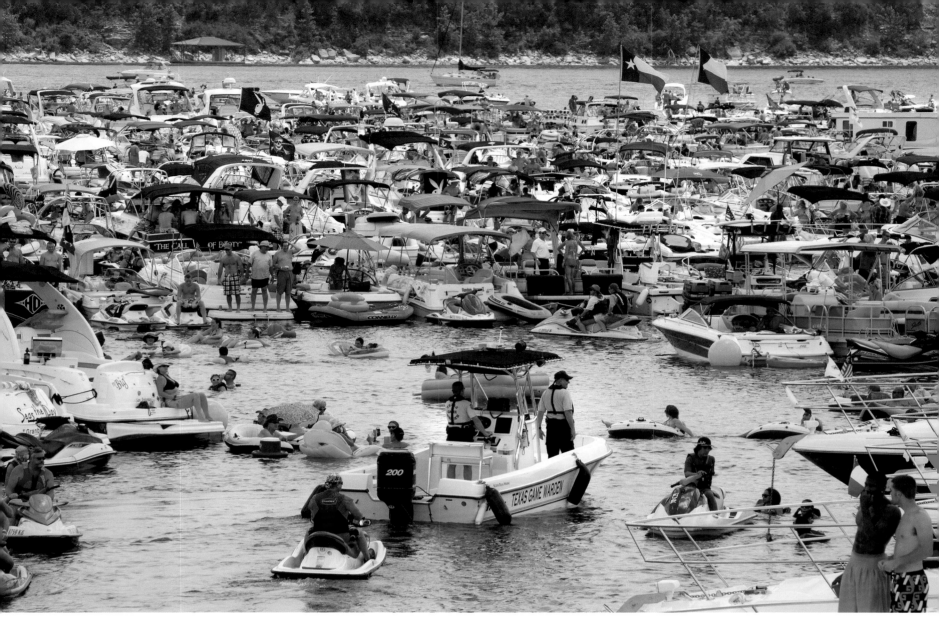

Game wardens patrol during Aquapalooza events on Lake Travis.

Game warden Colonel
Jim Stinebaugh.

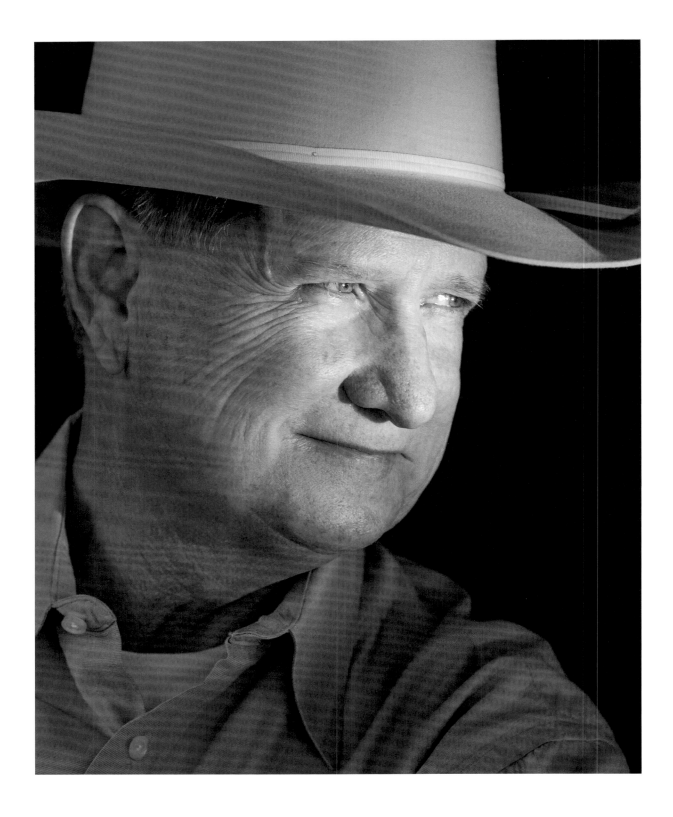

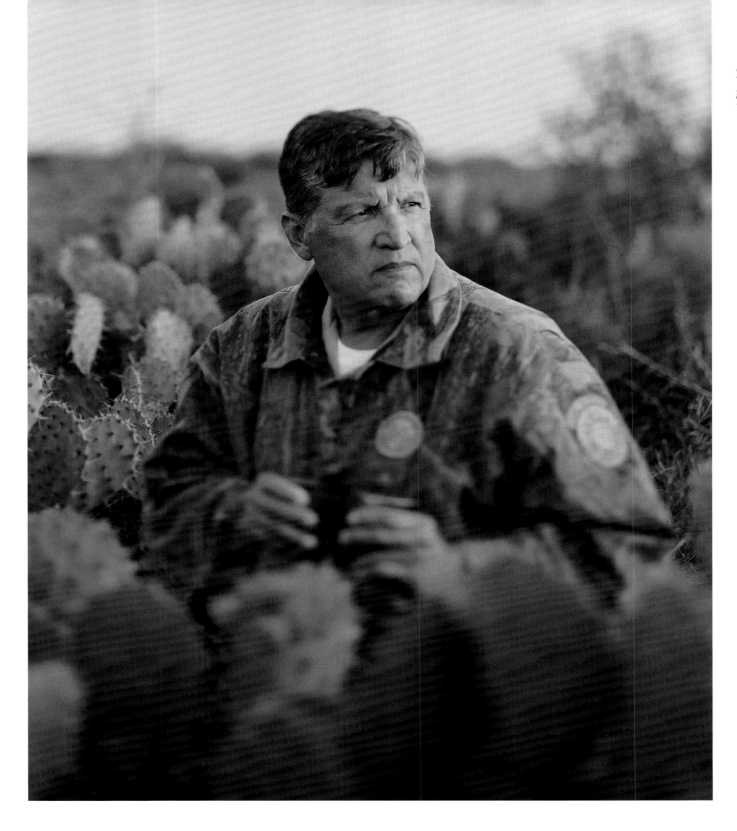

South Texas
game warden
Hector Garza.

Game warden
Cynthia Guajardo
in hazmat suit.

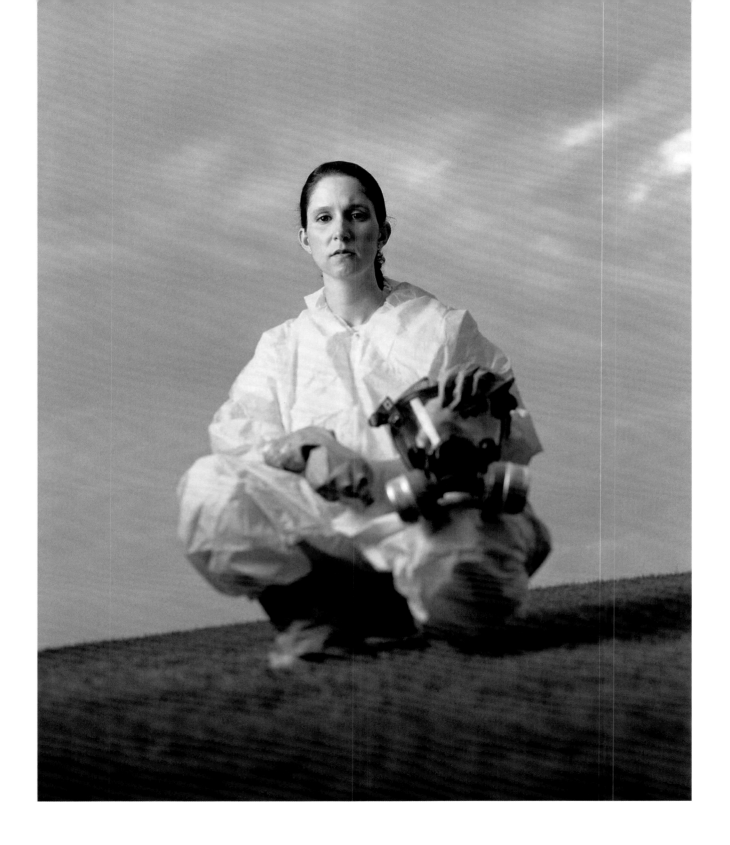

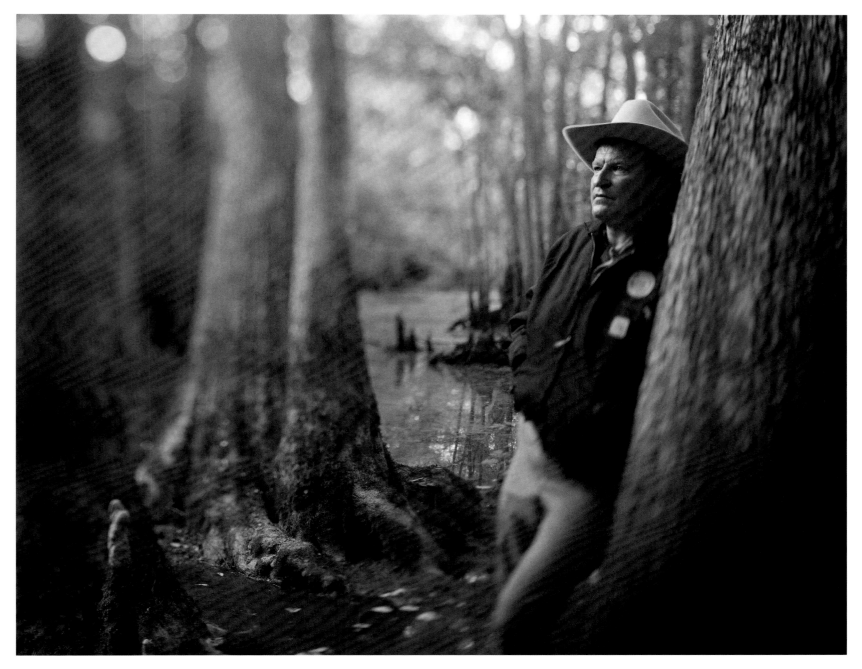

Game warden Raymond Kosub in cypress bottomlands of East Texas.

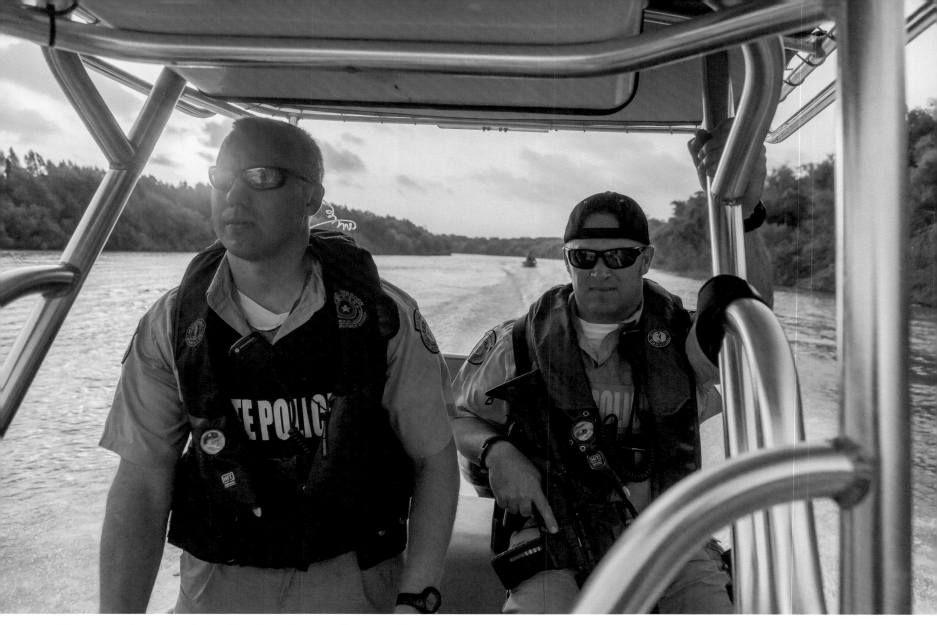

Game wardens patrol the Rio Grande near Brownsville

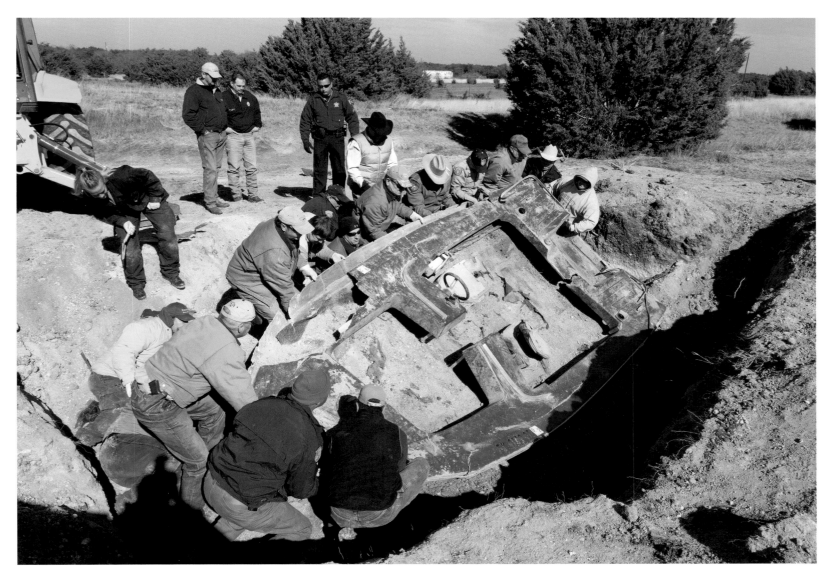

Evidence from a fatal boating incident is unearthed near Bertram.

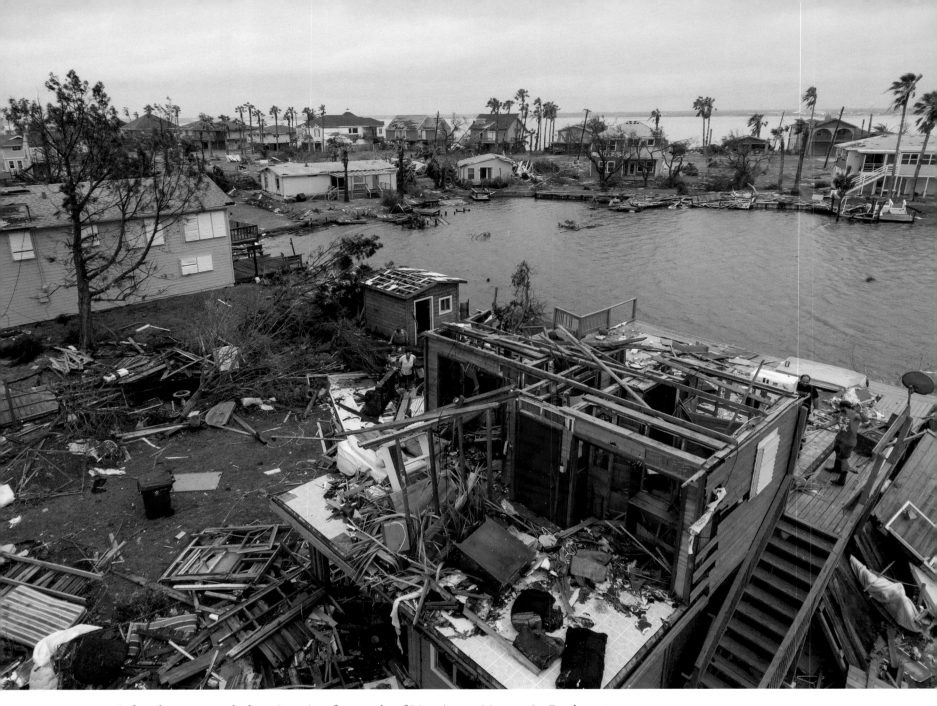

A family recovers belongings in aftermath of Hurricane Harvey in Rockport

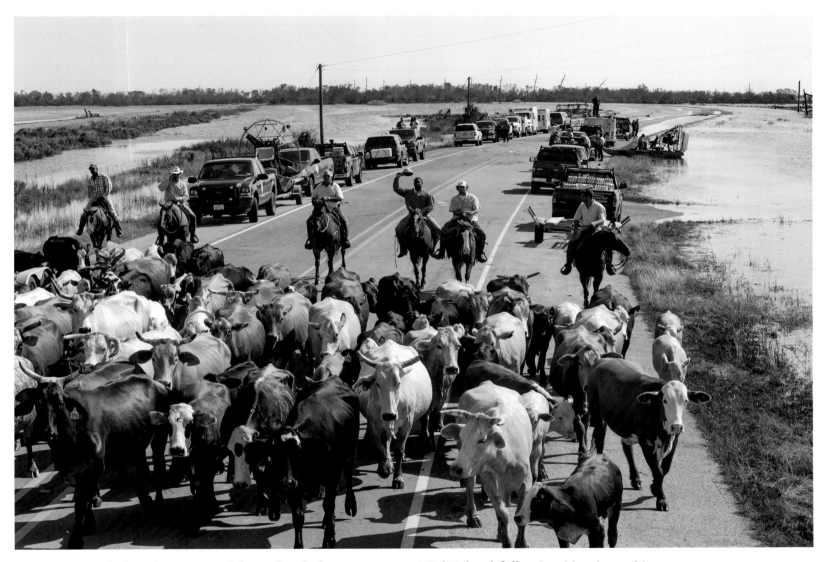

Cattle are herded to drier ground from flooded pastures near High Island following Hurricane Harvey.

TPWD game wardens are deployed in the Lower Ninth Ward of New Orleans following Hurricane Katrina.

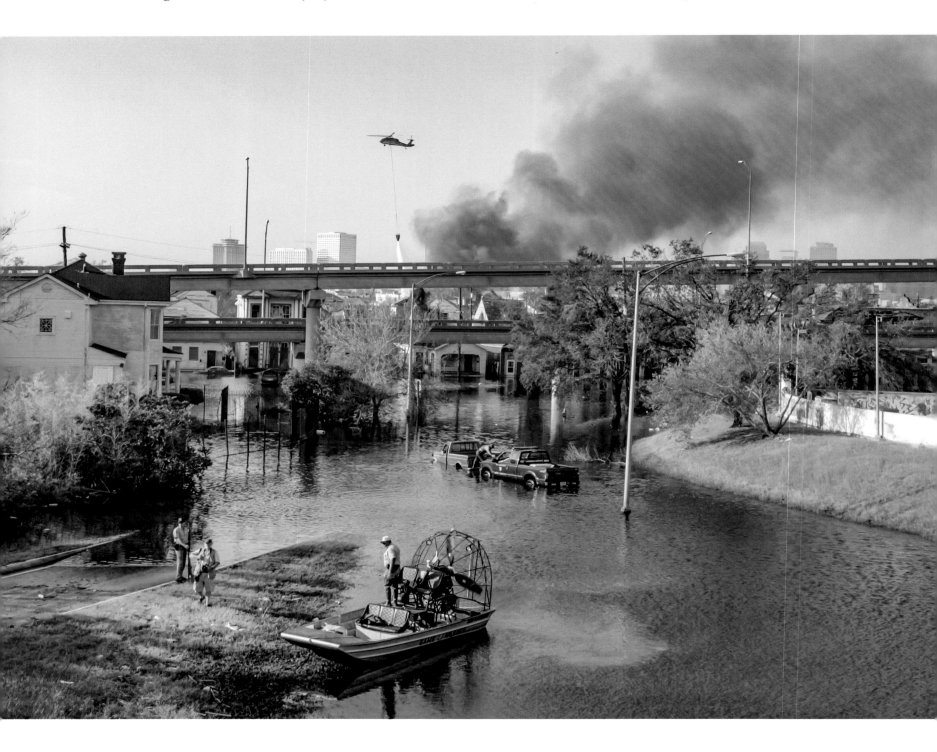

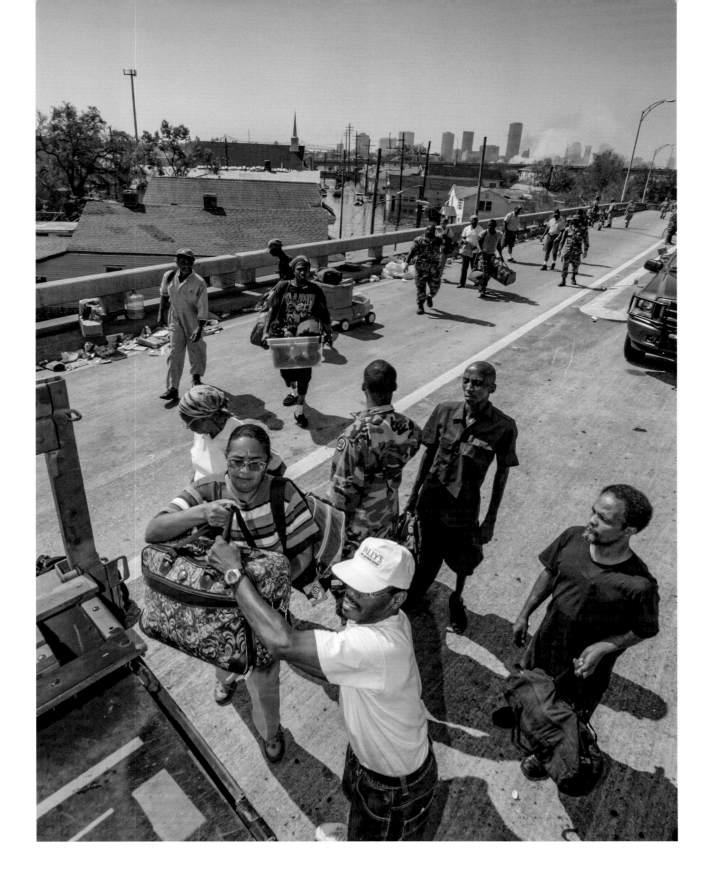

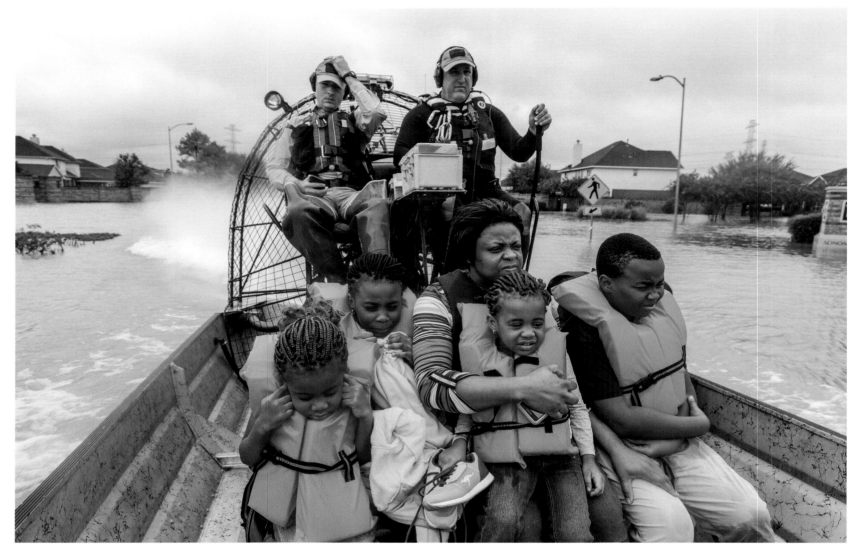

Rescued family from flooded neighborhood in Houston following Hurricane Harvey.

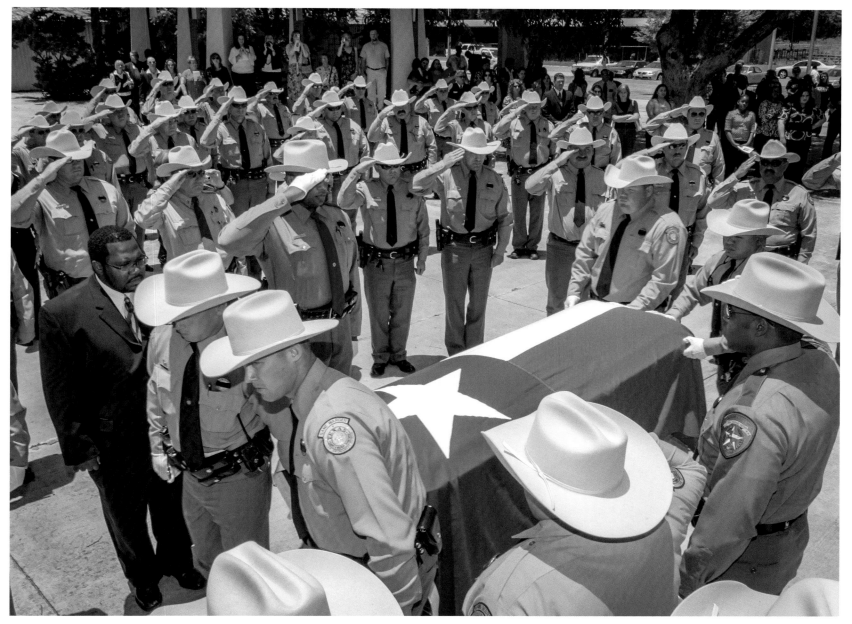

Funeral services for Texas game warden Teyran "Ty" Patterson, who drowned while attempting to recover the body of a teenage drowning victim in the Paluxy River.

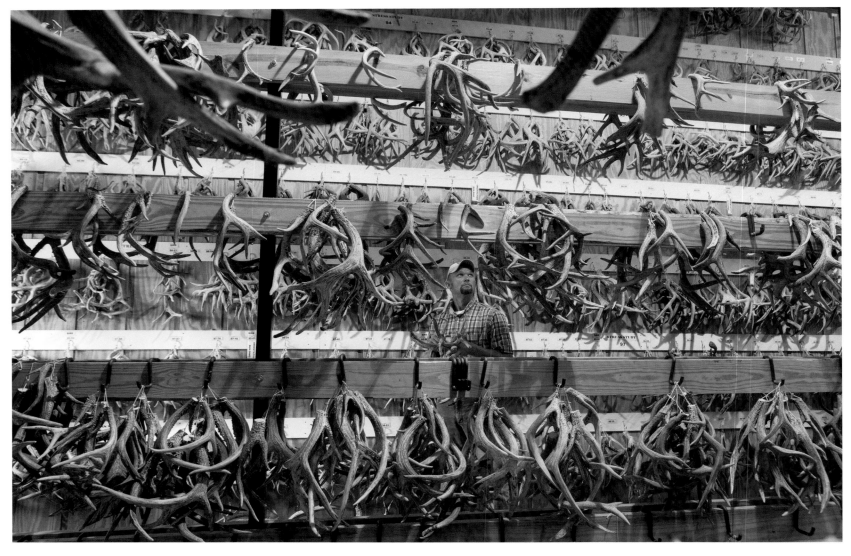

A wildlife biologist surveys antler collection, Kerr Wildlife Management Area.

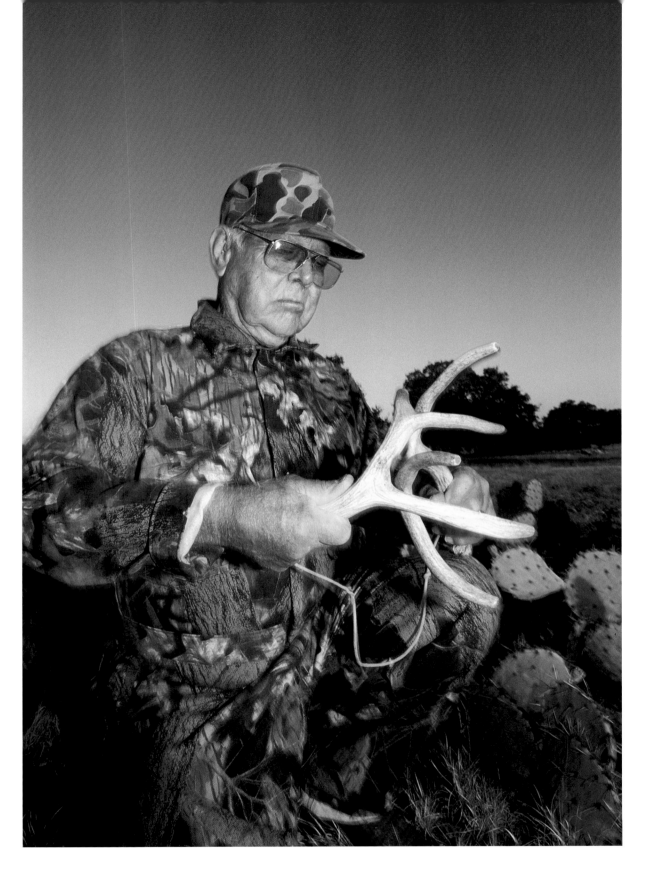

Bob Ramsey helped develop the technique of rattling antlers to attract bucks.

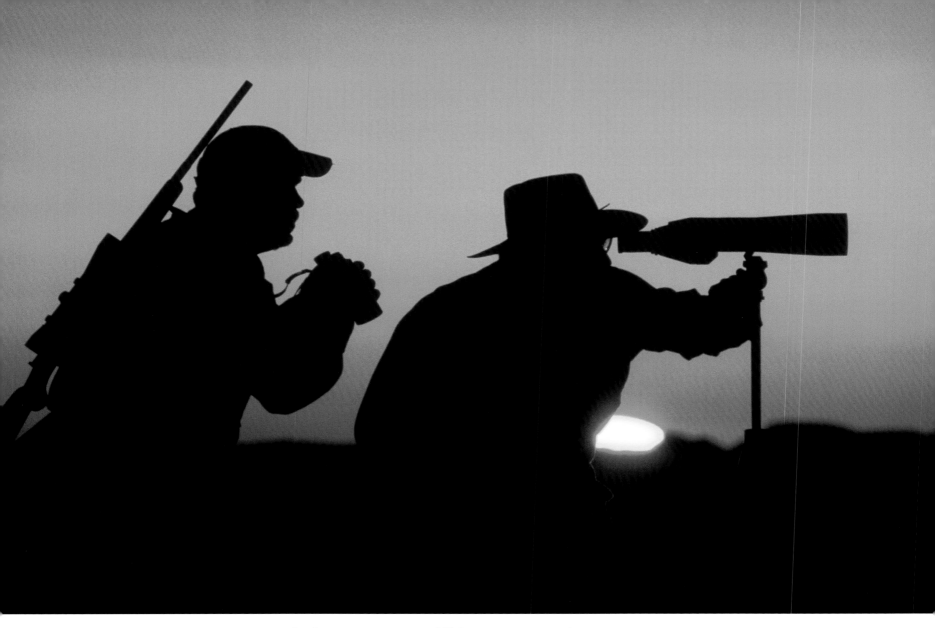

Hunters scout at sunrise, Elephant Mountain Wildlife Management Area.

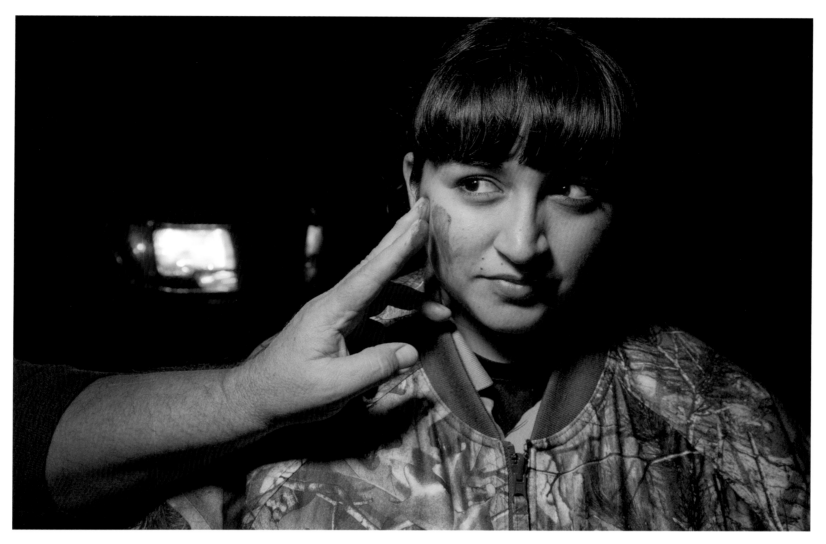
Stephanie Garcia is initiated as a hunter with a blood smear after taking her first deer.

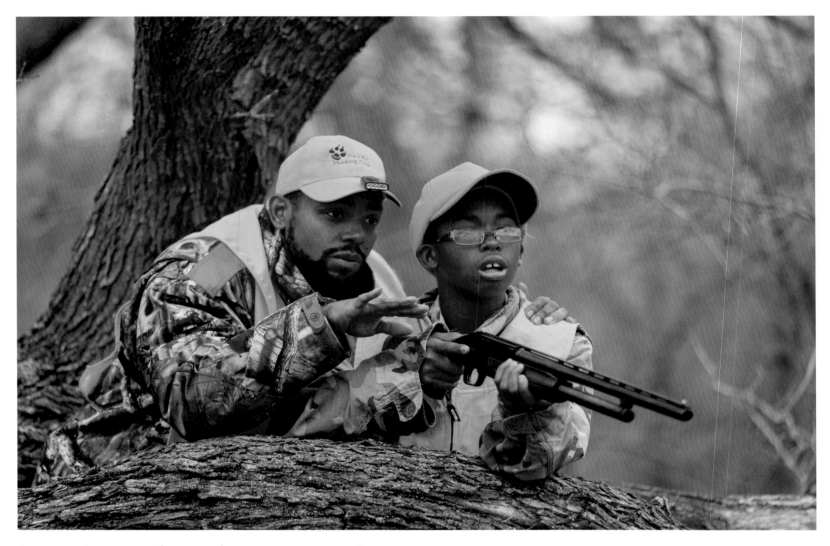

A mentor instructs a first-time hunter near Comanche.

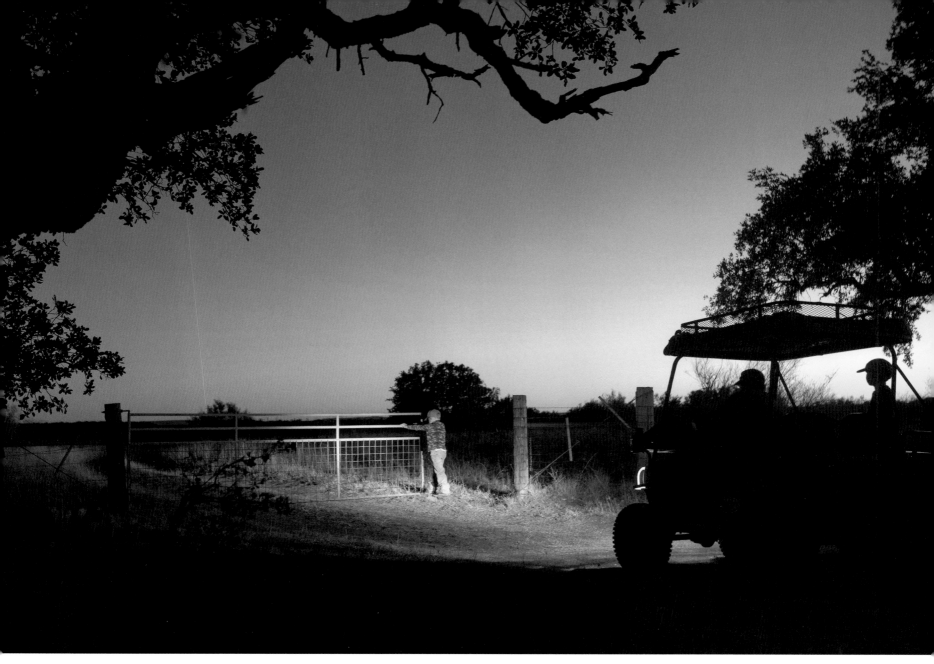

Returning to camp after a deer hunt, McCulloch County.

Falconer Manny Carrasco
with red-tailed hawk, Austin.

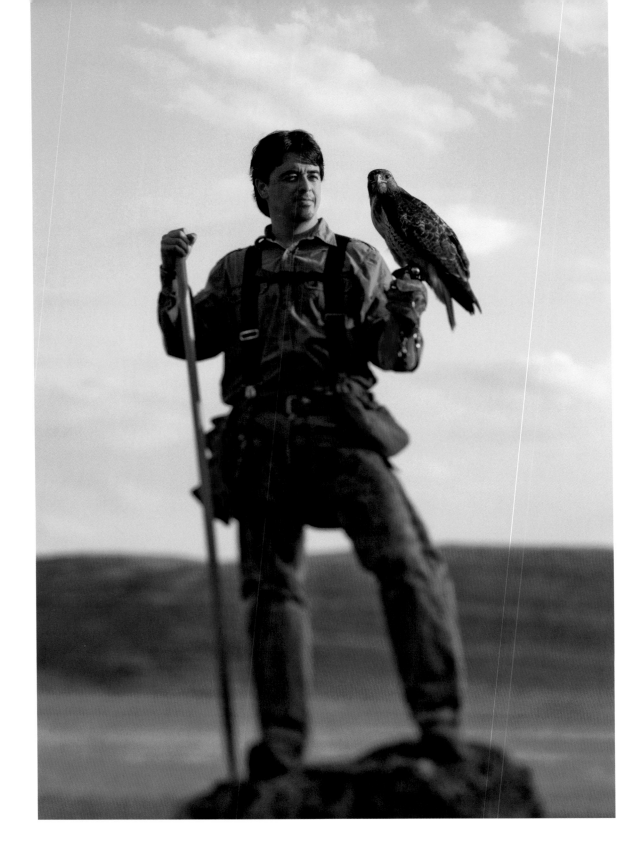

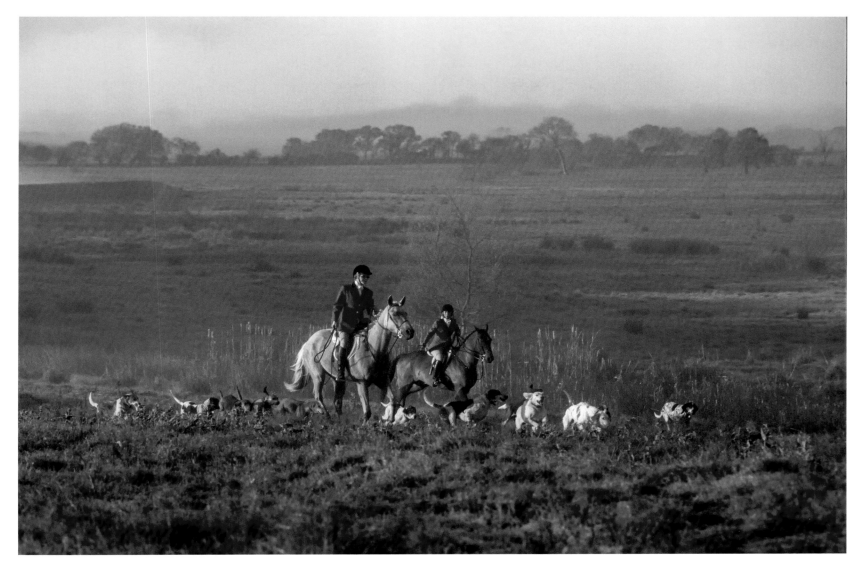

Fox hunt at Loneoak Ranch near Marquez.

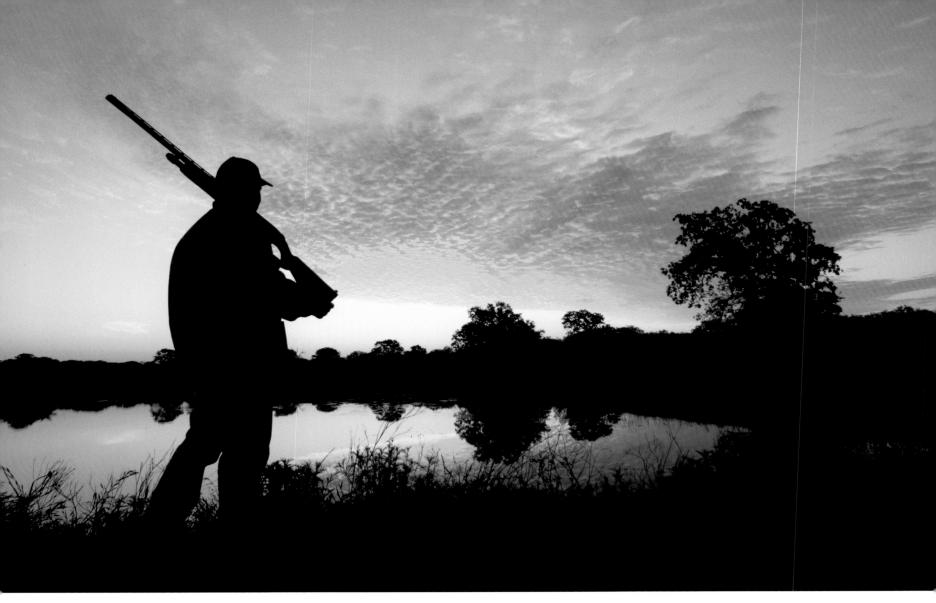

Preparing for a morning duck hunt at Mason Mountain Wildlife Management Area.

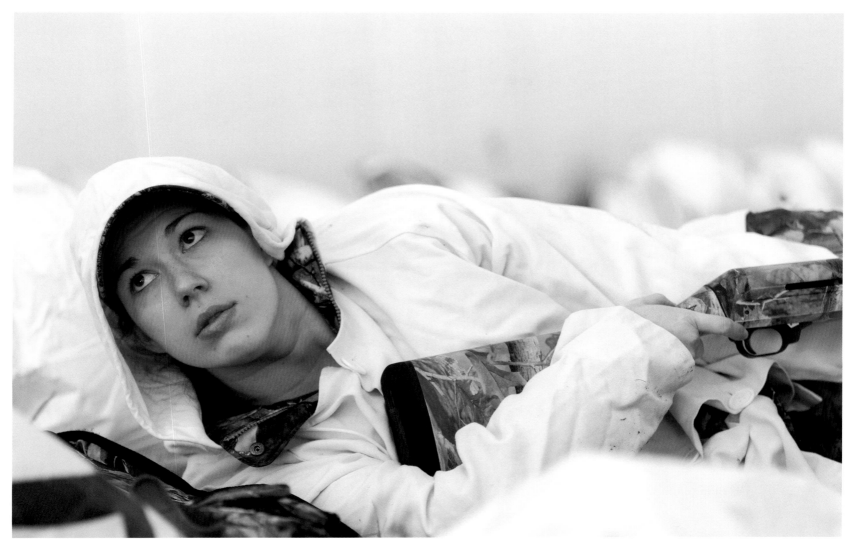

Lauren Laborde experiences her first goose hunt near Bay City.

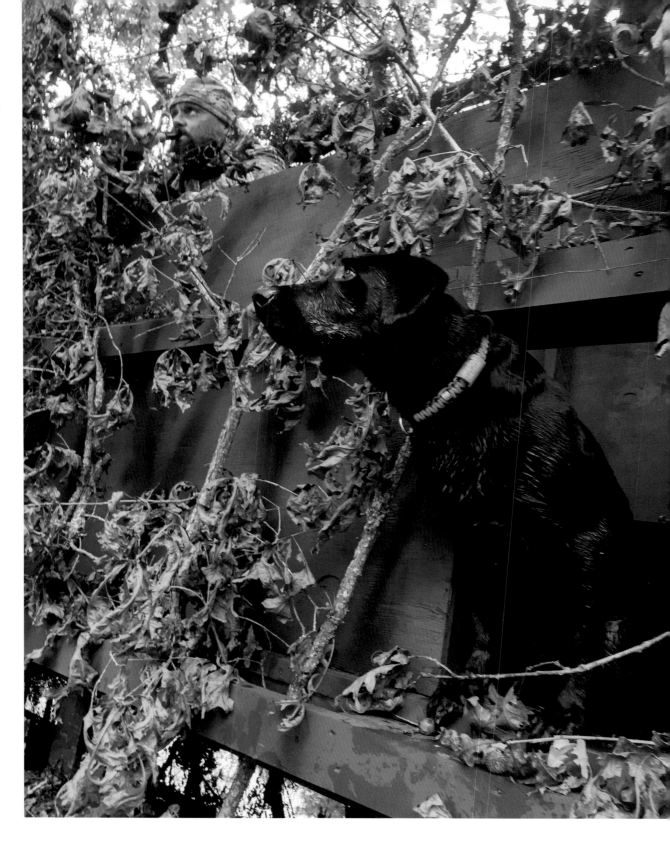

Hunter and retriever await incoming ducks at BigWoods on the Trinity Hunting Preserve, Tennessee Colony.

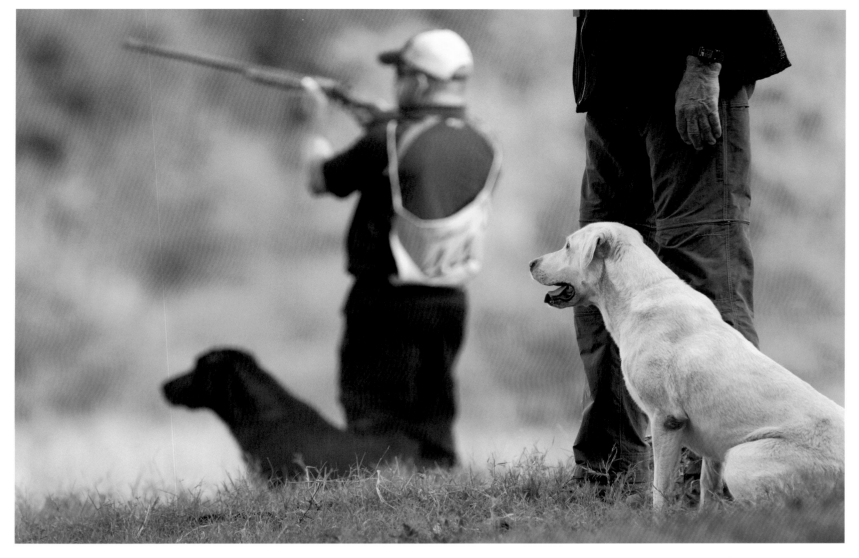

All attention is focused during the Retriever Master Nationals held at BigWoods on the Trinity, Tennessee Colony.

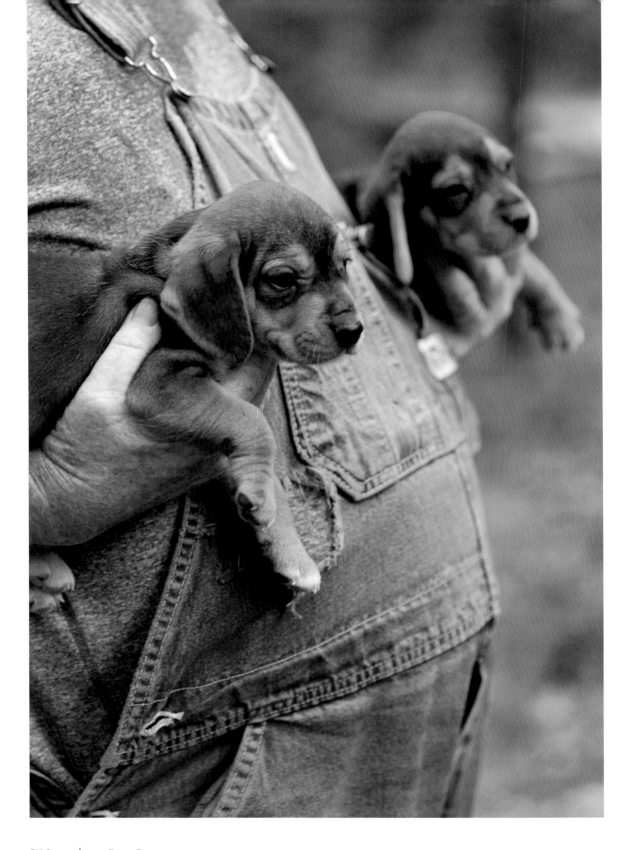

Donny Lynch with future deer-tracking hounds in Uncertain.

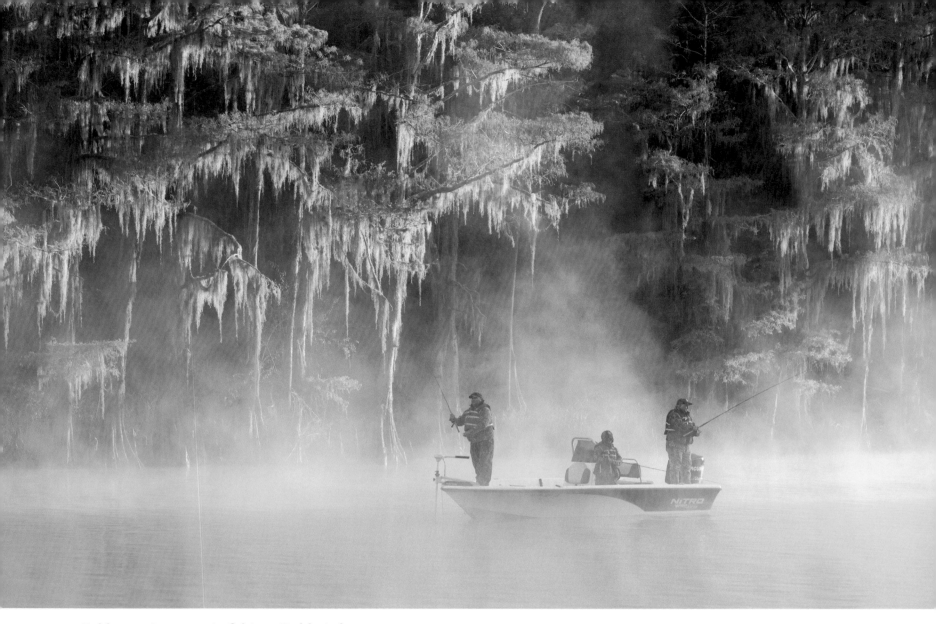

Cold morning crappie fishing, Caddo Lake.

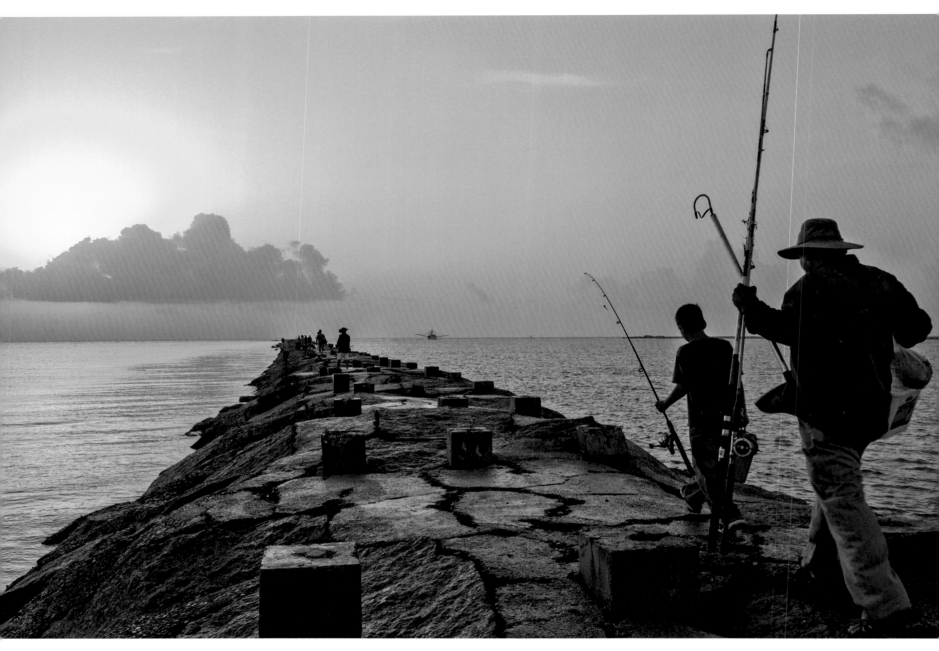

A father and son head out for morning fishing on a South Padre Island jetty.

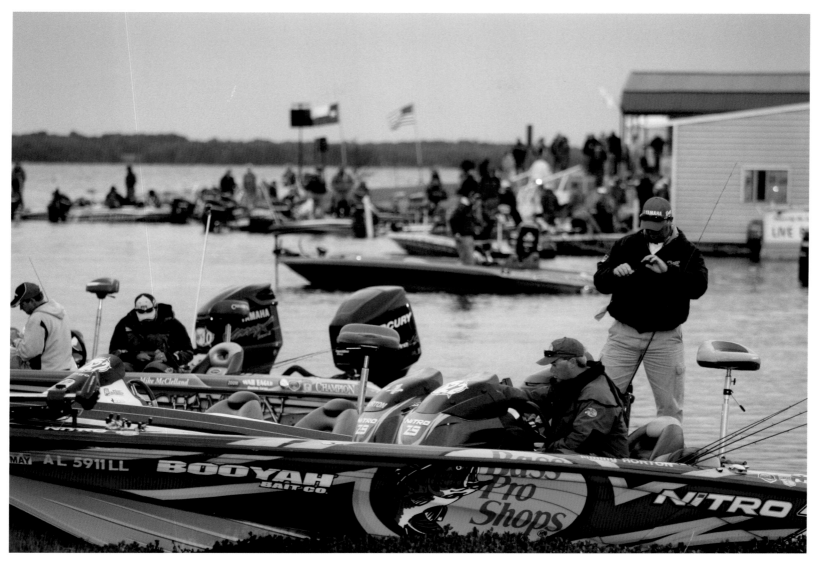

Anglers prepare before sunrise for the Toyota Bass Tournament on Lake Fork.

High hopes of that first fish at Lake Bastrop.

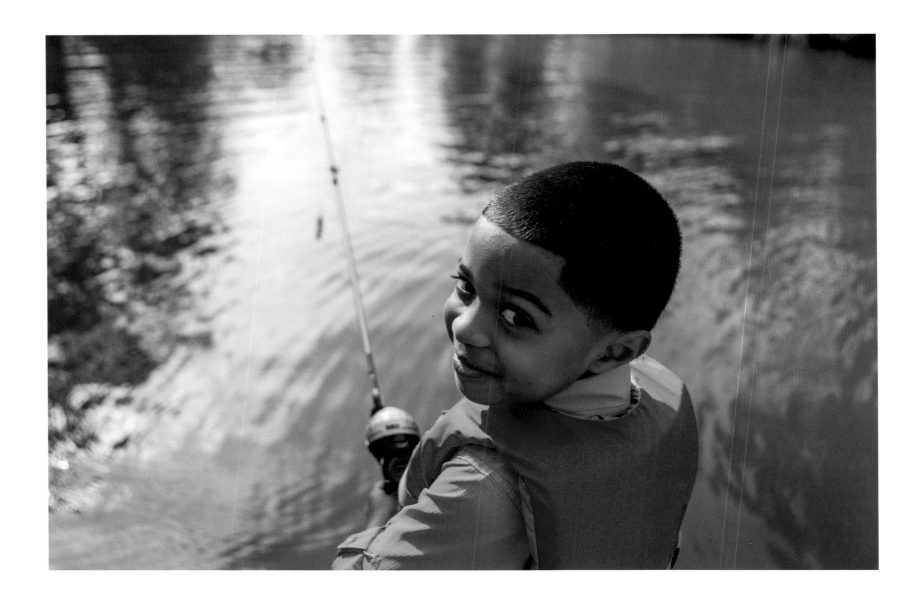

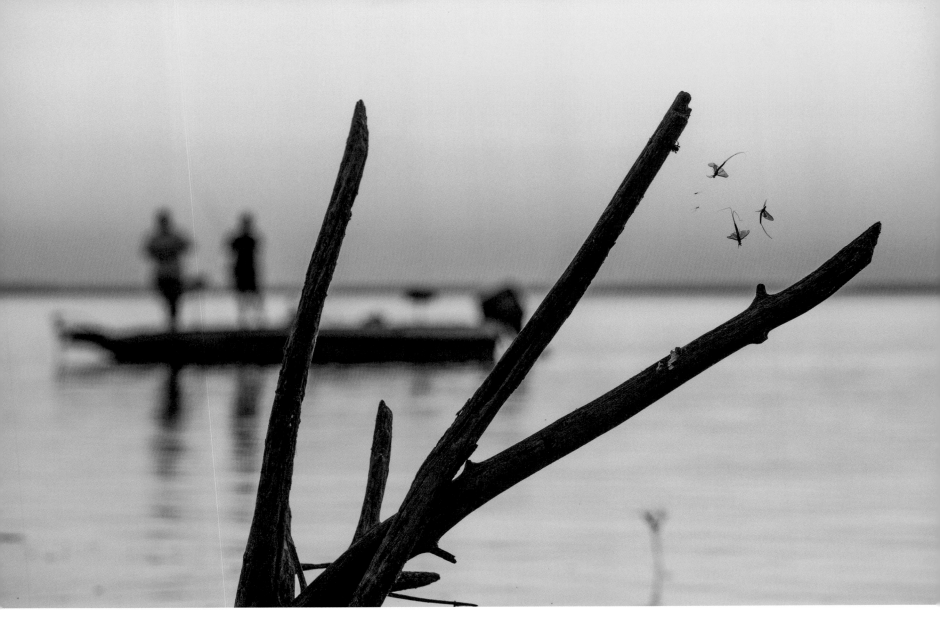

Fishing during the mayfly hatch, Cooper Lake State Park.

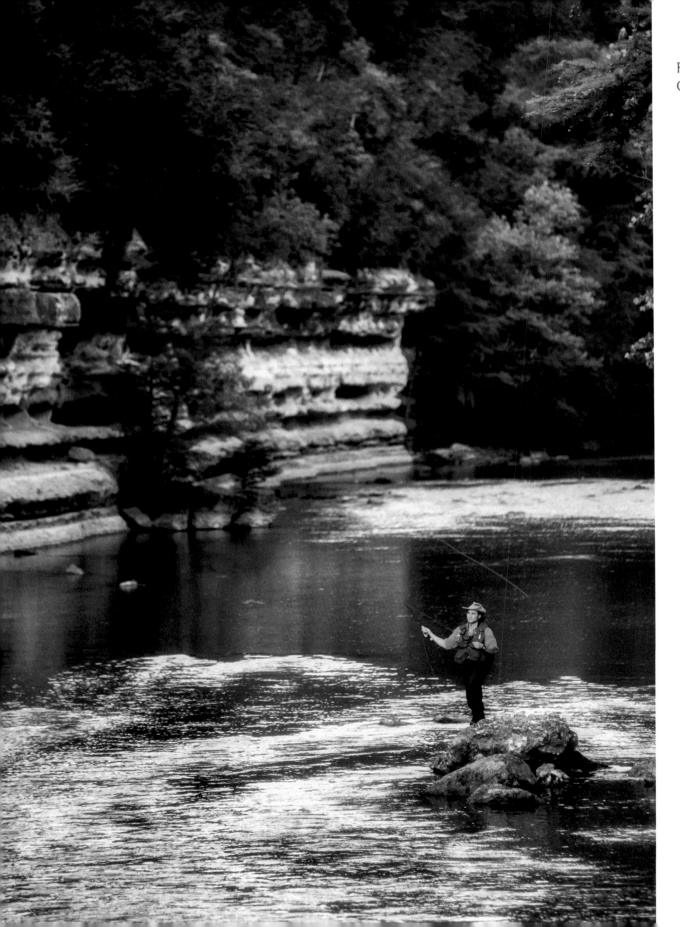

Flyfishing on the
Guadalupe River.

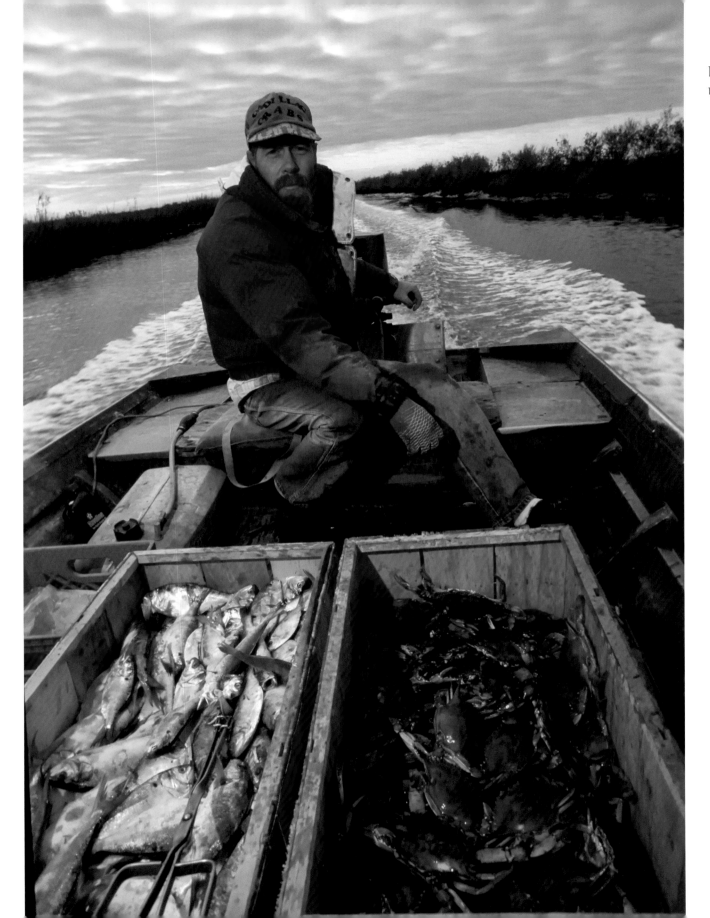

Running crab traps
near Anahuac.

Hunters have morning coffee in the dining room of the Blessing Hotel.

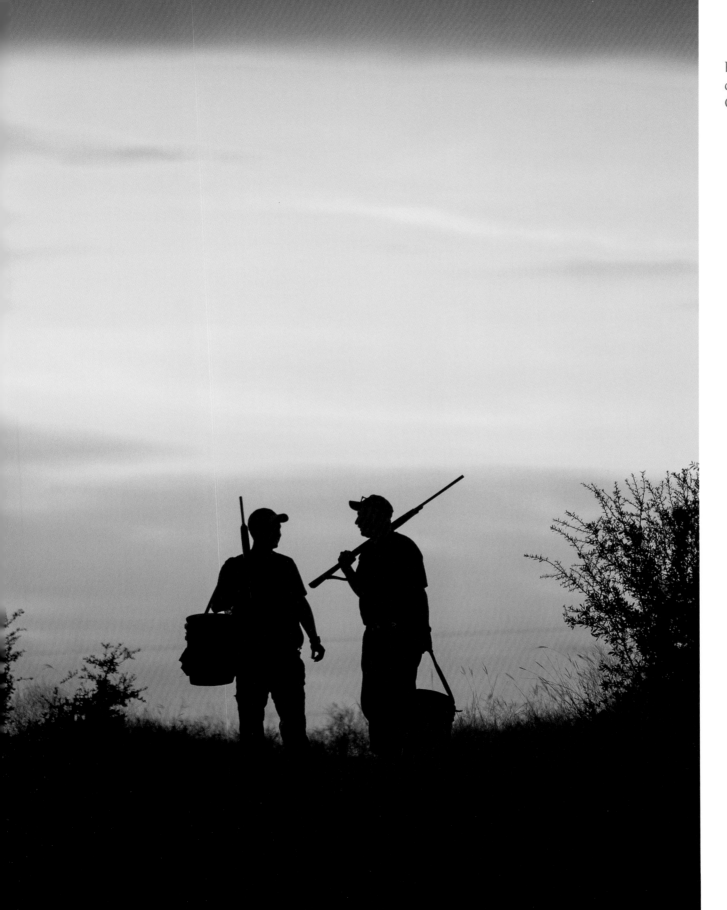

Last light on opening
day of dove season,
Coryell County.

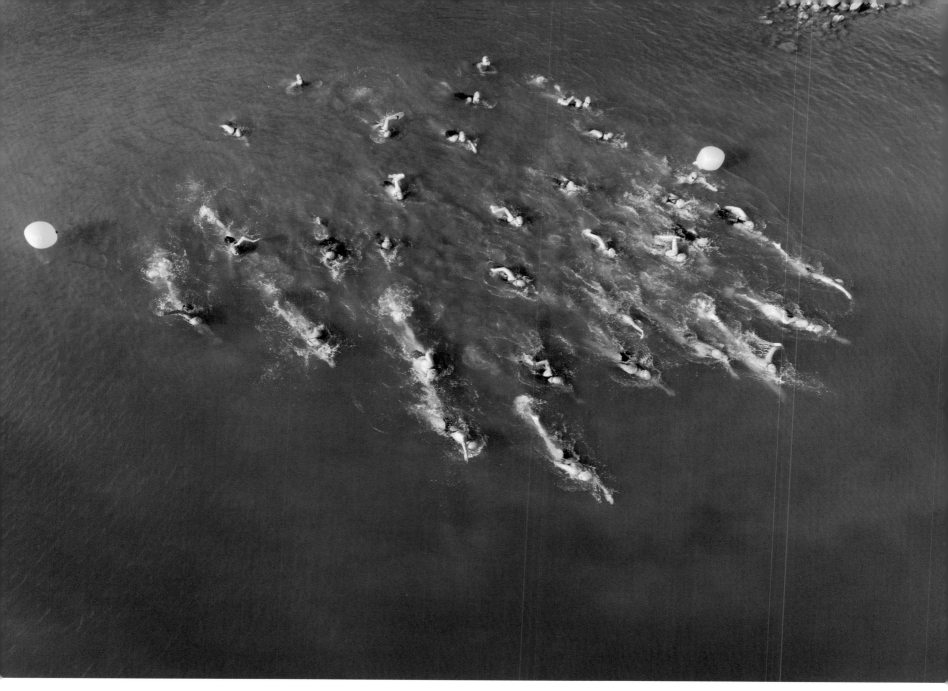

Overhead view of the swimming contestants during the Aquathlon at Cedar Hill State Park.

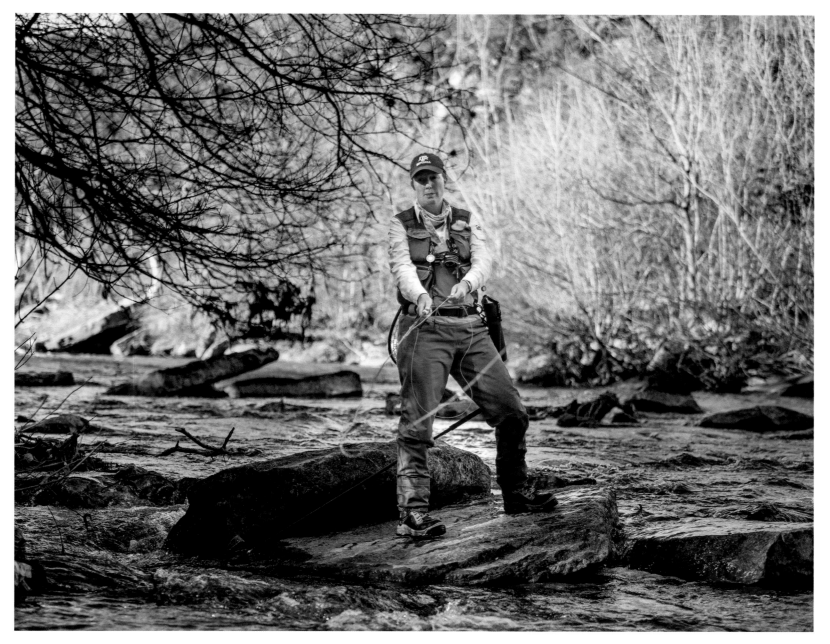

Dana R. Williams, president, Texas Women Fly Fishers, Brushy Creek, Round Rock.

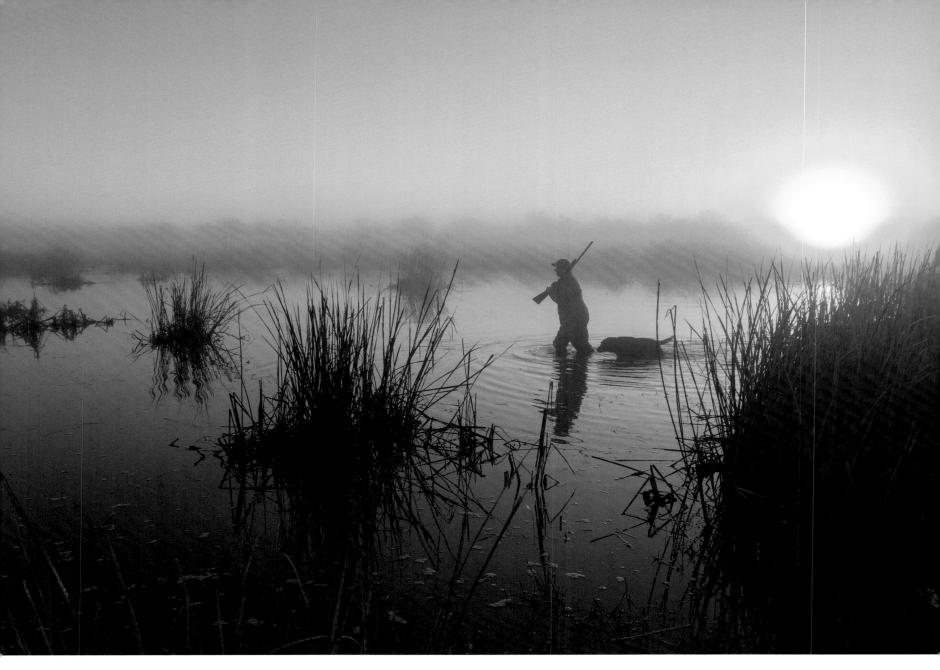

Hunter and retriever on a foggy morning, Matagorda County.

Index

Other titles in the Kathie and Ed Cox Jr. Books on Conservation Leadership, sponsored by The Meadows Center for Water and the Environment, Texas State University

———

Politics and Parks: People, Places, Politics, Parks
George L. Bristol

Money for the Cause: A Complete Guide to Event Fundraising
Rudolph A. Rosen

Green in Gridlock: Common Goals, Common Ground, and Compromise
Paul W. Hansen

Hillingdon Ranch: Four Seasons, Six Generations
David K. Langford and Lorie Woodward Cantu

Heads above Water: The Inside Story of the Edwards Aquifer Recovery Implementation Program
Robert L. Gulley

Fog at Hillingdon
David K. Langford

Texas Landscape Project: Nature and People
David Todd and Jonathan Ogden

Discovering Westcave: The Natural and Human History of a Hill Country Nature Preserve
Christopher S. Caran and ElaineDavenport

Rise of Climate Science: A Memoir
Gerald R. North

Wild Lives of Reptiles and Amphibians: A Young Herpetologist's Guide
Michael A. Smith